Robert Irwin **Getty Garden**

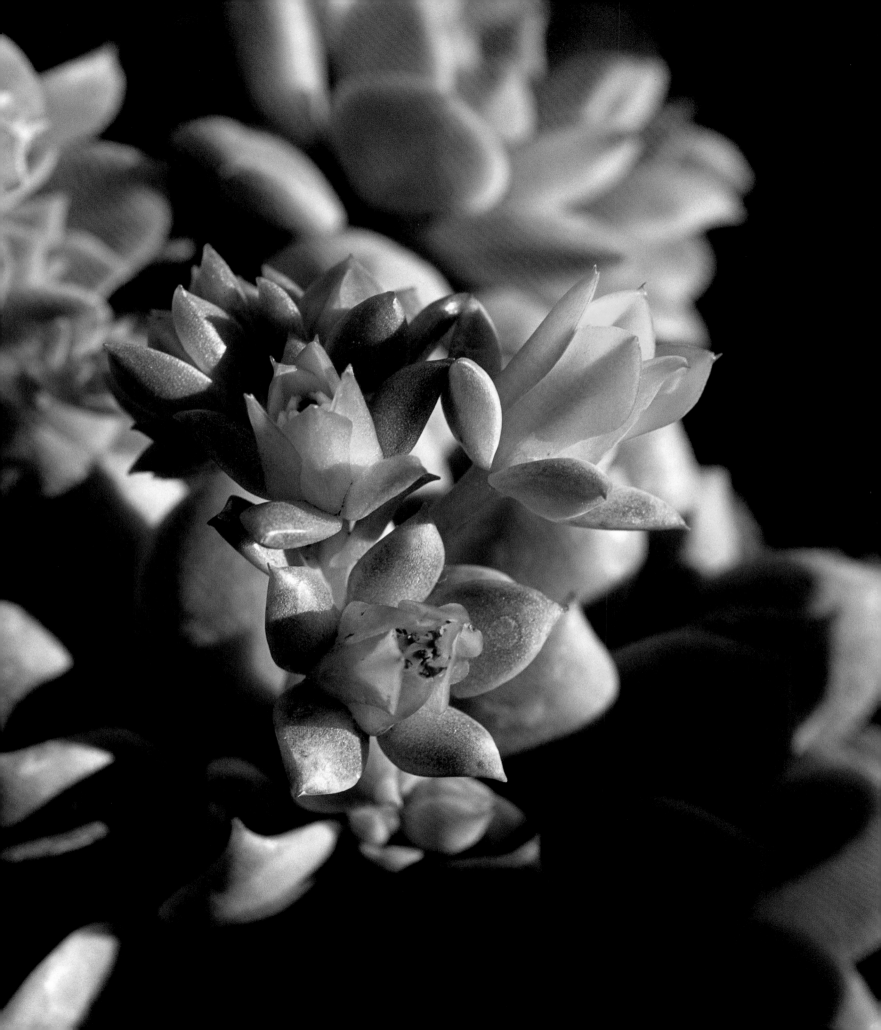

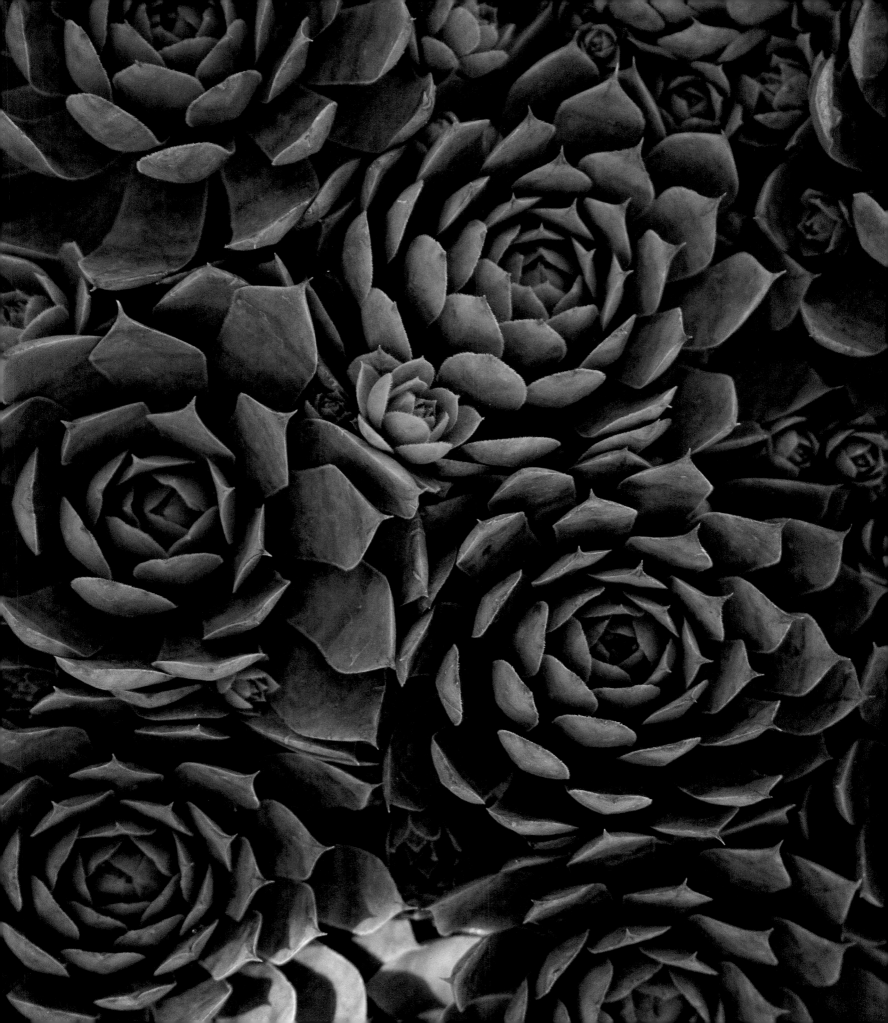

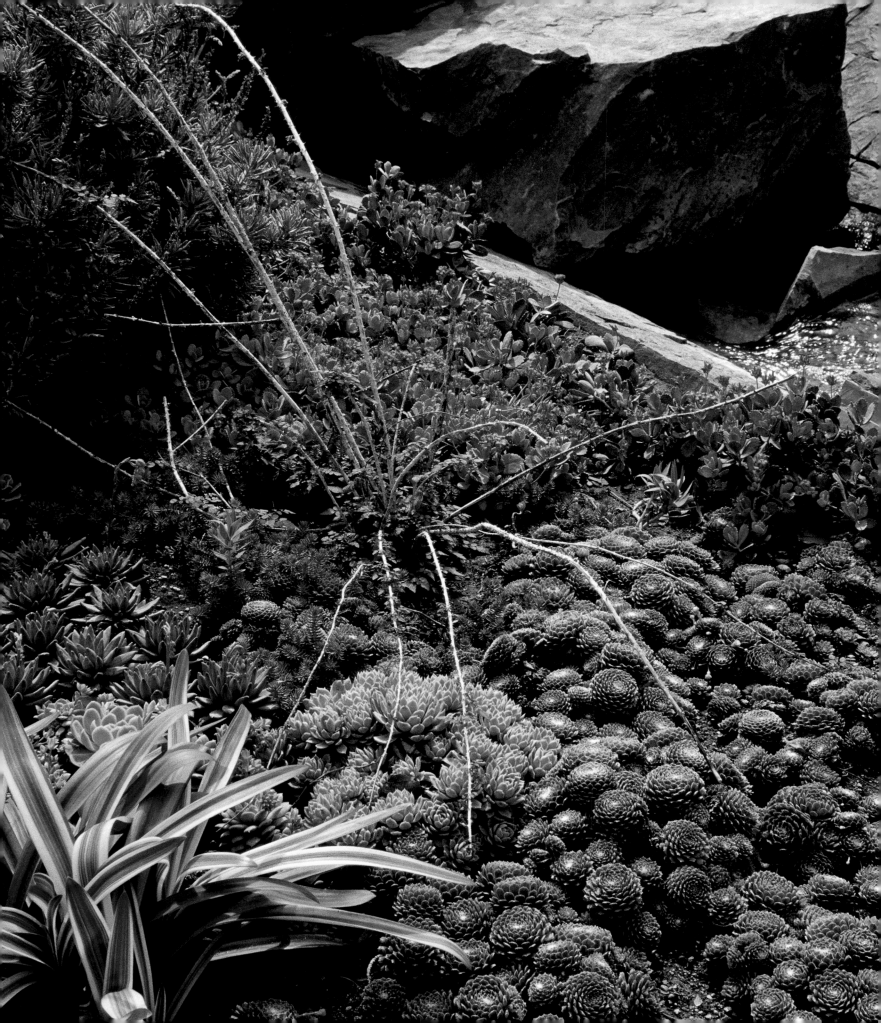

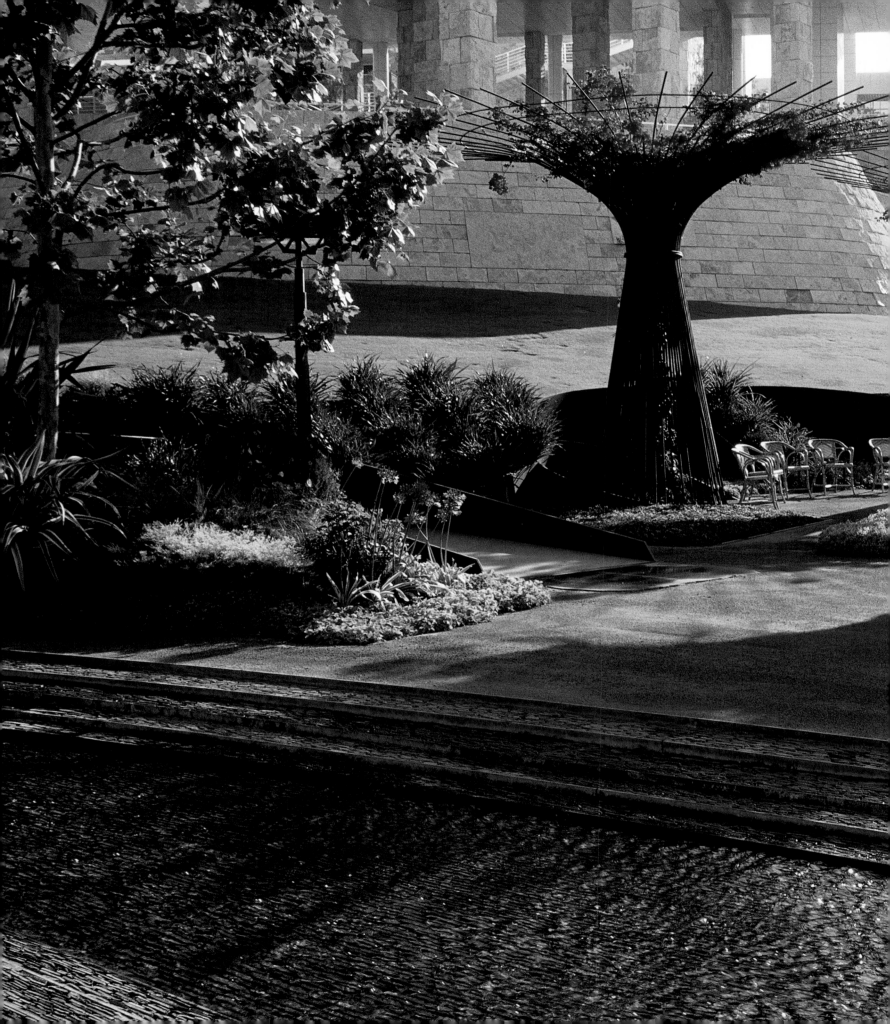

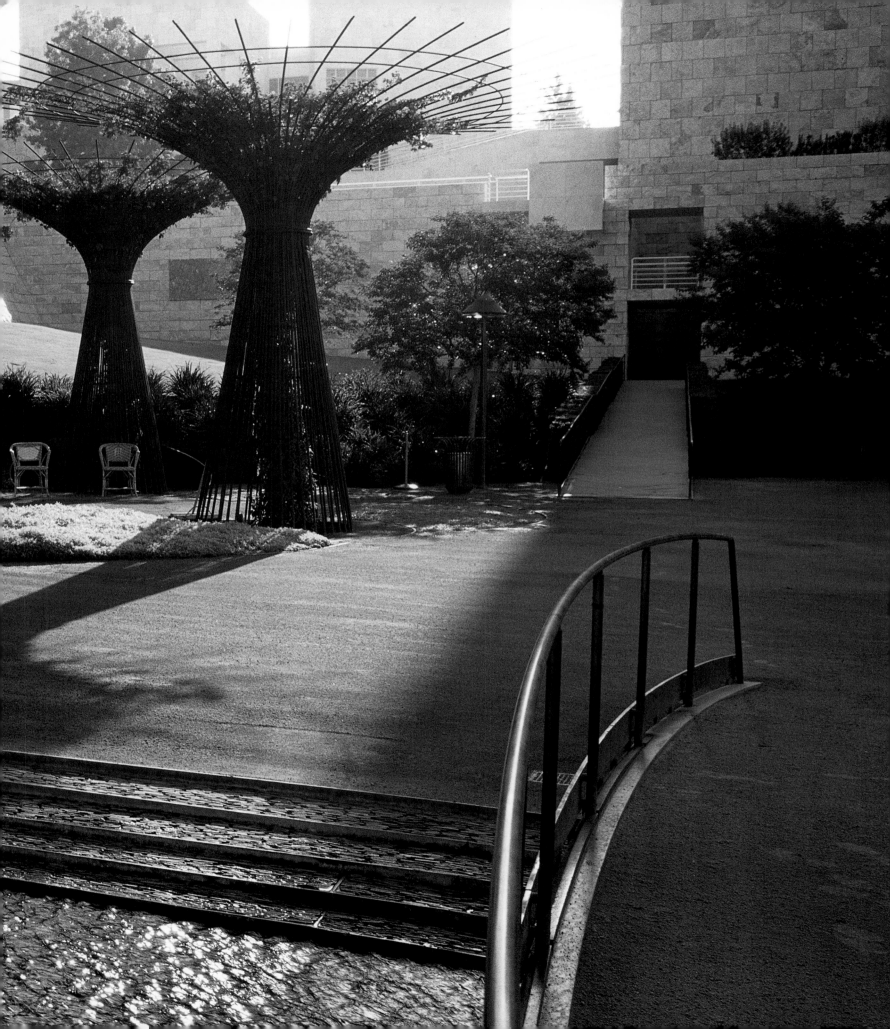

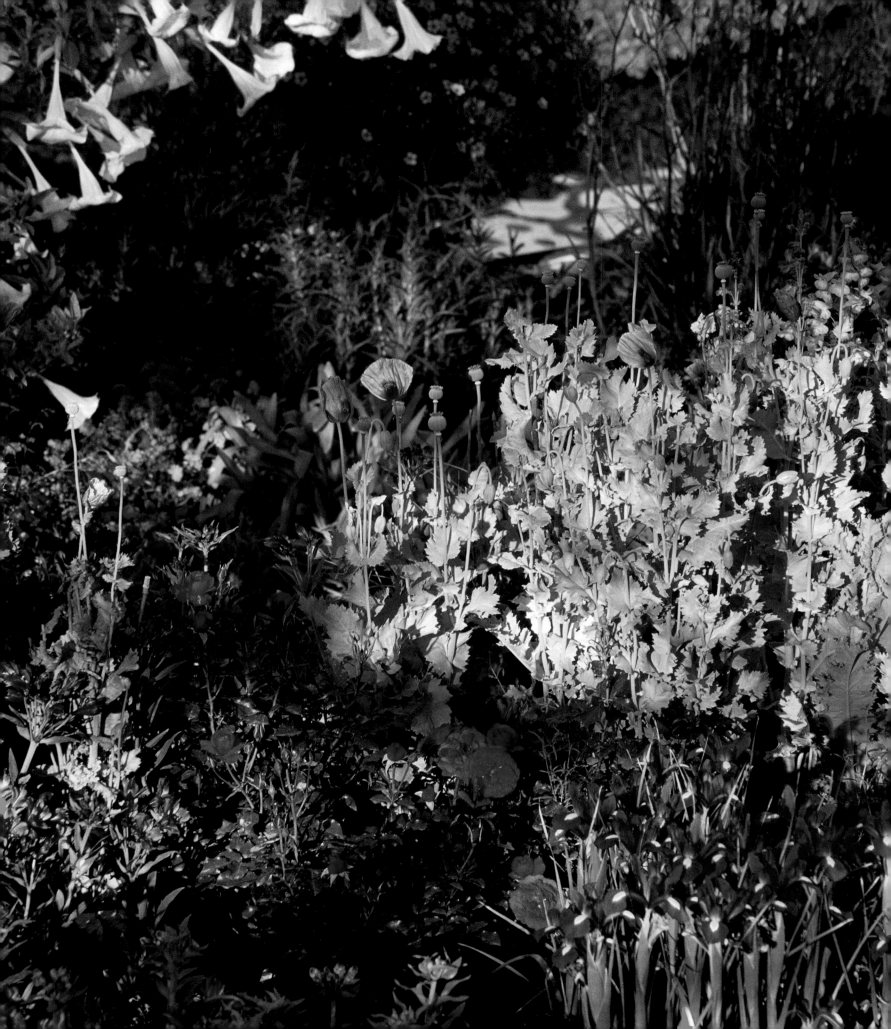

LAWRENCE WESCHLER

# Robert Irwin **Getty Garden**

Garden photography BECKY COHEN

THE J. PAUL GETTY MUSEUM | LOS ANGELES

## A CONDITIONAL ART

*In the beginning I just try to leave myself open…spend my time just attending…not planning… just running my senses over the possibilities. In time you can begin to recognize and develop sets of conditions and responses. You can't plan the phenomenological in nature…you can only court it…and to know its significance you need to bracket out intellect, for a time, in favor of direct, unmediated experience.*

*After a time I began to ask myself…What if? What would I like to see here? What kinds of things feel right in this space? Then I began to build things in my mind's eye…*

*I fantasize. I build things consciously when I am awake and subconsciously when I'm asleep. I build them and then I dwell in them…I walk through them over and over…in this way ideas become experiences.*

*There's an old adage that your first instinct is the best one…when at best it's just a good place to begin.*

*One thing to know is that this process is not limited to this particular instance…it's cumulative over a lifetime. Sometimes the thing I discover—a particular sense or feeling—doesn't actively come into play for years. Sometimes it turns up in the guise of a first instinct to be further explored. The best is when you really surprise yourself, when what you discover resonates in its place and is better than anything you could have ever conceived of.*

*The Getty garden is full of these kinds of surprises for me.*

ROBERT IRWIN

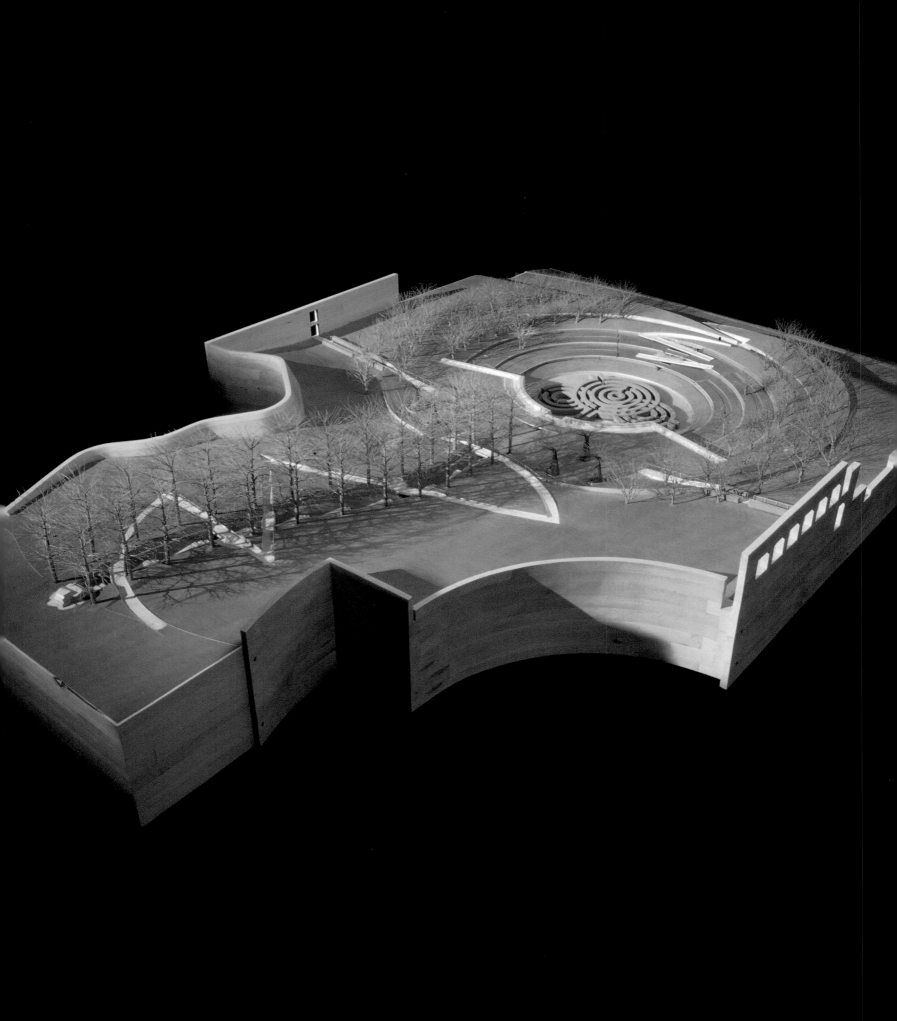

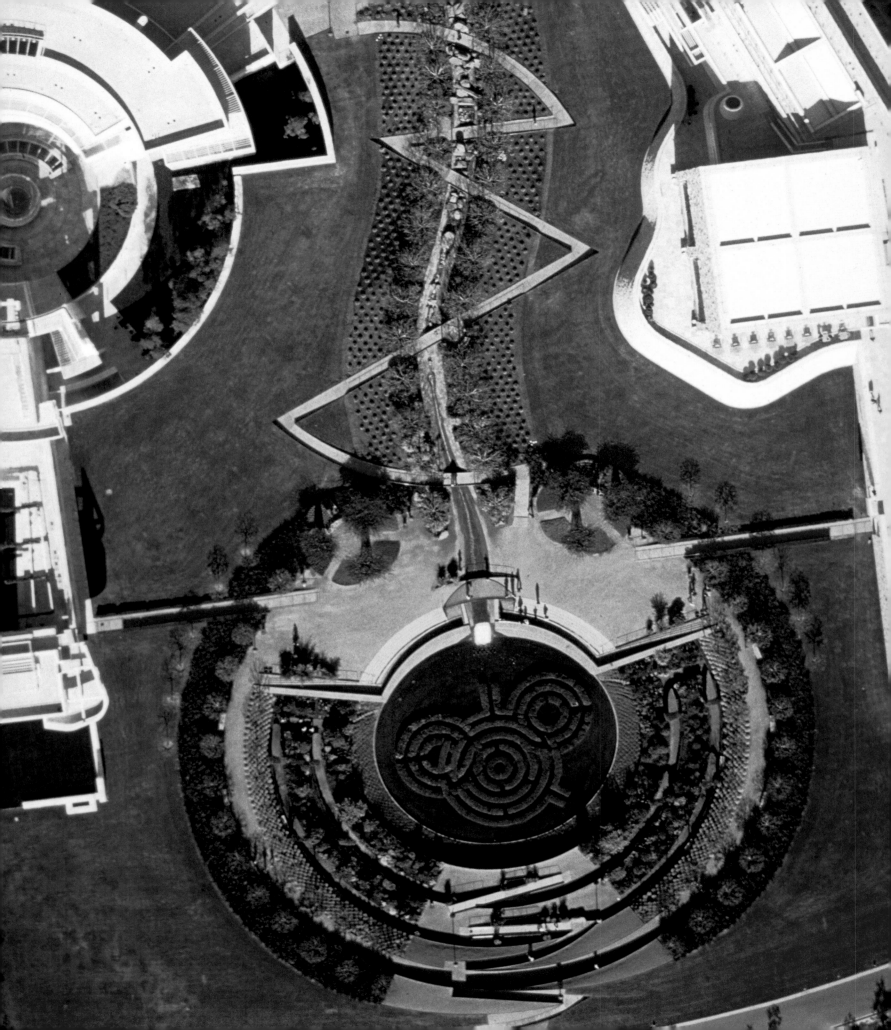

# CONTENTS

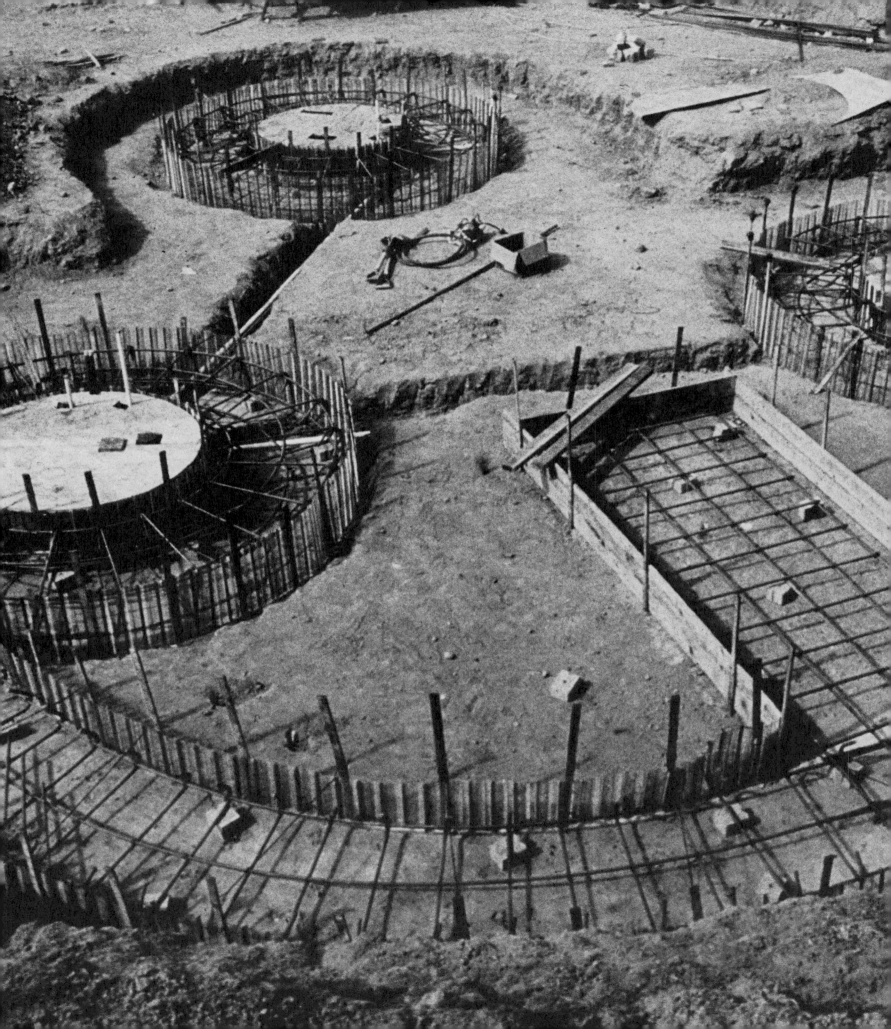

**INTRODUCTION**   Robert Irwin at Richard Meier's Getty (LATE SUMMER 1997)

LAWRENCE WESCHLER

A SOMEWHAT CONDENSED VERSION OF THIS PIECE ORIGINALLY APPEARED UNDER THE TITLE
"WHEN FOUNTAINHEADS COLLIDE" IN THE DECEMBER 8, 1997, ISSUE OF *THE NEW YORKER*.
IT WAS BASED ON REPORTING AND INTERVIEWS CONDUCTED EARLIER IN 1997.

"Got a few minutes?" Robert Irwin asked one bright winter afternoon as I climbed into the passenger seat of his gleaming black Cadillac at LAX. What he meant was more like "Got a few hours?" For in no time—having first stopped at a roadside doughnut stand for his perennially perfect Coke (ice crushed just right, syrup-soda ratio pitched exactly so)—we were coursing up the Pacific Coast Highway, past Santa Monica and the Palisades and Malibu and Point Dume and on toward who-knew-where, catching up on old times and new doings. The latter came principally in two categories: his astonishment, at age sixty-eight, to be finding himself, for the first time in his life, the utterly besotted father of a now three-year-old girl child, his darling daughter, Anna-Grace; and his almost equally overwhelmed astonishment, on this far side of that steadily inspiraling career and across those same three years, at finding himself presiding over the single largest public-art commission of his (or just about any contemporary artist's) life—the Central Garden at the magisterial new Getty Center, currently taking shape astride a hilltop about five miles inland ("Just over there," Bob indicated, as we raced by), with its vernissage set for a fast-approaching December.

As things developed, it turned out to be the latter of these two passions that had set us on this particular wild-goose, or maybe I should say wild-grass, chase, for after about an hour's drive Irwin eased the Cadillac off the road and onto a dusty embankment so that we could gaze upon precisely that—a tuft of wild grass. "Amazing, isn't it?" Bob marveled, and it was, though I'd otherwise never have given it a glance. He proceeded to tell me how he had had his eye on that particular tuft for almost a year now—auditioning it, as it were, in different lights, across different seasons. "Some grasses," he explained, "you can come upon them in high season, when they're really on their game, and they're just humming. But you go back a couple of months later and they're simply gone. Or else they've fallen apart completely—a real mess. But then there are others, like this one, that even when they're down, the dry seedpods are still beautiful. The stalks can get this haunting, graceful, quite striking quality." He got out of the car, crouched in front of the dried tuft, ruffled its stalk spray, palmed its feathery plumes. "Yup," he said, smiling, as he climbed back into the car and negotiated a happy U-turn. The tuft seemed to have passed muster—it, along with more than a thousand other plant types that, Irwin now explained, he'd been subjecting to similarly rigorous seasonal inspections over the past several years as he ever so gradually, ever so painstakingly, pulled together the horticultural components of his garden palette.

I found myself thinking, as we now headed back toward town, how not that long ago Irwin had compressed his entire artistic practice—from his origins as a vigorous Abstract Expressionist, through an increasingly minimalist passion—down to the point ("the zero point," as he'd called it at the time) where he was willing to declare that the way sunlight and shade played across an expanse of lawn had come to fulfill all his requirements for a work of art. And here he now was, just a few years later, effectively carving out that very tranche of grass, along with a myriad of other scrupulously selected ground covers, and deploying them all around a garden project budgeted at more than eight million dollars.

The rigor—or, at any rate, the fixity of attention and the intensity of ambition—ran all the way through, and all the way back. I recalled his stories of himself as a teenager, not twenty miles from there, in the Inglewood flatlands of southwest L.A., where he divided his time between perfecting his technique as a champion swing dancer and perfecting the various cars in which he'd ferry himself to the nightly tournaments. How, for instance, he would fastidiously layer coat upon coat of ruby-red maroon lacquer across the dashboard of his beloved '39 Ford—five coats, ten, twenty—until he'd got everything flawlessly cherry and

just so. And then, one day, how his friend Keith, in a hurry to pry open the locked glove compartment, had jimmied the thing loose with a screwdriver, slipping up in the process and leaving a deep zigzag gash across the twenty coats of ruby-red maroon. Irwin almost killed the guy, and to this day each time he tells the story he concludes, with fresh amazement, how he still can't get over it. "I mean, could you?" he asks. "I mean, how could a person do such a thing?"

*

Originally, no one but the architect was even supposed to be getting near that garden.

Back in 1984, as part of his presentation during the semifinal round of the Getty Trust's competition for what was going to be the premier architectural commission of the last quarter of the twentieth century (a nearly billion-dollar facility, to be constructed from scratch, to house the Trust's museum, library, research center, administrative offices, and various other institutes), the distinguished New York modernist Richard Meier (himself already the author of several of the world's preeminent recent museums, including exemplary structures ranging from Atlanta to Frankfurt) had declared: "In my mind's eye I see a classic structure, elegant and timeless, emerging, serene and ideal, from the rough hillside, a kind of Aristotelian structure within the landscape." And, indeed, Meier's scheme, which by the end of the year had gone on to win the competition, was determinedly Aristotelian, both in its rationalist, geometric rigor and in the unswerving unity with which that rigor carried all the way through: razor-straight lines and compass-perfect arcs melding the complex, disparate elements of the campus into a remarkable, often spectacular, whole.

Meier's plan paid homage to the landscape, in part by continuously playing off of the countless splendid vistas—downtown to chaparral, mountain to sea—afforded by its mountaintop site, but also by honoring the original topography of the mountaintop itself. The original site had consisted of a divided ridge—or rather a bifurcating ridge, the high ground forming a sort of upside-down Y, with a canyon opening out between its two prongs. Even though Meier knew that during the construction phase he was going to end up having to slice off virtually the entire mountaintop (so as to be able to layer in the foundations, parking garages, and various other understories), he nevertheless decided to echo the original topography in the campus's ensuing overall design: an arrival plaza, a restaurant, and various administrative and other lesser institute offices would be grouped around the base of the Y, with the Museum heading off along one prong and the Research Institute commanding the other. Into the now-reconfigured canyon between the two prongs would descend Meier's Central Garden, in many ways the Aristotelian spine, the prime meridian unifying his entire conception. It wasn't going to be a garden, exactly, but, rather, a staircase progression of broad rectangular terraces, with a narrow, concrete-girdled watercourse slicing straight down the middle (the prime meridian itself), toward and then under a perpendicularly bisecting viaduct-like structure— a see-through wall, as it were—at the garden's base (in effect connecting the tips of the Y's two extending prongs). The watercourse was to pour out beyond the viaduct wall, cascading further down the broadening canyon slope, toward a perfect circular pool glistening in the distance below.

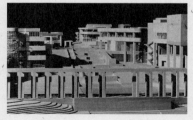

Geometry and panorama: Meier's conception was resolutely, relentlessly of a piece, as became clearer and clearer during the ensuing years as his team started pouring forth three-dimensional wooden models, each more elaborately detailed than the one before. (Visitors to Meier's model shop in West L.A. in those days were sometimes put in the mind of Borges's Land of the Cartographers, where "the map of a

Models of Richard Meier's original design for the Central Garden, 1990. Library Getty Research Institute, Los Angeles.

single Province took up an entire city, and the map of the Empire an entire Province." In fact, the final model eventually proved so huge that it couldn't be wedged inside the Museum's vast elevators and hence had to be left out of the inaugural exhibit surveying the history of the Center's design process.) Indeed, by the early nineties, some of Meier's most important patrons—the Trust's president and CEO, Harold Williams; the Museum's director, John Walsh; and the Research Institute's chief, Kurt Forster, among others—were starting to worry that Meier's rigid Aristotelian unities might be overwhelming the human-scale experience of the place. "It is a truism—but also a vivid experiential truth—that too much of the same is not necessarily 'wonderful' (pace Mae West)," Forster hazarded in a 1992 memo, further suggesting that the Central Garden, variously visible from sites throughout the campus, might be a place to make a stab at some sort of compensating intervention. At first, the Getty executives tried to soften Meier's hard-edged approach by calling in various consulting landscape architects. "Essentially, the Getty people wanted a lush garden," as a contemporaneous witness to the ensuing drama explained to me. "But Richard was beating up on the landscape architects, manipulating and ironing and then spitting them out, homogenizing the whole place, until the Getty people finally began to feel that maybe a full-fledged artist might be able to stand up to him."

Trust president Williams was in a particularly dicey position. A longtime fan of Meier's work, he had in the meantime become close friends with the architect during the many years of their intimate collaboration. Yet now, as the overseer of the Trust's entire operation, he was especially sensitive to the Getty's public image as a five-billion-dollar behemoth, a towering monolith bestriding the cultural horizon, and in all sorts of ways he'd been doing everything possible to diversify and broaden the Museum's image and programs. As such, he could hardly be immune to arguments favoring a greater diversity of experience at the headquarters site itself. But Meier would hear nothing of these concerns, and in the end it took several repeated calls from Williams before he finally began to credit that he might be losing absolute control over his Central Garden.

The Getty people were not insensitive to the fact that some of the world's foremost artists working on the articulation of space and site had at various times been based right there in Southern California. Robert Irwin's name came up in that original Forster memo, along with that of his veteran colleague in California's so-called "Light and Space" movement, James Turrell. (Once quite close, Irwin and Turrell had in fact hardly spoken in twenty years—but that's another story. Originally, the Getty people were hoping to enlist both of them, and Turrell did indeed submit a fairly detailed proposal for a series of observatory rooms embedded into the plaza area immediately above the garden, with crisp square sky holes slotted into their ceilings; but the proposal ran afoul of various seismic-safety concerns, and presently Turrell himself fell away from the project.)

Irwin received an invitation to visit the site and responded because that's just about all he was doing anymore (though never before on quite such a scale). It had been years since he had made an object that you could show in a gallery or, for that matter, buy and take home. People or places invited him over, and he visited to appraise the site, spending hours—or, sometimes, days and weeks—gauging the specific experiential qualities inherent in the situation, eventually either succeeding or failing to come up with a proposal that would be pitched precisely to that specific moment and place, "conditioned," as he likes to say, "by the site itself."

One day, I asked Irwin whether that wasn't pretty much what architects themselves always did. I pointed out that Meier, in his original Getty prospectus, had sounded many of the same sorts of themes. ("Buildings are for the contemplation of the eyes and mind but also, no less importantly, to be experienced and savored by all the human senses. You cannot have form in architecture which is unrelated to human experience; and you cannot approach an understanding of experience, in terms of architecture, without a strongly sensuous and tactile attitude toward form and space.") "Well, yeah," Irwin replied. "Except with him, as with most of them, it's lip service. He has a formula, this Euclidean approach"—"Euclidean" being Irwin's term for what Meier calls "Aristotelian"—"and he applies it everywhere he goes. Look at the result. The Getty proposal was obviously going to be a Meier building. It was going to read that way from a mile away—a Meier building on top of a hill, with a garden as its pedestal. This isn't even to criticize it, exactly: it's got all sorts of beautiful, really wonderful features. It's just nowhere near what I'm talking about.

"It's funny about the language, though," he continued. "When I first began talking like this, twenty years ago, I'd get blank stares. People would send out feelers, I'd do my song-and-dance over the phone, concluding as to how on that basis I'd be willing to come and see, at which point they'd say: 'Well, fine, but can you tell us what you'd be planning to do and about how much it will cost?' They didn't get it. Now, the invitations I get, it's incredible—it's as if I wrote them myself; they've got the rhetoric down pat: 'sensitivity to the unique conditions of the site,' blah-blah-blah. Only, when you get there, nothing's changed: contracts, up-front projections, supply requisitions, budgets. They still don't get it."

It was by no means obvious that the Getty people were going to be getting it, either—but at least they seemed willing to give his approach a try. Irwin came up from his San Diego home, paid several visits to the site and to the model shop, returned home, thought about it some more, came back up. "I began with a set of circumstances," he recalled. "As such, every decision had to make sense within the context of a set of cues. In this case, of course, the surrounding architecture was key. This was not going to be a garden off in a field someplace. I accepted its architectural setting—which was all but overpowering—but that, in turn, raised other questions. For how do you go from such a surround—from buildings like that—down to a flower? So that you can see this petal, that stalk? I began to think in terms of starting from geometry, compounding the geometry to pattern and the pattern to texture. And doing so in both directions—from the flower out to the buildings, and from the buildings back to the flower."

Eventually, Irwin was ready to make his presentation, and in a series of meetings in late 1992 and early 1993 he did so, in front of Meier, his associates, and senior Getty officials, at Meier's West L.A. office. For starters, he was proposing dispensing with the entire Meier "pedestal." The "natural" slope of the canyon would be reclaimed—at any rate, near the top of the garden. Toward the bottom he proposed raising up a curved embankment on the far side, thereby creating a sort of bowl. There would be plants everywhere—grasses, flowers, shrubs, low trees. Water would still course down the canyon slope, but now vaguely off center, in the form of a gently arching creek, girdled by rocks and boulders in such a way as to emphasize the sound of its gurgling. The creek would be bordered on both sides by parallel lines of stately sycamore trees—the sort one encounters, for instance, in the Luxembourg Gardens, in Paris. The trees, as they grew, would be shaved into sheer rectangular planes on the top and to the sides, in homage to the surrounding architecture—but over the creek their branches would be allowed to grow into each other in a virtual debauch of fertility. A shaded path of steps would run alongside and occasionally back and forth across

the creek, which in turn would pick up speed as the slope steepened, approaching the bottom of the bowl. Then, suddenly, the creek would launch out over a staggered, concave stone wall—a "chadar" of the sort common in Moghul gardens in India—once again carefully tuned for sound as well as spray. Down below, at the bottom of the bowl, there would be a wide oval pool. Inside the pool there would be a large maze, consisting of three intersecting circles, fashioned entirely out of flamboyantly red, purple, and pink azaleas, which, although embedded in intricately shaped planters, would look as if they were floating upon the water.

Meier was stunned and, frankly, aghast. Ovals? What was Irwin talking about—site-conditioned? There were no ovals anywhere else in the entire plan! And, beyond that, of course, what had become of his precious axes, his prime meridian, the Aristotelian unities? Perhaps, for that matter, Meier already sensed the truly subversive aspect of Irwin's conception, for with this garden the artist was positing an all-out argument against timeless permanence and eternal unities and in favor of immediate presence and almost delirious multiplicity. He was going out of his way to make this a seasonal garden—one that would be changing all the time. The trees would be deciduous (unusual for California): their leaves would fall in the autumn, revealing the stark, skeletal structure underneath. For that matter, the entire garden would be designed to go mute in winter, a wild notion in famously seasonless Southern California—a winter garden. Then, come spring, everything would come blazing back again to almost uncontrollable life. ("You can't control nature," Irwin explains. "You can only court it. That's why artists have always evaded nature. Landscape paintings, in a sense, are anything but.")

"You had to feel for Meier," as one of the Getty participants at the meeting recalled for me, "having this whole other set of eyes suddenly inserted into the middle of his conception." Another noted how with, say, individual offices, "if people ended up painting the interior walls some color he wasn't going to be able to abide"—which is to say virtually any color—"Meier would always be able to close the door. But this was going to be in the middle of his whole scheme, visible from every inward-facing window, plaza, or balcony. Furthermore, if you look at his original drawings, the elevations, this was going to be slam in the middle of his entire conception. Bob, of course, counters that those elevations will still all be visible, and visible everywhere, from inside his garden. But it's not the same thing."

The Getty people, at any rate, were sold on Irwin's presentation. "I found it completely convincing," Walsh recalls. "Its relation to the site: the recovery of that notional brook as a sort of homage to the spirit of the place, the canyon that used to be. I liked the poetry of the water meandering and then collecting in a basin upon which everyone could look down and within which there was this funny little intellectual puzzle, a maze that could only be solved visually or by ducks. I loved that. It took me a while to realize how astonishing it was that an artist would be proposing to install a work of art he couldn't possibly control, one in which change was not only inevitable but the very premise of the piece. In fact, come to think of it, it was a little like Getty himself, who simply left $700 million to a trust with virtually no stipulations—and then died. Bob's not about to die, but still…"

So the Getty people basically endorsed Irwin's proposal and directed Irwin and Meier to start collaborating from that point forward. Irwin, like everyone else on the site, was to run his plans and specifications through Meier's office, which would then contract out the work. Not surprisingly, things did not go altogether smoothly. One observer of the ensuing scene summed up matters at that stage under the simple rubric "When Fountainheads Collide."

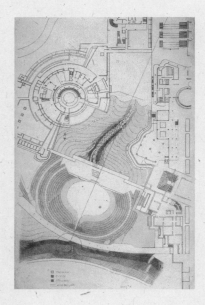

Robert Irwin's preliminary drawing for the Central Garden. Library Getty Research Institute, Los Angeles.

From Irwin's point of view, Meier's office seemed intent on sabotaging his efforts at every turn. "My personal opinion," one of the top Getty administrators told me, "is that Richard should have reached out more and embraced Bob, not that Bob could have been co-opted exactly, but..." His thought trailed off. "Instead," he continued, "Meier's office seemed to throw up ever more spurious arguments against ever more erroneous characterizations of Bob's positions, to which Bob reacted by expanding his proposals, pushing his ideas ever higher up the side slopes and toward the upper plaza."

Clearly things couldn't go on this way. Indeed, they came to a head in a meeting in Meier's office in May 1993. Apparently, the loss of the panorama, caused by the raised far embankment, was at issue, and John Walsh, the Museum's director, recalls trying to assuage Meier's fury on the subject by asking if he could really object if a visitor who had already been amply exposed to the view lost it for a while, especially if he was going to recover it again on the far side—to which Meier said yes, he could and he did. Harry Wolf, an associate of Meier's, now rose and laid out an elegant, thoughtfully reasoned restatement of Meier's argument, systematically eviscerating Irwin's core positions. Irwin smiled beatifically the entire time, waiting for Wolf to finish. Eventually, still smiling, he asked, "Do you want a response?" Wolf said yes, he did. Smiling, he asked, "Are you finished now?" Wolf said, yes, he was. Still smiling, Irwin pronounced, "BULL... SHIT."

"There followed the longest silence I think I've ever endured at a meeting," Walsh says. "And it was at about that point that we realized that these two guys were simply not going to be able to work together." In the days that followed, a boundary line was established—referred to almost immediately and ever after as the Demilitarized Zone ("The DMZ")—and ground rules laid down: "It's Richard's water up here in the main plaza and on down to here, and after that it's Bob's water." Irwin was authorized to hire his own consultants and deal with the contractors directly. As a regular visitor to the site characterized the situation for me, "In preschool I believe the phrase they have for this sort of arrangement is 'parallel play.'"

Among the senior Getty staff members, "the whole situation provoked a lot of soul-searching," Walsh recalls. "And in a big sense it was a leap of faith. Bob was so compelling, so much more articulate verbally than Richard—and yet, oddly, so much less so visually. Richard had all these gorgeous models and elevations and drawings. Bob had his schematic diagrams, which were, frankly, quite difficult to read." (In fairness, Irwin lacked Meier's huge model-generating office staff and budget.) "In the end, though, we went with his vision, which was absolutely commanding, and just prayed he'd be able to wrestle it to the ground."

*

"I was in way over my head, which, actually, operating the way I do, is pretty much where I live," Irwin confessed to me.

For one thing, he didn't know the first thing about plants. Early on, he bought about a thousand dollars' worth of horticultural books and began cutting them up, to generate collages of the kinds of plants he was hoping to be able to interweave [pp. 51, 56, 60, 73]. He sorted them as to height, texture, leaf shape and color, flower type—sorted them, that is, almost exclusively on the basis of their look, their feel, and their sensual presence, while, at first anyway, remaining virtually oblivious to the question of whether it was even possible to grow such plants in California. He began visiting nurseries all over the state, his collages in hand, crossing off the impossibilities, generating fresh leads as to alternatives.

Almost from the outset, he befriended the head groundskeeper at the Getty's old Malibu facility, an affably stout character named Richard Naranjo, who would eventually be playing a similar role at the new campus; as such, Irwin quickly realized, he would probably prove his most significant Getty interlocutor. Together, they undertook a crash course in azaleas, constructing a full-scale triple-circle maze of planters on the Malibu back lot and stocking it with prize specimens a full two and a half years before they'd need to start transplanting them to the hilltop. They went on field trips together, visiting far-flung nurseries. "Bob had this way of looking at plants unlike anyone I've ever encountered," Naranjo told me. "For instance, he'd talk about how trees looked completely different lit from in front than from behind—not only a whole different color but a whole different density—which was going to be important because here they'd have to work both ways, which wasn't always the case. Things I'd never really thought about before. Invariably, we'd visit some new nursery and he'd spot some strange, scraggly tree and get all excited, pointing—'Richard, I want that tree'—to which I'd have to say, 'Bob, that tree is dying.' 'Shows you how much I know about gardening,' he'd reply cheerfully, very easygoing. But he was a great listener and a fast learner."

Eventually, Irwin also teamed up with Jim Duggan, a youthful nurseryman closer to his San Diego home, in Encinitas. "I don't know," Irwin says. "I just liked the guy. He was smart and passionate and hungry and, bizarrely, he was really into swing dancing—a very good sign." Duggan began procuring specimens to Irwin's specifications, and Irwin went out regularly to Duggan's place to look and sort and mix. One day, when I happened to be in San Diego, he took me along. Duggan turned out to be a lanky fellow with stringy, strawberry-blond hair pulled back in a ponytail under a wide straw hat. "There's never going to have been a garden quite like Bob's," he said to me at one point, as Irwin loped up the hill to inspect a stand of Cupid's dart. "Most other gardens, you've got your roses over here and your wisteria over there. Things are organized vaguely on the basis of taxonomy or ecosystem—whatever. Bob's thrown all those categories out. He's mixing together things nobody ever thought of trying, simply on the basis of how they look, on some notion of beauty. Who knows if some of them will even succeed in growing side by side."

Irwin loped back, wiping his hands, made a few comments on the darts, and then elaborated on his vision of the garden. "For instance, in one area maybe we'll have white bougainvillea and white roses interlaced—slightly different colors, but both of them bulletproof, guaranteed to flourish—and then from out of their midst a little time bomb, a total exotic surprise, the snapper, say some dalechampias, this incredible purple-blue, just for a few weeks and then gone. And then, as those die out, from underneath will be rising up some new combination in time for the next season." Irwin smiled and, turning to Duggan, said, "Meier has *no idea*."

The three of us went into Duggan's shack, where it turned out that Duggan was a bit of a computer maven as well: he'd been charting the plantings for the entire garden, specimen by specimen, stand by stand, season by season. He offered to print out a list of the finalists—more than five hundred of them. There were fourteen types of vines and another fourteen kinds of small trees; there were twenty roses ('Blue Nile,' 'China Doll,' 'Gingersnap,' 'Iceberg'), fifty kinds of bulbs, and hundreds of shrubs and perennials. "I've got various nursery friends who come by and flip through these lists, shaking their heads," Duggan said, "and I tell them, 'You've got to understand, this isn't just an ordinary garden. It's more like'— what's that phrase you're always using, Bob?" They invoked it together, almost a singsong mantra: "'A sculpture in the form of a garden aspiring to be art.'"

It was a typically clunky Irwinesque formulation—he often reverts to phrases that sound really good, then parse a bit oddly on the page—but it struck me that the key word in this particular formula wasn't so much *sculpture* or *art* as *aspiring*. Philosophically speaking, Irwin was pitching his standard resolutely in the loam of Becoming, as opposed to that of Being. If anything, it seemed to me, the proper analogue was less sculpture than music—a sort of visual music, the formful unfurling of thematic material across time. My grandfather, who was a composer, used to talk about the architectonic embedded in a piece of music, by which I think he meant its structure across time. What Irwin's noodling around with is time stretched across a structure.

Just before leaving, Irwin and Duggan reviewed the soil situation. Before planting anything they were going to be laying in thirty inches of specially mixed soil—worm castings, scoria, oak-leaf mulch (the worm castings alone were going to take a hundred trucks to haul in). "As dark as possible," Irwin kept saying. "The darker the better. Worm castings, peat moss, whatever it takes. Nobody ever seems to pay attention to the color of the soil, but, especially in winter, the soil is going to be a lot of what's on show."

\*

And, for all that, plants and soil constituted only a fraction of Irwin's concerns when it came to the garden. He'd been just as deeply engaged by the challenge of rocks, for instance—scouring quarries throughout the country before settling on green chert from the California Gold Country for the boulders at the head of the stream, Montana Kennesaw for the flanks of the watercourse, clean-cut slabs of Tennessee Blue Ridge sandstone for the footpaths, and carnelian granite from South Dakota for the staggered waterfall. "And every single stone hand-selected," Irwin insisted. The same effort went into selecting the wood for the bridges, arbors, and benches, which turned out to be teak; the bronze for the railings and drains; the specially treated rebar for the bougainvillea bowers; and the decomposed granite for the terraces. In each case, not only was Irwin making choices about materials; he was having to track down just the right people—experts and craftsmen who could help him realize his vision. By the end, he had his own tree man, his rock man, his teak man, his watercourse man, and so forth (many of whom the Getty ended up bringing on as consultants for the entire facility); fourteen separate consulting firms, three engineering offices.

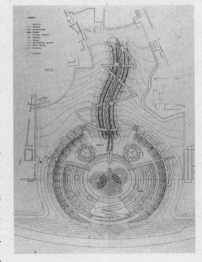

And that's without even mentioning the handicapped. Don't get Irwin started on the handicapped. In the midst of all his other concerns, Irwin learned that the "Disabled-Access Consultant" to the Getty Trust was objecting to the inaccessibility of his streamside path for wheelchairs. "I couldn't believe it," Irwin says, sputtering. "I mean, I'd provided ramps on both sides of the garden, running along the retaining walls down to the oval pool, but they were objecting to the fact that people in wheelchairs weren't going to be able to make it down the steps along the side of the brook as well, and all my counterarguments notwithstanding, they would not be swayed." In the end, though, as with many of these crises, the challenge only further enhanced the garden. Irwin dutifully filleted the stream of its steep path and, instead, deployed a widely swaying zigzag ramp, back and forth down the entire slope.

Now, back at his apartment (with his wife of eight years, Adele, in the kitchen preparing a meal and their daughter, Anna-Grace, merrily capering underfoot), Irwin spread out a revised plan of the garden on his drafting table. "See," he explained. "You'll start up here, just below Meier's plaza, and then cut diagonally right through the sycamore allée and across the brook—only, this first time, the water won't even be

A later version of the Irwin design; drawing by Andrew Spurlock. Library Getty Research Institute, Los Angeles.

visible yet, it will be coursing deep between the rocks under the bridge; you'll get this nice throaty sound wafting up, you'll feel the vibration, but you won't see anything—and then on out the other side a few hundred feet and then a switchback, after which you'll slice through the allée once again, over the brook, now splashing quite visibly beneath you, and on out the other side, then another switchback, and back again. Walking the path should induce this strangely mesmerizing effect, and with each switchback the character of the surrounding garden will change, getting more and more effusive as you go down, till you reach the terrace here, with its bougainvillea bowers, overlooking the chadar waterfall and the pool below. And every inch of it, I assure you, is wheelchair-accessible—in fact, precise to the inch!"

It sounded wonderful. Lying there, spread out across Irwin's worktable, it also looked—if you momentarily allowed yourself to imagine the prospect through another set of eyes—like an almost excruciating act of defacement: a jagged, zigzag gash across the heart of a perfect Aristotelian expanse.

Not that Meier was entirely without recourse. Irwin, as if he'd read my thoughts, pointed to a spot at the top of the DMZ and said, "This is where Meier was charged with delivering the water over to me. As you can see, it flows along this straight channel, cutting across his upper plaza, and then it has to descend about twenty feet to the start of my garden stream, and what he's basically done—you can see it here—is that he's constructed this twenty-foot-tall white urinal, the water continuously streaming—or should I say 'flushing'—down its sides, visible from just about everywhere in the garden."

Whether such had really been Meier's intention is hard to say (I suppose he could always invoke an ironically knowing homage to Duchamp). Others of those involved in that particular phase of the project from among Meier's team insist on their complete innocence, characterizing the falls chamber as an "amphora" and citing the example of the waterworks at Chantilly. Who's to say?

An art historian with whom I was discussing the situation laughed, recalling the Piazza Navona in Rome in whose fountain Bernini included a sculpture of a towering titan, cringing, cowering in horror at the spectacle of the church across the street, which had been designed by one of Bernini's chief rivals. It was unclear, from the art historian's analogy, just which of the two—Irwin or Meier—he was casting in the role of Bernini.

\*

Shortly thereafter, I paid a visit on Irwin at the Getty hilltop work site as he was rushing to complete the garden's installation in time for the December opening. Looking down from the upper plaza, from a spot alongside the top rim of the urinal (in fairness, more like a grotto), I found it hard to imagine how Irwin and his team of coworkers—more than seventy-five of them—were ever going to pull things off. The garden itself was nowhere in sight. Sinuous crape myrtles rimmed the distant embankment, but there were as yet no other plants, shrubs, or grasses—not even any dark soil. Dry, light beige dust was billowing up everywhere. Cranes sliced through the air, ferrying their load of boulders. Workers in gleaming-white hard hats were spreading gravel, laying slabs of Blue Ridge sandstone, welding Cor-Ten, jimmying trellises, boring tree holes. Amidst this hive of activity, it was easy to spot Irwin: he was the one with the wide straw Vanessa Bell garden hat flopping incongruously beneath a hard hat of his own. "Yeah, sure," he said when I reached him. "Round here you're a lot more likely to get whacked by the sun than by any falling girders."

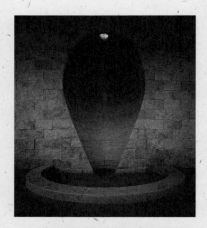

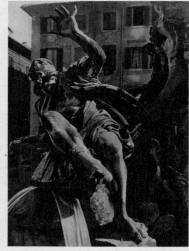

**TOP** Richard Meier's "amphora."
Photo: Scott Frances/Esto.

**BOTTOM** Detail of Bernini's *Rio della Plata* in the Piazza Navona, Rome. Archivi Alinari, Firenze.

He didn't seem overly concerned by the pace of the garden's progress. The opening was still a good ten weeks off, and he reminded me how in the old days it used to take him longer, sometimes, to prepare the intricate armature underlying his ever-so-slightly bowed canvases than it subsequently did to apply the paint itself onto their surfaces. "It's all right: we're basically on schedule, provided about a million things fall our way over the next few weeks—and not a single one fails to. And in the meantime," he laughed, "every morning coming up here it's like Christmas, getting to see what the trucks have brought up today." As if on cue, another parcel of hand-picked boulders went flying by above.

Irwin strode around the grounds, checking on individual work sites, crouching down on his knees to chat about specific details with the workers, most of whom he seemed to know personally. They greeted his arrival in that goofy straw under-hat with stylized jocularity, but they obviously held him in high regard. "For one thing," one of the foremen commented, "he's here almost every day, and often long after we've packed up to go home." (Meier, by contrast, well on to new projects back in his New York base, has been returning to monitor final progress on his buildings for only a few days at a time, once or twice a month.) "Guy's sixty-eight years old and he's the hardest-working artist I've ever seen." They marvel at his resilience and his ingenuity. "Meier has one solution for a thousand problems," one of them commented to me. "Bob seems to have a thousand solutions for every single problem, and he wants to deploy them all." Laurie Olin, a distinguished Philadelphia-based landscape architect who's been helping to coordinate details between Meier and Irwin for the Getty, remarked how "Bob's rapport with the workers is extraordinary. Reminds me of something Noguchi once pointed out about Bernini during the days he was building St. Peter's in Rome: how what made him so special, aside from his own obvious gifts, was his ability to extend himself through the work of others, to get them on his side and working in his direction. It takes great skill. Olmstead had it too, and so, clearly, does Irwin."

As Irwin ambled about, it was obvious how highly the workers thought of him, but perhaps even more striking was the regard in which he held them. He treated them as peers, immensely respectful of their skills, their craft. ("Of course," he once commented to me, "if we're going to pull this whole project off, the thing that's really going to matter experientially is the craft, much more than the design, the sorts of things—the underside of the bronze railings, the jointure in the teak benches—which you might not even notice till your fifth or sixth visit.") Such regard was all the more striking when you recalled how much trouble Irwin often has treating his artistic peers (Meier, Turrell) like peers. With them, the relationship sometimes seems to shade into something more akin to gladiatorial combat.

Irwin presently wandered over to the far embankment, under the crape-myrtle canopy, and gazed out over the circle-maze pool (empty, as yet, of either water or azaleas) and beyond it—up the zigzag path and toward the buildings towering on the ridges above. "This is a real power spot," he said. "You know how Indians in the desert sometimes talk about power places? Well, this may be The Power Spot for the entire Getty Center. Standing here, you've got the whole place by the short hairs."

And the effect was striking. You could see where Irwin got the otherwise arbitrary-seeming idea for the three concentric circles, how they'd derived—virtually been introjected—from the configuration of the buildings looming along the flanking Y-ridge above. But somehow he had managed to turn the effect inside out: it was as if someone, Godlike, had dropped three pebbles in a crystalline pool and the concentric

Robert Irwin in his garden gear.
Photo: Andrew Spurlock.

ripples, shimmering ever outward, beyond the pool rim and up the sides of the canyon, had somehow magically coalesced into the very buildings.

It was like that, and then it wasn't like that at all—I mean this contest of egos. Wandering around by myself (Bob had gone down to the empty pool to consult with Naranjo about the imminent arrival of the azaleas, scheduled for later in the week) and gazing back up along the creek, I realized that my own associations were with some of the possibly more autobiographical taproots for Irwin's garden conception. For instance, it suddenly dawned on me, uncannily, how, almost twenty years ago, when I first published my midlife biography of Irwin, I'd broken the book into aquatic sections: Lifesource, Narrows, Delta, Oceanic. A few minutes later, I was talking with Andy Spurlock, a landscape-architect friend of Irwin's from San Diego whom he'd enlisted for his team at an early stage, and we'd taken to talking about some of those sorts of associations. "It's funny," he said, "because I've long felt a different sort of resonance. You know who I see all over this garden are Adele and Anna-Grace. I think this garden grows almost directly out of this deep new sense of Bob's—late in his life—of family life. He's terrifically sentimental. Tears come easy to his eyes when he's watching Anna-Grace and Adele. I think when you get the plants in here and they start playing off each other you're going to have this tremendous sense of an enveloping heart and intimacy, this cusping sense of fertility, a real strong emotional feeling. The whole thing even looks like a womb. And I don't think there's any doubt where that's coming from."

In that context, it seemed sadly ironic that the garden would be down and barren at the time of the Getty's grand opening festivities. I walked over to join Irwin, who'd now climbed out of the azalea pool and was inspecting something on the bougainvillea terrace above the chadar wall. I asked him whether the December opening grieved him. "Ah, nah," he said. "I mean, does it bother me that all those bigwigs will be converging on the place and my garden will be down, so that some of them won't see it, they'll come out here and say, 'What's all the fuss?' Won't be the first time that's happened to me. The elevator doors used to open on some of my gallery shows, people would step out and step right back in, thinking there was nothing there. Maybe it would have been a little easier had the place opened in the spring, but the point is, the spring wouldn't have been the garden, either. Or anyway, December with its haunted, mute, skeletal quality is just as much the garden as June or July with their riot of color. And in any case, it's going to take three, seven years for the trees to grow in, the underbrush to fill out. That's part of what the garden's about. If you're going to experience it in all of its qualities, you have to keep coming back. A garden is a commitment."

He was quiet for a few moments, his mind obviously wandering. "It comes back to this question of what people see when they look, what they base their gestures on. You walk around the campus with Meier, and you can be deep in the bowels of the library, and he'll indicate some imaginary point on the floor, completely surrounded by walls, and tell you how that point lines up perfectly with some other point over on the other side, in the Museum. With him, it's purely conceptual, it's the purest abstraction."

But hadn't Bob used to tell me stories about himself and his friends as teenagers, working on their cars, how they'd spend hours trying to decide whether to buff-grind or cad-plate a bolt on the inside of the car door panel, or just leave it raw, a bolt that no one was ever going to see?

"Exactly," he replied. "But we were basing that decision on how the bolt looked, how it felt—not on some abstract geometrical conception."

Hadn't he himself, at a key juncture in his career, back in the early sixties, holed himself up in his studio, laboring sixteen hours a day, seven days a week, for three years, ending up producing ten canvases, each consisting of two straight lines floating on a square monochrome field? What could be more abstract, more geometrical, than that?

"But that's the point," he insisted. "They weren't. I never used a ruler, or a compass, or a protractor. It was all by hand, by eye—raising, lowering, lengthening, shortening those lines: I was honing my eye. It was all about honing my own sense of experiential perception. And it was exactly during that period that I started understanding what the whole modernist project which art has been embarked upon for the last two hundred years—and which we are still in the middle of (postmodernism is complete nonsense: we've only begun to scratch the surface of the modernist project)—what that's all been about. It's been a long, arcing dissent from the dominant abstract systematization, the technological quantification that has so characterized the rest of human experience during the past two centuries. Technology is wonderful, the improvements it has brought are fantastic. But the modernist trajectory over the past two hundred years has been about everything that progress has been leaving out. Quality as opposed to quantity. Quality, which can only be experienced by each unique individual, phenomenologically, across the passage of lived time.

"In this context, 'abstraction'—you know, modern art's being 'abstract art'—is a red herring: the word just confuses people. People are going to come up here and at first glance they'll look at Meier's buildings and say, 'Yup, modernist,' and they'll look down here and think, 'My God, the guy's gone completely baroque, he's rococo!' But that's to think of modernism as a style rather than as a project, a way of engaging the world. Maybe I'll be lucky in the next ten years and I'll get one or two more cracks at realizing some other big project, which won't be a garden—of course, I have no doubt that I'll now be getting dozens of invitations to do gardens, as if that's what I'm mainly interested in; and it will be a shame not taking them up, not being able to deploy all this practical knowledge I've built up. But maybe I'll get to do one or two other situations, completely different, like this invitation coming up to tackle the third-floor space at the Dia Foundation in New York—and maybe then the point will be clearer for people."

The point being?

"Well," Irwin smiled, as we ambled toward the base of the zigzag walk, "it's funny. The Getty people wanted me to put up a signature plaque somewhere, and I was resisting, but eventually I agreed to place a pair of little landing stones here where the walk ramp opens out onto this terrace. They'll face each other, Rorschach style, with my signature and the date—'Robert Irwin, December 1997'—but mainly they will say on one side 'EVER PRESENT, NEVER TWICE THE SAME' and on the other 'EVER CHANGING, NEVER LESS THAN WHOLE.' "

I pointed out how Irwin's Heraclitean koan seemed a perfect foil to Meier's Aristotelian rhapsode. And of course, Heraclitus, as a Pre-Socratic, was much admired (as over and against Plato and Aristotle) by many of the same phenomenologists Bob most prized.

"Well," Irwin responded, "I suppose so." We began climbing out of the garden bowl. "Because it all comes down to how you answer a single question: Is the moment of perception—that first moment, before all the abstracting, conceptualizing processes that follow—is that moment closest to or furthest from the real? Everything depends on how you answer that question."

I recalled Auden's line "Does God ever judge by appearances? I suspect that he does."

"Okay," Bob agreed. "But of course Plato and Aristotle go the other way on that. Heraclitus stuck with the primacy of perception."

As we climbed, and the buildings above loomed larger and larger, it occurred to me that, despite all the tensions of the ensuing collaboration, the Getty leaders had had a truly striking intuition when they invited Irwin into Meier's space. Irwin could have had no better—no stronger—site against which to stage his argument. And Meier's strengths, in turn, may yet leap out all the more vividly set off against Irwin's.

I tried this notion out on Irwin as we emerged from the garden and out onto the plaza. At first he seemed to bridle, but then he began to relent. "Maybe," he said. "Maybe. It's a little like the Lindy, which was my favorite dance back in the days of those swing contests. The whole key to the Lindy was the shoulder twist: you and your partner would be coming at each other full force, and at the last moment you'd do this little shoulder twist and spin each other around, so that you were acting as counterweights to each other, and, man, if you got it going real good, it could get to the point where you were almost floating—really—just flying."

He laughed at the memory of it. "Great dance," he said. "Great dance."

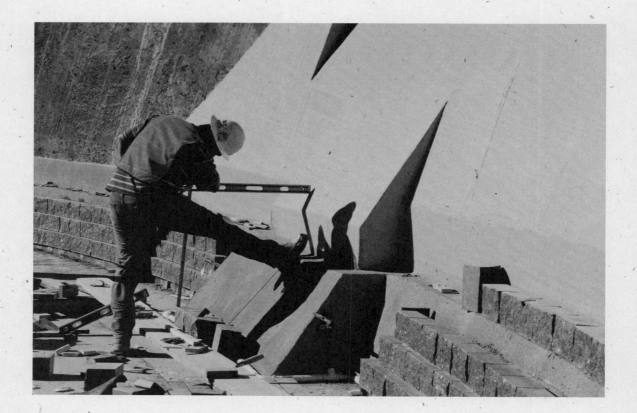

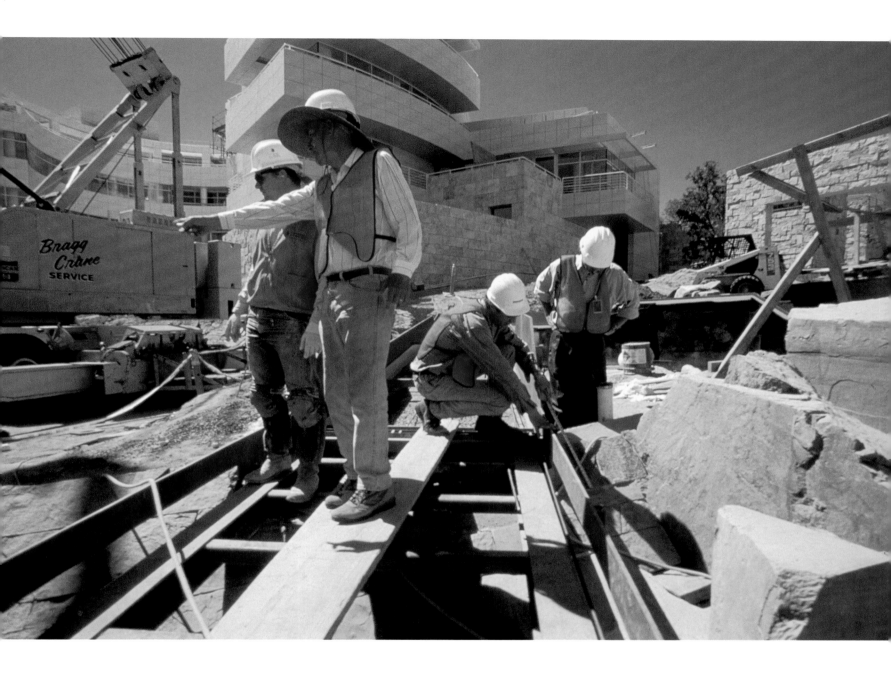

PAGES 14–23: The Central Garden under construction.

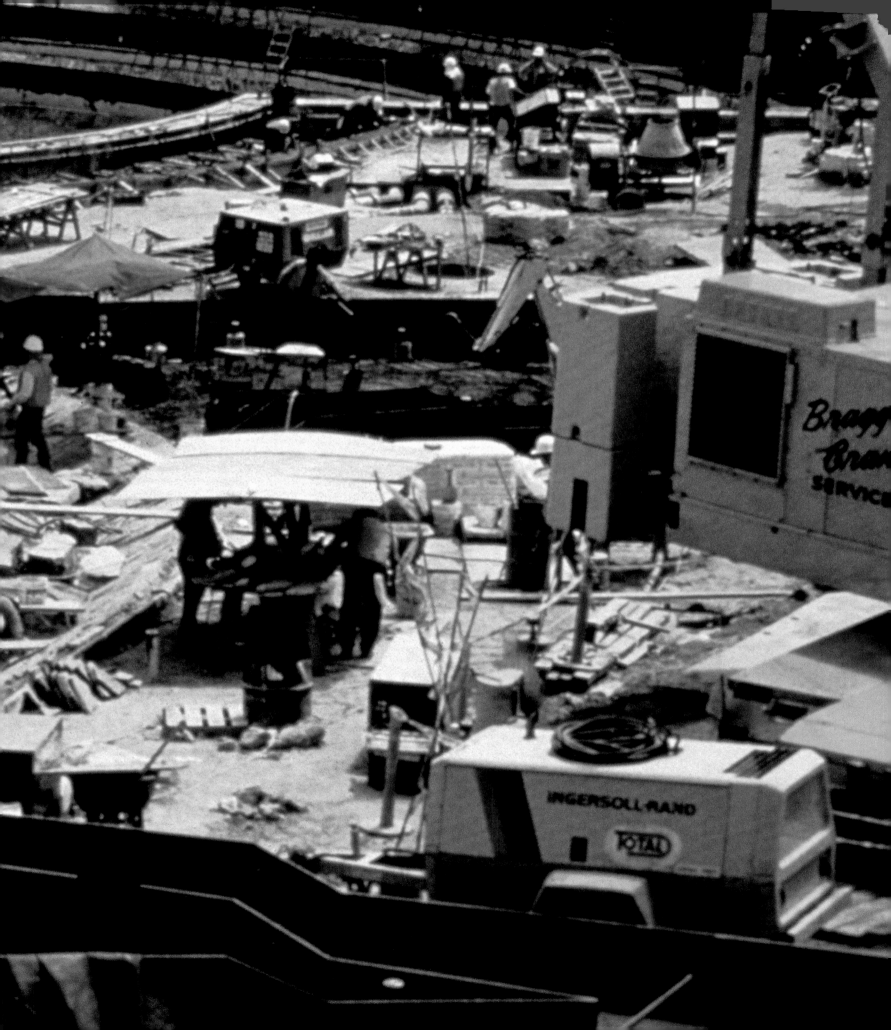

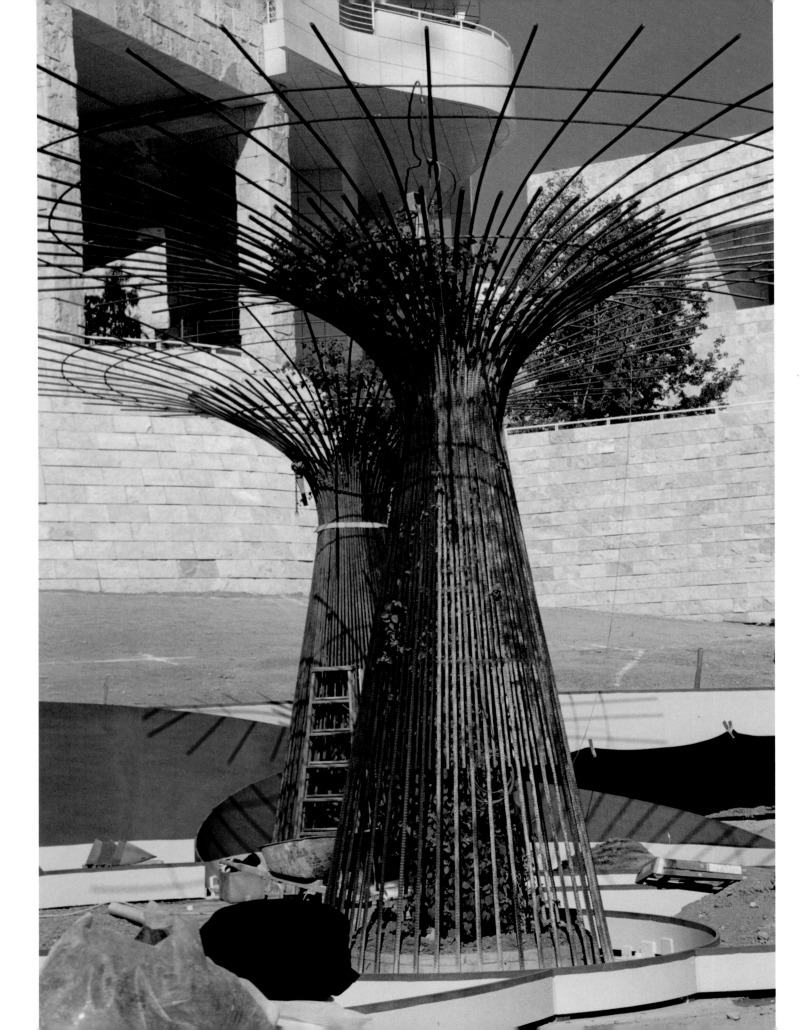

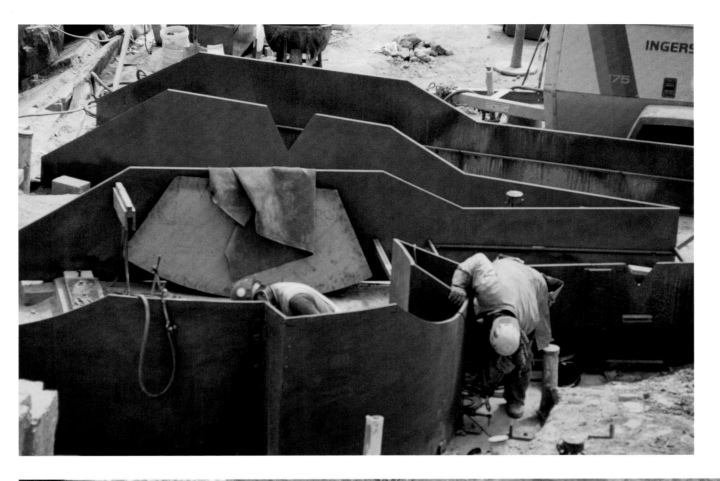

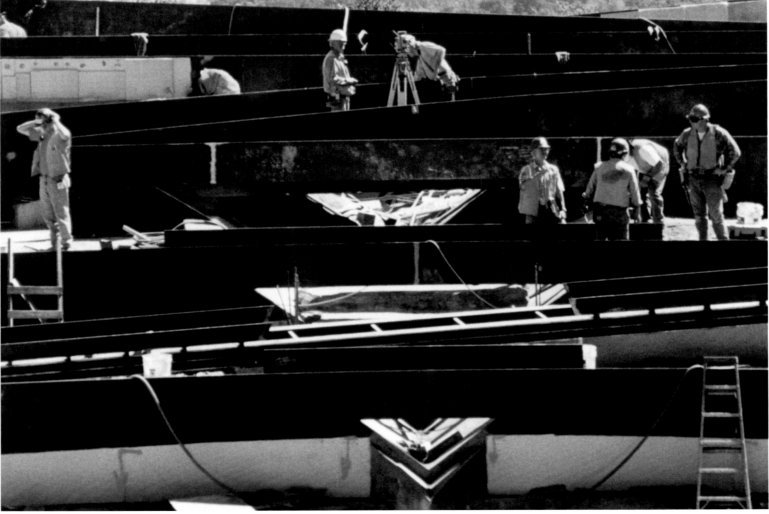

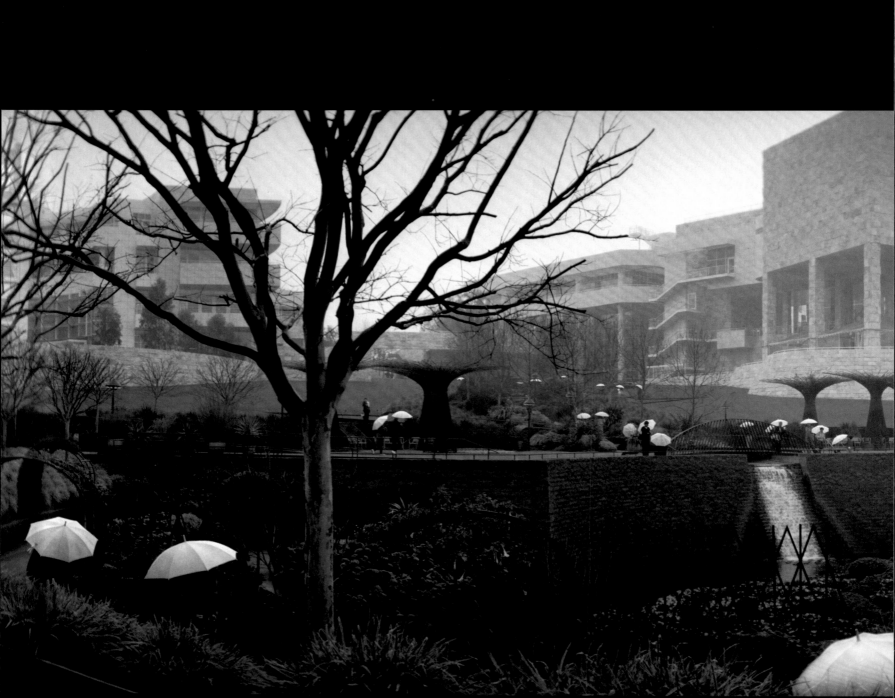

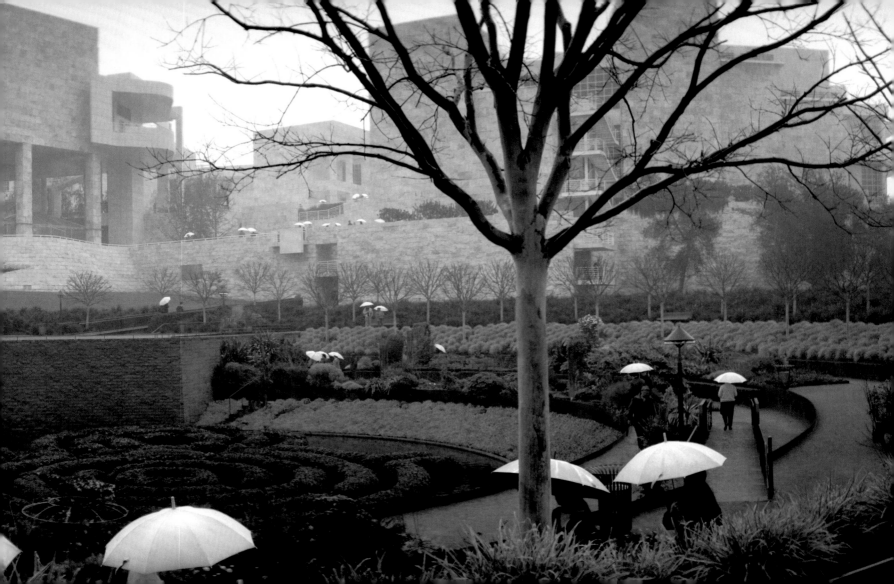

**THIS PETAL, THAT STALK**  A series of garden walks

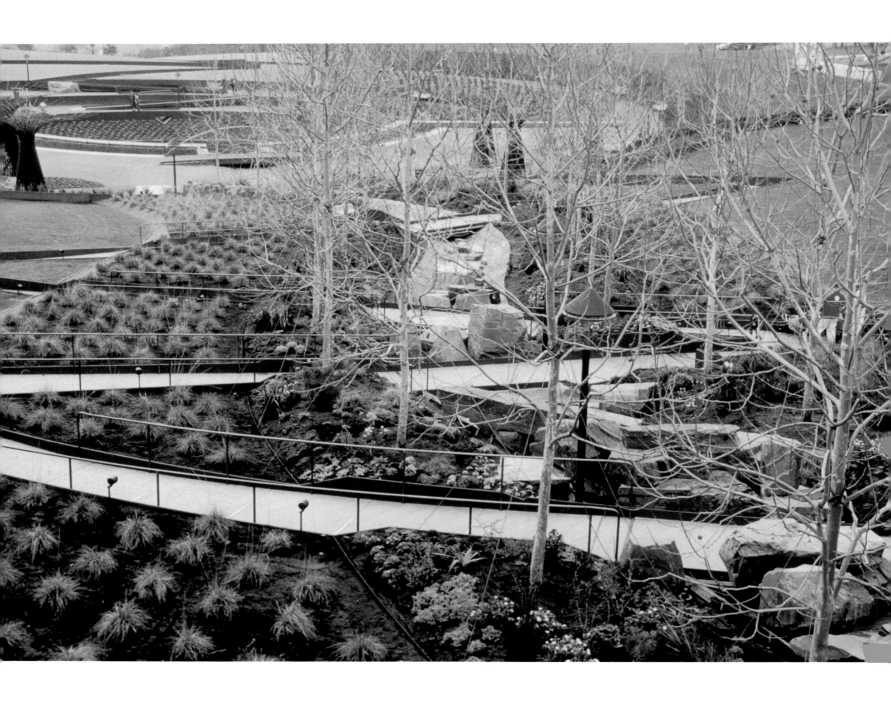

ENTICING YOU DOWN; THE RAKU EXPERIENCE;
A CONDITIONAL ART; CHOOSING THE TREES
AND WHAT THAT CHOICE LED TO; A TRULY
MODERNIST GARDEN.

**LAWRENCE WESCHLER:** *Well, Bob, this might be a good place to begin. It's the start of winter, a bit over a year since the Getty's opening, and the garden is down, as it were; subdued, muted. And here we are looking down on it from the plaza above, and it seems to be beckoning us down.*

**ROBERT IRWIN:** One of the elements of the garden is this process of enticing and pulling you down. Your first view of it, of course, from up here or one of the other vista points, is as this really strong graphic element, which is one of the reasons why I left the green around the side, so that you'd get this really clear configuration in the middle. That's what supplies much of the scale of the garden, as up against the grand scale of the surrounding architecture. But what you see is, hopefully, interesting enough that you are being enticed to come down to the path over there to the side. And then the path itself draws you down to the plaza, and the plaza then lets you look down on the bowl, and then, hopefully, you have the desire to want to descend into the bowl. So the whole thing is a series of descents, becoming, in a sense, more intimate as you go along.

I think intimacy was really one of the key elements that was missing from the whole Getty experience, especially with regard to the architecture. Which was not necessarily the job of the architecture. But it was one of the things the architecture didn't really take into consideration—and that even went for the people who work here: a place where you could go that was essentially quiet and sort of down-in and surrounded and . . .

**WESCHLER:** *Nested.*

**IRWIN:** Yeah, nested. And the garden really does go through a process of nesting itself as it goes down. It starts with the big scale up here, the overall bang, and then hopefully takes you by degrees—in terms of your willingness to participate—down to a more and more intimate level.

It all reminds me of my early days as an Abstract Expressionist, when I was first exposed to Raku ware, which was very interesting for me because Abstract Expressionism, as you know, was so committed to this idea of large scale. And for good reason: when you took the figure out, scale became an element in and of itself, a thing. You know, a real thing. So I was doing huge paintings, but one of my first introductions to Raku was this guy who would—

**WESCHLER:** *What is Raku, by the way?*

**IRWIN:** Raku is a Japanese tea-ceremony bowl that has a kind of almost . . . I mean, it's become a national treasure in Japan. With very much of a kind of a Zen overtone to it. And the thing about it was that this person who had collected these bowls, if your karma was right, he would let you see a tea bowl. And the way he would do it is you would have dinner with him and at the end of the dinner, he would set on the table this box with a beautiful little tie on it—very Japanese—and you untied it, you opened up the box, he let you do that. And then inside of it was a cloth sack. You took the sack out, and it had a drawstring, and you opened up the drawstring and you reached inside and took out the bowl. By that time, the bowl had you at a level where the most incidental detail—maybe even just a thumb mark—registered as a powerful statement.

And this whole idea of how you bring somebody down to a level of awareness where they can deal with intimacy, they can deal with the most subtle kind of nuance—that kind of thing is normally lost in the bigger scale. So the idea here is that even though you start out with this kind of grand scale, hopefully, by the end, you're able to really

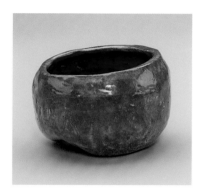

*Raku Ryonyu (Japanese, 1756–1834). Red Raku-ware tea bowl, copy of "Hatsuzakura" by Kakkakusai. Japanese, Edo period, 19th century. Clay, 9.1 x 13.5 cm (3⅝ x 5⅜ in.). Freer Gallery of Art, Smithsonian Institution, Washington, D.C.: Gift of Charles Lang Freer, F1911.388.*

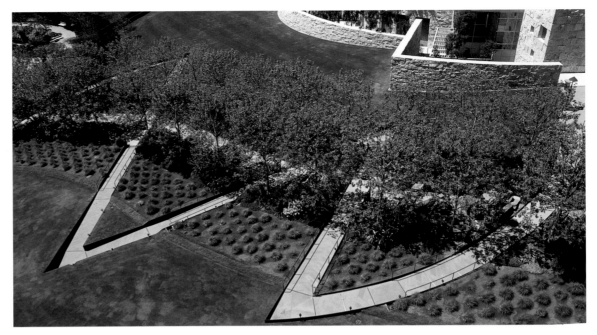

look—and I'll show you when we get down there—to really gaze in wonder upon a single flower: this petal, that stalk. One of the reasons for raising the platforms of the flowers in some areas down there is so that you don't even have to bend down: you can really just look at a flower up close.

**WESCHLER:** *You speak of this project's having been generated in a "conditional," as opposed, say, to a conceptual, manner. Can you talk a little bit about what you mean by that.*

**IRWIN:** Well, the idea of a conditional art—an art, that is, conditioned by the specific phenomenological circumstances of its site and occasion, as opposed to one governed by prior biases and doctrines and conceptual imperatives—is something I've been talking and writing about for some time: in fact, I've been going around declaring the elaboration of such an approach to be the central project of modern art for our time. So the challenge for me with this particular opportunity was going to be to finally put my money where my mouth was, to find out if I could make real-world decisions from the intimacy of a phenomenological conditionality, in real time and at this scale. Oddly enough, working with Richard Meier—or in occasional opposition to him, as the case may be—helped put all of this in sharper focus. Because despite the seemingly modernist look of his work, Richard is in fact strictly a classicist in his approach and thus proved the perfect foil for the kind of exercise I was trying to advance. On top of which, he is really good at what he does.

**WESCHLER:** *Can you give a specific example of this conditional sort of approach?*

**IRWIN:** Well, early on, as I say, I knew that from up here the garden would have to evince a really powerful sense of scale. And of course, one of the key ways that one can

do that is with trees. I mean, a tree is a great way to gain scale—certainly the least expensive way possible. So early on I committed myself to this idea of a curving allée of trees, which would eventually be boxed on the outside, giving the garden an element of geometry to rival the surrounding architecture's.

Now, the trees we chose—and I should say here that in this I was relying on Barry Coate, this great arborist I was able to find; if I hadn't found him I'd have bought all the wrong trees in the first place—anyway, we chose London plane sycamores, a very statuesque kind of tree with a lot of strength to them. I wanted them to be able to grow together in the center. And the center is going to remain just that, very organic. But then they're going to be very carefully clipped so as to be boxlike on the outside. Now, I don't want it to be hedgelike. Hedgelike would be the way you normally see these trees when they're shaped, say, the way you see them along the Champs-Elysées in Paris: they're totally opaque, because they have a large leaf. So we're not only having to continuously shape the trees on the outside, we're also opening them up on the inside so that they're very open and lacelike.

**WESCHLER:** *You're pruning them continuously on the inside?*

**IRWIN:** Exactly.

**WESCHLER:** So that inside, instead of there being fifty branches, there'll be ten branches, or something like that.

**IRWIN:** Right. See the guys down there? That's what they're doing—again, with Coate's expert advice and guidance. Now that the trees have just about lost all their leaves, they're undergoing their winter haircut. We take off all the little extraneous branches inside and open it up and keep it open so that it's a very open and lacy tree. And then—see that one there? See all the branches along the edge? You have to encourage that

everywhere, so that when we start to trim it square, all those little tips come far enough out to that point and there's enough of them so that you see the shape.

**WESCHLER:** *So you want a lot of branches on the top and the sides, but not in the middle.*

**IRWIN:** Right. So they're doing what they call budding them. Look at that tree, right in there where that one little leaf is. It's a weak spot. So you'll snip that one. Next spring there'll be two branches there. And then you come back later and you snip it again and there'll be four branches there. So you multiply it at the edges, so at the end we have the ability to have a subtle tracing of a square on the outside edge rather than its being like a solid hedge.

The point about all this in terms of conditionality is that the ability to be able to do all that became key for choosing this particular tree. It was the only tree which really had that potential to it, that stature, that would take that kind of pruning and clipping. But once you had the tree, very quickly other decisions followed in a conditional manner: To get them to grow together, they couldn't be planted any farther apart than about twenty-three feet, which in turn established restrictions: suddenly a stream flowing down the center of the allée, because of that strict twenty-three-foot limit, could no longer be a meandering natural stream, which is sort of what I thought of at the beginning—that was no longer practical. So then I looked at the idea of its being possibly very formal, but that was completely out of character for this garden in terms of what I was trying to accomplish, and so the idea finally became to approach it as a sculpture and not as a stream. It has natural aspects to it, but if you look at it, the whole thing is really put together as a single piece of visual and auditory sculpture.

The point is, once you'd decided on the character of the tree, which is really a main element in this thing, that defined the character of the stream, which had to respond to that initial decision and which in turn, interestingly enough, was better than the first two thoughts I had had about it. Much better than its being a natural stream for this situation. Much better than being very overtly formal. Finally, it essentially evolved into what it is.

**WESCHLER:** *The sculptural quality of the garden seems to me especially evident seasonally, which is to say, as now, in winter.*

**IRWIN:** Well, to me, the winter begins with a tree that is particularly nice when it's bare. I mean, these are just small trees now, so they haven't taken on the real statuesque quality they will have: eventually they'll be forty-five feet tall. Also, they have a very beautiful trunk, a very beautiful exfoliating trunk. But it's a tree that I really liked bare.

And everything goes backwards. In other words, I found a tree that has the right characteristic which can live in this climate and which I can do what I want with it. Along with that comes the fact that it turns out to be deciduous. Suddenly I realized I had a tree which has a winter condition. Even though it's in California, it has a winter condition. And the same is true with the other main stand of trees, the crape myrtles down below in the bowl, which also turned out to be deciduous. Which then in a sense spoke to me about the possibility of doing a garden that had a winter character to it.

**WESCHLER:** *Which is unusual. One of the things, standing here, and looking out over the neighboring vista—Bel Air, Beverly Hills, Brentwood, Santa Monica—is that I'm seeing thousands of trees in the distance, and they're all—*

**IRWIN:** And they're pretty much all evergreen. Right.

**WESCHLER:** *So that this up here is very unusual.*

**IRWIN:** Very unusual. Essentially, we are working on this garden with the idea that it will have four distinct seasons, one of which will be a winter season, which requires a lot of rather unusual ways of approaching a garden, because in California no one even thinks in those terms. In fact, most people around here are conditioned to actually think that if it isn't green, it's dead, and that at the very least this is a bad time for gardening, when of course just the reverse is true. People in the east know that when you see a garden bare or with snow on it, that it has a wonderful melancholy aspect, but with a rich filigreed character to it. But to get that to take place here, we're having to go to some lengths to find plants that will reinforce that.

**WESCHLER:** *The skeletal undergirding of the garden in particular gets reinforced now.*

**IRWIN:** Well, in the simplest sense, my feeling was that these deciduous trees gave me a chance to let two things happen. One is that in the winter, you get this— well, you say "skeletal" quality, but it's also that the sculptural quality of the garden really reads through. This is when you see all the stuff, not just the trees, that I did to establish the so-called bones of the place. But all of that in turn allows me to do the opposite in summer, which is what I really wanted to do, to let the garden be completely taken over by its plant material. At that point I will allow the garden to obliterate the boundaries, to ignore all the geometry and go for complete exuberance, which may be the one critical difference between this and other ideas about gardening, say, a French garden, where the boundaries are held at all times, or a Zen garden, which is just in a sense a series of staging events. So it's none of those, though it partakes of all of them.

Maybe, in a sense—and this is just between you and me—but I think no one's really attempted a truly modern garden in this sense before. You see either a more contemporary version of one of the traditional garden approaches or else someone makes a garden which looks like a modern painting, you know, having the geometry of a Cubist painting in a way.

**WESCHLER:** *Say, a Cubist herb garden.*

**IRWIN:** Right. But without any of the underlying rationale; how one looks at things, how one participates in things from a phenomenological point of view. Which is strange, because there's nothing more phenomenological than a garden.

**WESCHLER:** *What do you mean by "phenomenological"?*

**IRWIN:** Well, in the simplest sense, it has to do with seeing, seeing from a kind of a tactile, purely perceptual point of view, rather than seeing as passed through an intellectual, conceptual, literal-minded filter. It's seeing that requires an individual to weigh the unique qualities of things, a realm where feelings are the equal of intellect, and beauty the equal of truth. Everything is phenomenological to begin with, while at the same time having the potential to be seen as a sign or a symbol and understood in that other sense, so that they're both true. The emphasis in this case, however, is on the phenomenological qualities of things intersecting over time.

**WESCHLER:** *And what Cubism was about, for example, is getting us closer and closer to a—*

**IRWIN:** Well, Cubism was a step along the way, though not the final step. What Cubism did was move you from understanding the painting purely from a pictorial point of view—i.e., a reading of the painting with its separation of figure and ground—to that very critical idea of marrying the figure and ground, with its inevitable consequence of a reality made up of conditioned relations. That is, you're suddenly looking not at a picture of something, but at a picture. Okay? And the humanistic core of the experience comes not through the sign of the human being in the painting, but rather through you, as a human being, participating in the process of the painting.

**WESCHLER:** *So a Cubist garden that simply did a replication of Cubist shapes in vegetable would—*

**IRWIN:** Miss the point, I'm afraid. In other words, it would take on the style of Cubism without necessarily taking on the reasoning of it.

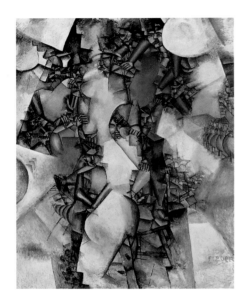

*Fernand Léger (French, 1881–1955). La noce (The Wedding), 1911. Oil on canvas, 257 x 206 cm (101¹⁄₁₆ x 81½ in.). Paris, Musée national d'art moderne—Centre de Création industrielle, Centre national d'art et de culture Georges Pompidou. Bequest of Alfred Flechtheim, 1937. © CNAC/MNAM/Dist RMN. Photo: Philippe Migeat.*

I mean, once you seriously buy into Cubism's marriage of figure and ground, you're not just honoring a style—you're honoring a whole change in how you think about things. A whole new set of values. A whole new way of going in the world. And I find it very peculiar, how many people honor those paintings without somehow being affected by them. People have just accepted those paintings without consciously accepting their implications.

**WESCHLER:** *Well, having said that, however—you're saying you don't want to have a frame anymore, but this garden, if anything, seems to have an exaggerated sense of frame, established by the perimeter of the surrounding buildings.*

**IRWIN:** But that was the best part of the whole garden project in a way: it was about things already existing in sets of conditioned relations and not in some sort of vacuum. That was my first dilemma from the beginning, because if you looked at the edge of the garden, you'd say to yourself, "Who in their right mind would've designed that?"

**WESCHLER:** *You're talking about the contour of the surrounding walls and the resultant shape of the—*

**IRWIN:** In the simple sense, the space of the garden was not planned. The architecture was planned, all very carefully articulated: how the buildings ended and the edges on them and everything. But there was no consideration of the space that was left in the middle. When I got the space, what was left over is essentially what I got. So in a funny way, the beauty of that situation was, if you could somehow capture that space and make its eccentricities work for you, you would have something which is a total surprise. I mean, it's wondrous in a way, because who would have thought to do that? No one would think to do it. It goes beyond anybody's ability to conceive it. But if you can take it and, as it were, caress it into being a piece and a part of this whole thing, then suddenly you have this great element of surprise.

At first, it wasn't so clear how I was going to be able to do that. At first, I was just going to have the path going down beside the stream. But once I got the requirement of the zigzag foisted upon me, for reasons of handicap access, I suddenly realized that that was how I was going to be able to engage the whole space, weaving in and out, and developing the interplay between the curved and the straight, and more to the point, occasioning an active interplay between the descending viewer and the curved and the straight of the architectural surround. So in a way, I'm in harmony with the place all around, and more so than if I had just aped and repeated the contours, which would've been really uninteresting. In other words, the solution did not ignore the architecture at all. In fact, it totally took it into account.

First section of the path curves. Straight. Straight. Straight. Curve. Down to there. Curve. Straight. Straight. Straight. Curve. Continuous interaction between curves and straights, which is exactly what the architecture is like.

**WESCHLER:** *One other thought before we start moving down, and this goes back to your Raku point. From here, from above, you don't have any sense that there's going to be that azalea maze at the bottom.*

**IRWIN:** No.

**WESCHLER:** *That's all withheld.*

**IRWIN:** That's a surprise and a reward for making the trip.

**WESCHLER:** *In Raku terms, that is the cup in the path.*

**IRWIN:** In a sense, yes, it is.

**WESCHLER:** *That's one of them. Another one being the individual flower later on.*

**IRWIN:** Right. Exactly.

**WESCHLER:** *So at some level, this whole garden is a machine for preparing you to be able to receive things in some sense.*

**IRWIN:** In a sense. Now, a Japanese garden would, for example—and they do it very beautifully, and this is not an either/or—but they would bring you all the way down and then at the bottom there would be, precisely, maybe a small pot.

**WESCHLER:** *Right.*

**IRWIN:** A thing, you know, there. Whereas I bring you down, by a series of stages, to where you can appreciate a single flower. It's the plant material. In other words, it's not the overlay of that kind of man-made design element. I'd rather, in a sense, you ended up with a flower garden. And finally the pièce de résistance of this garden, especially in the summertime, is just its dazzling display of plant material, rich in color and texture and sounds and smells and feelings.

**WESCHLER:** *Okay, let's start going down.*

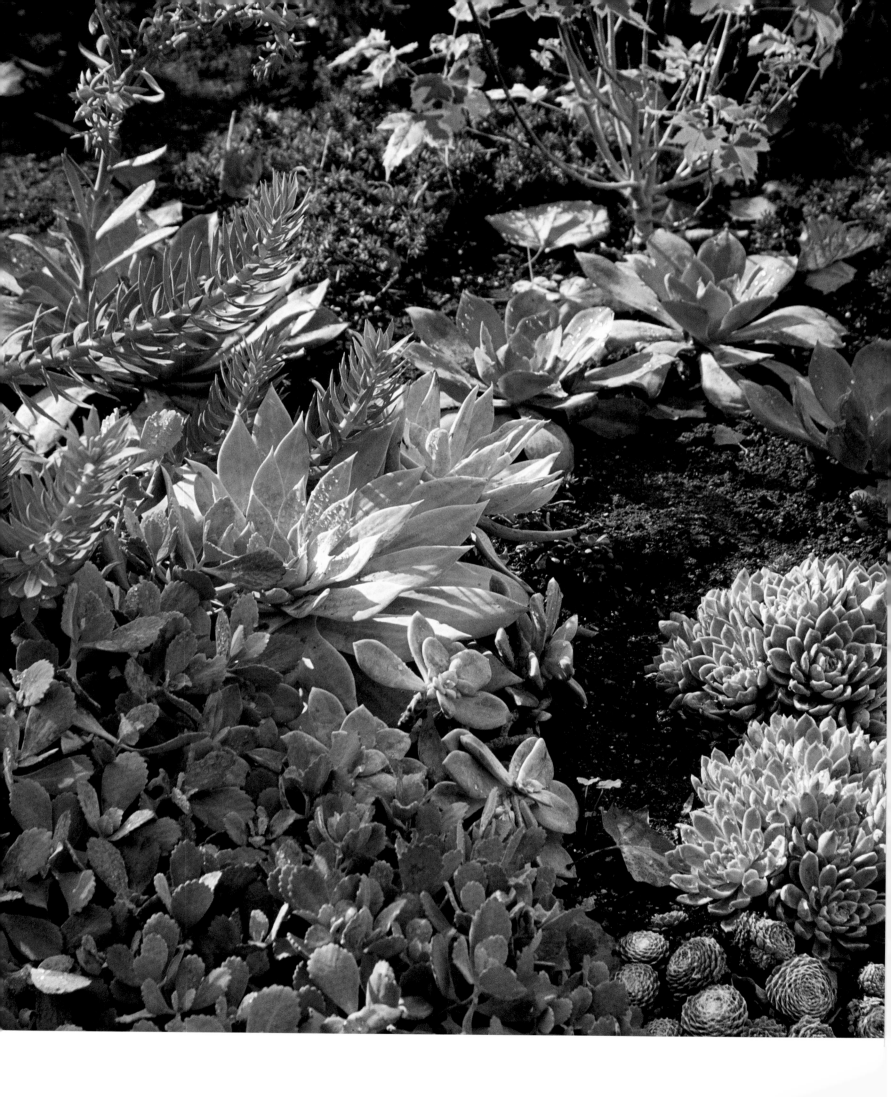

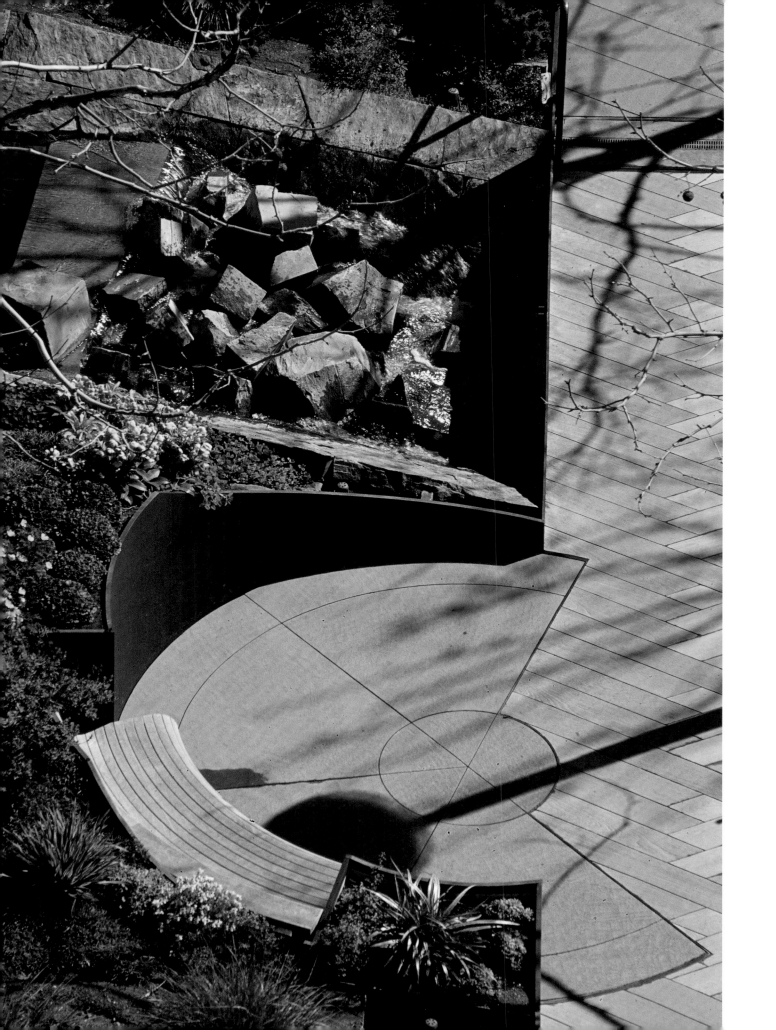

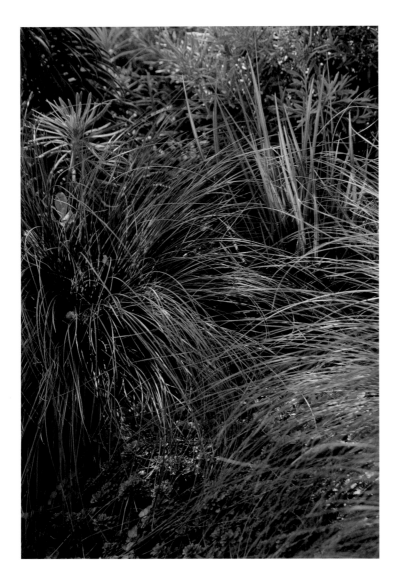

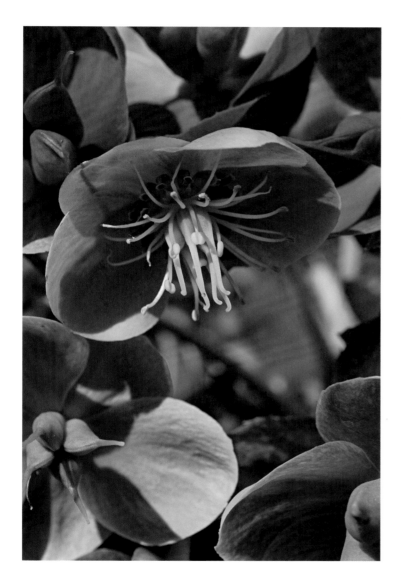

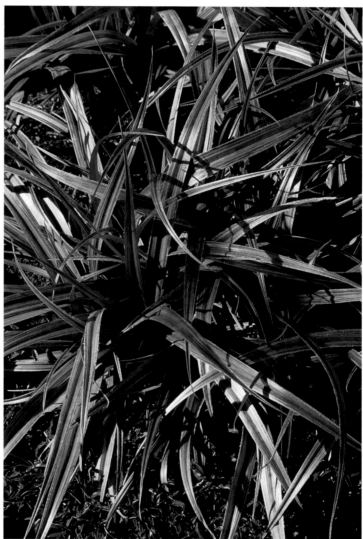

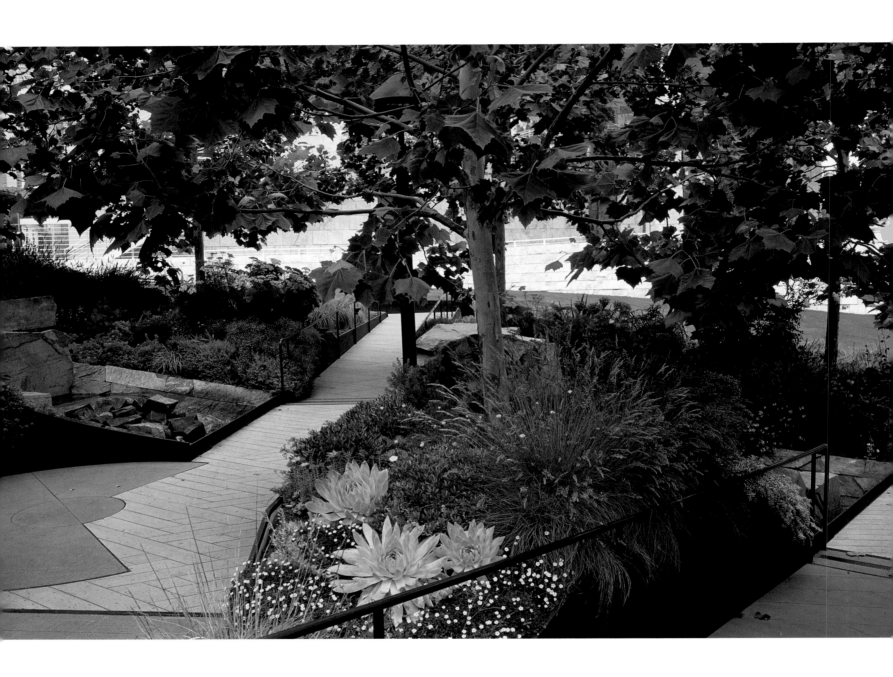

WESCHLER: *It's going to be six feet tall actually?*

IRWIN: Oh, yeah. They're going to get quite a bit bigger. But not dense. I mean what's high will be—

WESCHLER: *Oh, the stalks.*

IRWIN: Yeah, the flower, what they call the flower, which is the stalk. And the idea was to plant them in a geometric pattern and cut them back in the winter, like now, so that the geometry would show through, but then to let it grow out into a field of grass in the summer.

Now, I'd been looking at grasses for a long time. I'd even wanted to use them for an earlier project in Miami, where I had a whole different thing in mind. I'd become very fascinated with them there and even researched them with the so-called dean of grasses, Kurt Bluemel, up in Maryland. I just like them. I also liked them because basically, though they've become more prevalent now, people still don't really plant with grasses, it's not a thing that they think of. But I think they're amazing.

WESCHLER: *What's amazing about them?*

IRWIN: Well, I love both their structure and their infinite textures: they're a real artist's plant. They've got this incredible structure to them, though they're all quite different. Some of them go up in spirals, some of them are featherlike, and others have this bent character, like a bent grass. Some of them get very, very fine in texture, and some of their flowers almost look like a mist in the air. We've got some in pots down there like that. They're really ephemeral—almost like smoke in the air, you know? It's like looking at the world of rocks, if you go through the world of grasses. There are hundreds of grasses and they're all totally different, and each one fascinating in its own way. They're like an artist's rose garden: really spectacular.

WESCHLER: *Talk about this specific grass here.*

IRWIN: Well, I looked at a lot of grasses, and I found about a dozen that I really liked and thought might work for one reason or another. And I started watching this dozen. I had found places where I could see them, either in these nurseries that I was talking about or, in a few cases, actually out in the field.

WESCHLER: *I remember you picked me up one day and we drove out past Malibu to look at this one little tuft of grass.*

IRWIN: Right. A little tuft of grass. And what I was doing was watching to see how they performed. One grass will be really terrific all through June, July, August, September, then all of a sudden it will just fall apart. I mean, just totally fall apart: be gone. Deciduous to the point where it would be just totally gone. Or become so messy and ugly that . . . And in this situation here, the outlying grass

needs to be there all year long. This isn't a garden that you can just shut down for a while, or where it could look not so hot for a while. People come from all over the world to be here for a single day. So, in a way, you're dealing with something that to the best of your ability has to be up all the time—and that's really hard to do.

But I looked at all these different grasses, and I really zeroed in on a couple of them. That one that we went up to see in Malibu performed extremely well—*Pennisetum setaceum,* otherwise known as fountain grass. It just was there all year round, a very successful grass. But in the ecology of the plant world, which has become like a religion, it has become a no-no plant. It's too invasive, it grows everywhere. Which is part of why it's a good grass. I mean, it's deeply successful: you can hardly kill it. So everybody hates it, and you're a bad guy if you plant it or if you use it. So in this particular situation, I would've caught way too much heat for it. Which didn't necessarily eliminate it, because at the time I hadn't yet found a replacement for it, until I finally found the *Muhlenbergia rigens.*

WESCHLER: *Where was this? Where did you find it?*

IRWIN: Down in Chula Vista. There was a planting of it outside of a nice library building that the Mexican architect Ricardo Legorreta did. And so I started watching it and watching it, and it was just good all year. Better, or worse, but never bad, never really fell apart, never got really ratty, you know, as grasses can. And it turns out that it's very available and it was an easy grass to get and to grow. And it's worked well.

THE OVERALL STREAM-GARDEN PLANTING SCHEME (FOUR AREAS); GARDENING AND PAINTING; FOUR ELEMENTS OF COLOR; MONDRIAN AND MORANDI.

WESCHLER: *Let's head back up to the top of the path and walk back again, this time focusing on the rest of the plant material.*

IRWIN: Okay. The plant material on the first level was to be very low and close to the ground, so I allowed myself to use these kinds of echeverias and succulents [p. 52], because up here in the plaza area, all this DG has a kind of slightly—

WESCHLER: *DG is?*

IRWIN: Decomposed granite, which is the only thing you can use on a garden path and still get handicapped through it, because it's firm enough that you can run a wheelchair over it. Some people even argued that it was

*Robert Irwin's plant collage used in designing Area One of the stream garden.*

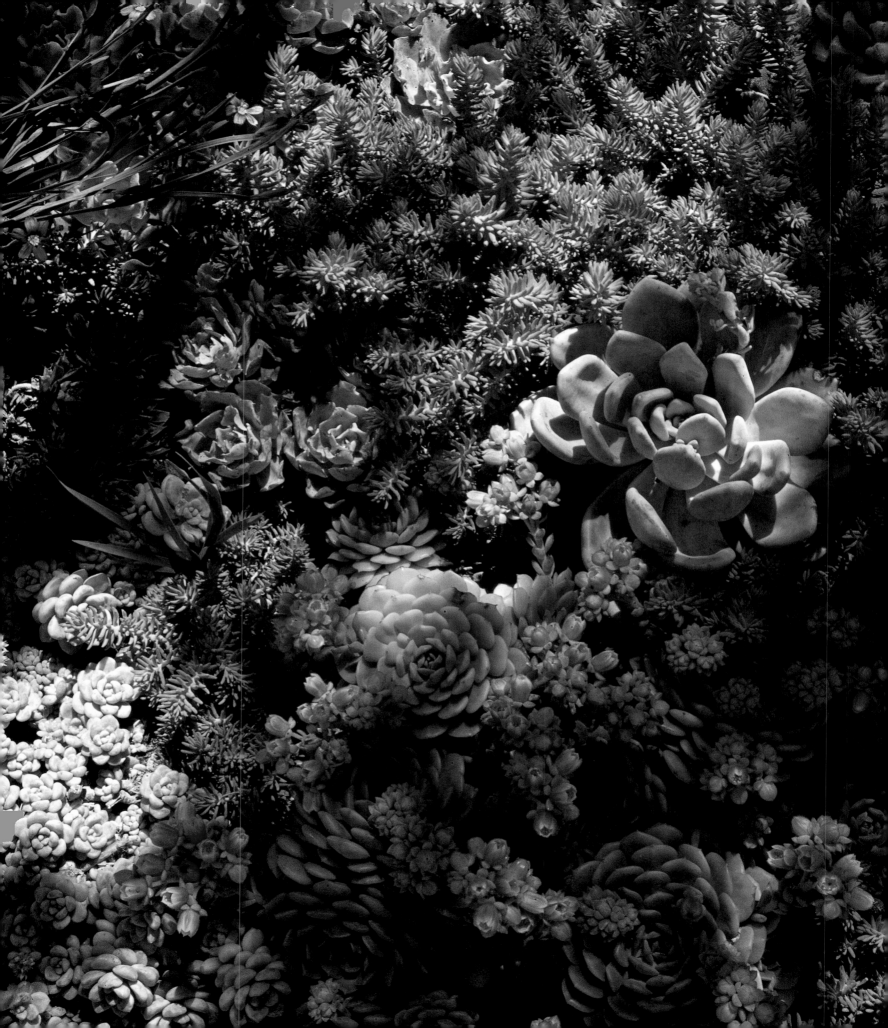

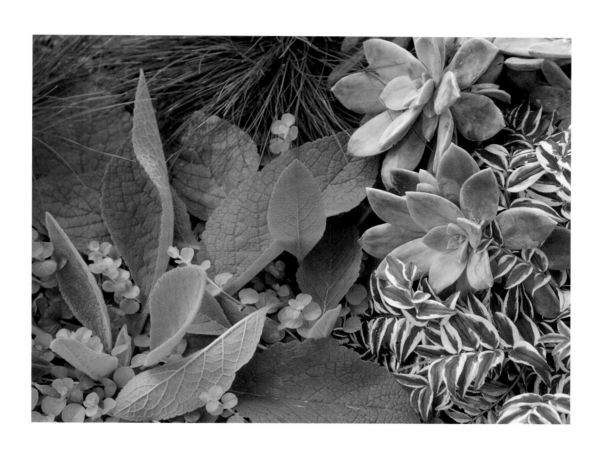

going to have to be concrete, but how the hell can you have a garden if everything is concrete, you know? It was a real problem. So I've used these kinds of plants, which look good against that kind of material up here, and also they have the other properties I wanted, being low and quite colorful in a muted way. They're really quite interesting in themselves. Good color, and color all the time. So they're a very successful plant. Some people like them, some people don't. Some people think you can't mix things. If you're going to have this kind of a garden, you have to have only certain plants and you can't suddenly bring in, say, heather, which I have: you can see it sitting right in there behind. Or some of the other kind of things that are over in there. But I don't agree with that. I think it has to do with what looks good with each other. So I just strictly use my eye for all that stuff.

I should say that in the beginning, once we came up with this idea of a zigzag path—again, initially on account of the handicapped-access issue—but I saw it as an opportunity to layer the experience by making each resultant crossing feature a different combination of plant materials, with different heights, colors, textures, complexities. So I laid out a plan for four different areas or zones as one went down the stream.

**WESCHLER:** *When you say "area," for example, you mean on both sides of the path?*

**IRWIN:** Yes. Area One, for instance, goes up to about the middle of that next crossing, where you see that dark brownish plant there. From there to maybe three trees down, I can point it out when we get there, is Area Two. And then there's Area Three. And then there's Area Four. And in the overall scheme, they each have different characteristics.

In terms of height, the first one is low. The second one is medium. Third one is high. The fourth one is medium again. Part of the effect of that is that the first time you walk in, in terms of how the trees will end up being clipped, you'll be able to see out, see all around, underneath and on out. The second one, where it's medium, you're going to have almost like a window. I mean, the plant material will come up so high and the tree will be down so low that you'll actually see out through it, but it will be like a framed view. The third area, which is the largest one, you actually won't be able to see out at all. It will eventually almost grow all the way up, so that you're totally enclosed. And then the fourth one, you'll start to see out again and you look out onto the plaza and the arrival area. So that's the first thing: height.

The first area is essentially fairly rich in textures, in terms of complexity of leaves and all that. The second one is less textured and the third one is even less

*Robert Irwin's plant collage used in designing Area Two of the stream garden.*

textured: I mean, bigger-leafed sorts of plants. And the fourth one is going back to being very textured again, okay? So there's a change in the amount of texture in each area.

**WESCHLER:** *The fourth one is as textured as the first?*

**IRWIN:** Even more so. The fourth one is the most textured.

Now the first one, in terms of color . . . Color is all thought of primarily in terms of leaves, since that is what will be there all year long. By the way, one of my key things about plants is . . . I look at every plant, but I'm most interested in those plants in which the overall structure and the leaf are great; the flower is, you know, a surprise and a reward, but the plant has to be able to succeed without its flower. A lot of plants are not much without their flower. Or not as much, let's say. There's a time and a place and an argument that can be made for every single flower and plant. But, anyway, that's one of the things I look for. And the whole coloration in this first area is a kind of a pale gray-green, with a kind of chartreuse as the kicker.

**WESCHLER:** *That's Area One.*

**IRWIN:** Area One. Area Two is a gray with a pale bluish, sort of a blue-gray, blue-and-violet kicker, okay? Area Three is a very dark verdant green, a real rich green with like a kelly green as the kicker. Again, these are all things that you can find in leaf colors. And then Area Four is the brightest and has the most liveliness to it, okay? By the way, that's another thing: the garden gets brighter and stronger as it goes down.

**WESCHLER:** Now, you've so far talked about height, texture, color.

**IRWIN:** Right. With color being the pièce de résistance for me since there is no color in the rest of the project. It was the one thing that had not been used up, developed, and exploited in the rest of the Getty as a whole. Other than walking in and looking at the paintings—there may be some color in the paintings. So the color is the most important sort of element here, and now we've got that. And the flowers are all thought of as bonuses, okay? Terrific.

Now, with most plants, their flowers are really compatible with their leaves. It's a rare occasion, almost impossible, when that's not the case: Nature really has that worked out very beautifully. It's like in the genes of the thing. I figured the flowers are going to work if I can get all the leaves to operate in concert. So they're thought of in terms of leaf. Which I don't think most people do.

And also, it's a way of getting an area to be homogeneous, and that's one of the things I've done in terms of structuring the entire garden—the geometry. There's a lot of structure in here, which I think gives me the license in the end to allow the thing to be completely exuberant

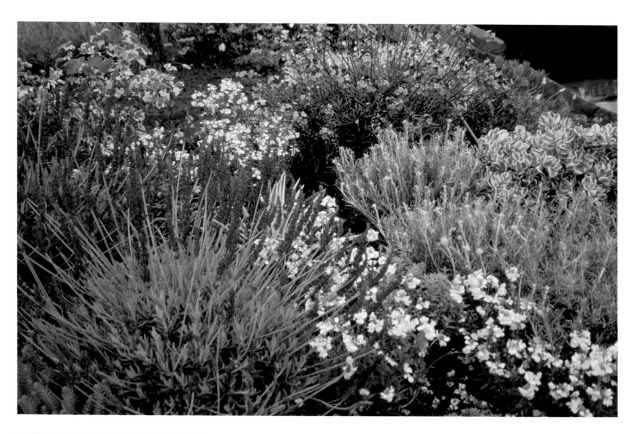

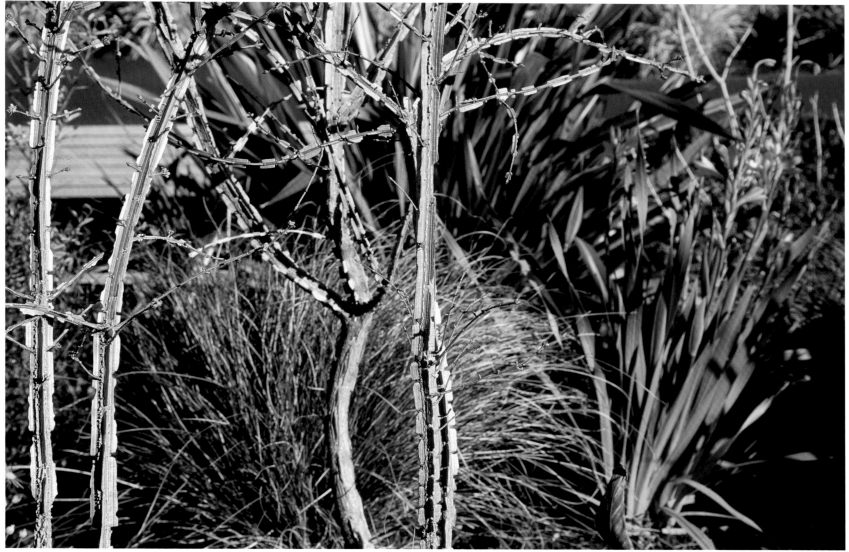

and go crazy, and yet avoid becoming chaos. There's that final balance there. I want to get the thing as exuberant, as wild, and as absolutely spectacular, color-wise, as I can—and what keeps it from just being total chaos? The key is that there are all these built-in structures behind it.

WESCHLER: *Form, texture…*

IRWIN: All the hidden geometry in form, textures, and degrees and amounts and relationships of one to another. All that's built in there. But it's hidden in a way, so that you're not looking at a garden laid out to look like a Cubist painting. As I say, I'm not interested in style. I'm interested in using each element in concert, as a tactile tool woven into a layered overall experience, but with no single element standing out, such that it's like 10 percent, 10 percent, 10 percent—and then one element, say, Element X, gets 70 percent: and people say, "Ah, 70. This area is different because of X." That becomes like seeing the magician's hands revealed.

Whereas, on the contrary, one of the really nice things to do is to layer the thing in such a way that each one of six or seven parts does an equal amount of the lifting, so that you're never conscious of why it is, but only that it is. Okay? I learned that as a painter. It's really nice when there's a kind of magic about the painting, when the painting becomes more than just the sum of its parts and you're conscious only of the power of its being.

WESCHLER: *In painting, the parts would be—what?—the color, the form, the gesture, the—?*

IRWIN: The surface. The edge. These are all pieces and parts of a painting. Which is hard to teach young artists about because all they're thinking about is subject. "This is a so-and-so." "That's a meaningful this-or-that." But whether it has a subject or not, the painting has to have a coherence to it as a painting in which all the pieces and parts are all in harmony, they're all aimed at the same end. Even if there's a figure doing something important, how the edges touch can defeat the whole, or the surface can defeat it, or the color or the shapes can defeat it. They need to be of the same purpose and weight. But people are normally so preoccupied with the subject that they don't know much about painting at all.

If you go to a museum…I used to send students to a museum, and I'd say, "I want you to look at nothing but the color. But I want you to look at it specifically, I want you to look at the painting and try and get a sense of the color strategy, what's going on in the thing." And you find out that even in many of the best paintings at some of the best museums, that everybody avoided color like the plague. For example, if on a palette you mix red and green together, you'll get mud, okay? And what they do is, they'll put red in the painting, and they're so afraid of it that they'll put in the equal amount of green, and they'll balance them in such a way that finally the painting is mud

or gray or brown. Ninety percent of paintings end up brown to gray. Even though they may have a lot of color in them, colors you can isolate individually, when you look at the painting in sum total, it's mud. The colors just cancel each other out. People have very little understanding of color and how to employ it. Because it is so complex and so emotionally demanding, they're afraid of it, they stay away from it.

And I'm finding the same thing is true in the garden. "Oh, you can't put that color with that." "Oh, you can't…" But there are no rules like that; there are no Oh-you-can'ts. You can do anything, if you do it right. If you figure out how and what goes with what. And the amounts.

It's been the hardest thing to try and explain to the garden people, and to Jim Duggan, even. I've explained to him a dozen times that you have these four different elements working for you, but infinite complexity in terms of the numbers of exchanges. I mean, just in color itself, not even getting into how the color is made with regard to texture, with regard to whether it's made with a large leaf so that it has a kind of single character or it's made up of five leaves or it's made up of five thousand little teeny, feathery things. All three may be green, but they are not green in the same sense of green, okay? So you have all of that, but even within color, you have these four elements, you have hue, and you have intensity, you have value. And then you have amount, which is to say proportion and juxtaposition.

WESCHLER: *How are those different? What is hue? What is value?*

IRWIN: Hue is essentially red, green, yellow, blue. Intensity is bright and dull. Value is dark and light. Okay? And then there's amount—you put amounts together. And there are so many possibilities that there is almost nothing you can't do if you know how to do it. For instance, you can have a range of color-hues and hold them all together or not by keeping them near the same in intensity-brightness and near the same value, dark or light, and near the same amount or not in terms of juxtaposition, near or far—by degrees thereby creating more or less intense relationships. It's an incredible tool.

But I would say that to 99.9 percent of all people, color is more associative or sentimental. That's the first vulnerability of people's criticism: they have no idea what they're talking about. When they start talking about color, generally it becomes Amateur Night in Dixie. I mean, on the level of "I like this" or "This reminds me of that" or "I think these are nice." "These go together, they match my dress." That sort of thing. But no idea about what makes things happen and how you can break the rules, and make the rules in a way which is not only fascinating and surprising but one that totally resonates and generates real-time feelings and emotions.

**WESCHLER:** *And this goes back, in a way, to your days of spending hours and hours in front of a canvas?*

**IRWIN:** Absolutely.

**WESCHLER:** *The yellow canvas and the single lines—*

**IRWIN:** Absolutely. It all goes back to that. Being a painter, when you start getting things down to like a half-a-dozen elements, you find out suddenly what those things really do. Say, like, when you're looking at a Mondrian, suddenly you realize that the edge is incredibly important, that the real ones don't look like they do in a book. In a pictorial painting, edge is essentially neutralized; the subject was just whatever it was and all the edges were neutralized. But in the modern era, since painting became painting—take a van Gogh, for a simple example—surface, edge, and color have all become real-time players, a fact that still tends to get masked or glossed over by simplistic, naive, or Rorschach-type readings of a painting. In the real world, for example, when I look at people and stuff—that lady over there— they're not touching, she's not touching the grass, even though it's behind her. There's space and distances and what have you, and things touch or don't touch, which is to say these are all active parts affecting the makeup of the whole. Whereas in a painting, everything touches everything else, okay? And whether it touches by slamming up against something like this, or whether it touches it like this . . .

**WESCHLER:** *Whether it's soft brush, whether it's a hard push . . .*

**IRWIN:** Right. Exactly. Right. I mean, what happens when two things come together in a Mondrian is really critical. And it is phenomenological.

**WESCHLER:** *Or a Morandi.*

**IRWIN:** Oh, absolutely. Or a Morandi. This is exactly why Morandi was such a great painter. There isn't a single wasted motion, every brushstroke counted for something. Man, what he did with edges is a lesson. He neutralized subject by using the same mundane still life over and over—that array of jars and bottles and vases—but while the subject didn't change, each painting was a whole new adventure in seeing. Everything's brought out, everything understood.

And the point is that that's finally what a painting is. I mean, the subjects and all that are fine, but, finally, a painting is a painting. And if you don't know something about painting, if you don't understand something about

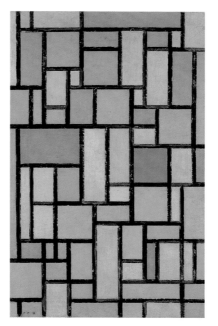

**Top** *Piet Mondrian (Dutch, 1872–1944). Composition with Grid #1, 1918. Oil on canvas, 80.2 x 49.8 cm (31⁹/₁₆ x 19⅝ in.). The Museum of Fine Arts, Houston; Gift of Mr. and Mrs. Pierre Schlumberger.*
**Bottom** *Giorgio Morandi (Italian, 1890–1964). Still Life, 1955. Oil on canvas, 27.5 x 40.8 cm (10⅞ x 16 in.). Freiburg im Breisgau, Morat-Institut für Kunst und Kunstwissenschaft. Photo: Bernhard Strauss.*

the tools you're using and know how to make them work for you, and I mean really work for you, well then, they'll all work against you.

WESCHLER: *And how does all that relate to the garden, for example?*

IRWIN: Well, the garden is the greatest, most complex, and most challenging palette of all, add to which it's truly phenomenological and ever-changing.

WESCHLER: *You just described these issues very nicely in terms of a Morandi. Try to describe them in terms of two pieces of vegetable matter.*

IRWIN: You've got one grass, the lawn over there: low, tight, green. And then you've got a second grass made up of large, individual-feathering, gray-green plants acting together to knit the surrounding architectural edge with the plantings along the stream. Then you have this third ground cover—*Dymondia margaretae*—small, tight-knit, green-to-gray plants with a delicate white edging acting to knit the two grasses together. Three kinds of fine texturing—green, gray-green, and gray—all working together to occasion this design idea of entering and exiting from the architectural to the organic realm.

Or, for example, look up here at the very top of the garden, before you even start down the path: the echeverias we were looking at before. Now, as a single plant at this scale, they tend to get lost. But when you plant them in groups like this, they work really well [p. 52]. And they lend themselves to a certain regimentation like this, which I wanted to have at the beginning.

WESCHLER: *Seemingly, a little more order at the beginning.*

IRWIN: A little more order. You start out with all these elements of order, and then you're led to chaos in a way. Except not chaos: structured chaos. But in the beginning, I'm meeting certain expectations. You've just come from all of this—

WESCHLER: *From all this order of Meier's campus.*

IRWIN: Right. And so you can't just suddenly—it would be too big a jump.

WESCHLER: *So that that in itself is an example of the way that the edges abut one another.*

IRWIN: Absolutely.

WESCHLER: *So you have the edge of the Meier travertine world . . .*

IRWIN: Yes. Right.

WESCHLER: *And then you begin your garden with a kind of order.*

*Robert Irwin's plant collage used in designing Area Three of the stream garden.*

IRWIN: Yes. Exactly. Regimented echeverias. And they're a plant, like I say, with a number of properties. Forgetting about whether you like echeverias: that's not an issue. Everybody's "Oh, I don't like those plants." It's not an issue. For all these other reasons. You put all those reasons driving the process together and maybe come down with the three or four plants that would work, and you play around with those plants until finally you decide on one. But the selection is made on the basis of all these qualities that it has in terms of all the different relationships and associations and roles it has to play. You try and take all of that into account. And that finally tells you which plant makes the most sense.

But then add on top of that just one last caveat: I will entertain anything that I like. Same as with the rocks.

And all that bothers Jim a little bit, you know, because he kind of gets the four-level schematic plan figured out and then I'll say, "I really like this plant in here, you know? Let's just leave it there." And he'll say, "Well, but that's not the color of the . . ." "I know it's not." I mean, the schema was just a place to begin. This area, for example, only has to have the feel of being gray, it doesn't have to be all gray. Sometimes Jim gets a little bit too—

WESCHLER: *—literal minded?*

IRWIN: Yeah, literal minded, you know. "But this isn't gray. You can't have that plant in there." Not true. In fact you might want that plant in there, precisely because you don't want people to become too aware that this is an all-gray area. And anyway the garden as a whole is strong enough to take those variations or exceptions.

WESCHLER: *This being another one of those awarenesses that comes out of your earlier painting practice?*

IRWIN: Well, one of the things you learn—and in the beginning it's like a shock—is that when you've got something in the studio, you can totally condition how people come upon them. And I did that with the discs. In the beginning I fussed over every little detail.

WESCHLER: *How the shadows fell. Where the lights were.*

IRWIN: Right, and the color of the baseboard, whether or not to patch up a crack in the wall. I really agonized over such questions. Well, turned out the pieces were strong enough to overcome a lot of that, and now I don't worry so much about how they get displayed. But in the beginning, I was going through the transition myself, teaching myself to see anew, so all that stuff became really a critical issue.

When you go outdoors and you build a project like this that has to live in the everyday world where nothing stands still, things change, they're moving all the time—the key to it is the project has to have enough integral integrity, it has to have enough power as whole, to be able to live with some changes without its changing the overall intent, the overall thrust of the thing.

right, it's the sum total of those ten thousand or two hundred million decisions you've made. So it's not just floating around somewhere in thin air.

The same thing goes with this garden. Only, there's never been a more complex palette, and believe me, you can drown in this world.

**WESCHLER:** *I've been thinking for some reason as you were talking about the garden as a kind of daydreaming. Or of thinking, reasoning. Letting your mind go. Letting the plants go. Letting the thoughts go.*

**IRWIN:** Well, yes and no. I understand what you're saying, but it's much more contextually bound than that. There are boundaries, like I was saying about color, and it is more of a trial and error. And yet, at the same time, you do definitely float. You've got to float when you're doing it because it's not a system, it's a process.

FRONTLIGHTING AND BACKLIGHTING; PATIENCE; THINKING LONG-TERM AND BEING OUTLIVED; UNDERLYING STRUCTURE; PERFECTION AND CHANGEABILITY.

**WESCHLER:** *So, where are we here?*

**IRWIN:** We're just at the beginning of Area Three. Which is taller, more enclosed, more verdant, with richer green leaves and a bright kelly green as the kicker. Less texture on the whole, and a lot of larger-leaf plants.

**WESCHLER:** *Okay.*

**IRWIN:** This, by the way, here, is quite a spectacular plant, this one right here [*Geranium maderense;* right]. But look at it. It's a plant that gets quite big, such that the branches start going down to the ground and acting like extra feet to balance it, because it gets a flower head that's literally three, four, five feet around. Just huge. A big flower, made up of hundreds of small flowers. It's one of the more spectacular plants you've ever seen. Amazing that so very few people know about it.

Now, one key to the plan of the garden is that as you go down into it, basically you're going south, so that the sun, generally speaking, is on the back side, aiming at you. Now, there are a lot of plants which really look better when they're lit from behind. They have translucent leaves like those you can see there. See how bright they get. When we walk around to the other side, you'll see: they won't be nearly as interesting or as spectacular. But there's a number of plants that are the reverse. Like the one right behind it here, the hebe, which is the opposite [p. 48, right, foreground]. It doesn't look particularly good lit from the back side; it looks really good lit from the front side.

**WESCHLER:** *We'll make a note to remember to look at it from the other side when we get there.*

**IRWIN:** So, on the way down, you try to feature the plants that are best lit from behind, and on the way back up, in terms of your orientation, you try to feature plants that are enhanced by being lit from the front. A simple idea really, just taking advantage of the light as given.

**WESCHLER:** *The other day you were pointing out a plant where it's going to be a few years before the flower even happens. Generally speaking, isn't it going to be years before the garden as a whole really kicks in at full force?*

**IRWIN:** The first thing that everybody cautioned me about as I came into the plant world is that you have to have patience because gardens take a while. One year you try this and if it doesn't work, you try it differently the next. It takes two, three, or four years, and it takes even longer than that to really make a garden. In the case of the trees, I had to make a decision, and I decided the opposite of the way that decision is generally being made in most cases these days, which is to buy large trees and put them in so you have kind of an instant karma for the big opening. You've got people coming from all over the world, so there's a strong motive, you know, so they roll out the grass and they put in a big tree. And that's what they did everywhere else on this site. They brought in large, mature trees.

**WESCHLER:** *For the photo-op.*

**IRWIN:** For the photo-op, exactly. Especially all the stuff around the building. Which is okay in a way, except that you really can't get a great tree that way. First of all, back at the nursery, to make trees so they're salable and to rush them along, they do things to them: They top them and what have you to speed along the growth and fill out the tree. This tree, for example, is ideally a single leader tree: the single central trunk going all the way up. That's its real strength. But anytime one of them is more than two years old now, you just can hardly find any that haven't already been topped off and become dual or triple leaders, you know? So the tree never obtains its real stature: I mean, the beauty of it as it grows naturally.

**WESCHLER:** *Right.*

**IRWIN:** So, in this case, I had to buy small trees and wait ten years. Which is what I'm having to do: ten years before these trees are how I propose them to be. So, at least in terms of how I propose the garden, it will not be finished now for another seven years. Which is a big difference from being a painter or something like that, where you never work on something with that long a time-frame. But for me, first of all, it's a change of values—the values I get to base my decisions on—and it allows me to do

something which is more intimate from the outset. Since it was material that I wasn't familiar with, had never really worked with before, I was doing a lot of just guessing the first time around. Second time around, now I can look with a different eye. I can look at this combination and say, "Well, I really like that. I don't like this. This one's not doing what I thought it would do. What can we do if we change it?" And then do it again next year and then do it again the following year. In other words, now I've got this living palette with a mind of its own.

The first year, I decided if I was going to err, I was going to err on the side of excess, because I wanted to see what was possible. I wanted to see all the possibilities. And so this past summer, I felt the garden was actually too chaotic. Even for me. And so for next year, I've got a better idea why that was so, and what I really liked. What I could eliminate. What I could, in a sense, consolidate. Things that I could maybe feature a bit more, organize a bit better. And I'll do that. But you can't do that without having it there to look at, really; you need that firsthand, hands-on—

WESCHLER: *You're saying it's going to take ten years for all this to happen? You're seventy years old. I mean, this is a garden that's going to—*

IRWIN: Yeah, yeah. Well, I'm going to be around for another twenty.

WESCHLER: *Okay. But in twenty-five years, what's going to happen? It's one thing for Titian at the age of ninety to do a painting and then it's there, it's finished, and that was his last painting or something.*

IRWIN: Right.

WESCHLER: *But you're doing a work that clearly, by definition, is going to have to outlive you.*

IRWIN: Well, yeah. But in all sorts of critical ways, it's going to be resolved, if not finished. There are a lot of things about it that are not going to change: They're not going to change the path or the stream. They're not going to change those trees once they're in place. All the structure and all the major elements are going to be there. The one thing that's very flexible and continuously changing is the plant material. But I'm going to give them a pretty elaborate plan that they can follow the spirit of. You know? That spirit will be clear when I get to the end: the idea of sequencing the areas, the idea of the different kinds of strategies we're using, like reserving the strongest colors for the end. I mean, when I leave, I will actually give them a very specific document that they can follow. Now, they won't follow it in every detail; as time goes by, they'll move away from it to some degree, I'm sure. To what degree, of course, I don't know.

WESCHLER: *How does that compare with the occupants of, say, a Meier building—how, after he leaves, the occupants inevitably start changing it?*

IRWIN: It's a whole different idea about the ideal or the sublime. Meier's got this idea of some kind of abstract perfection, some ideal form, some Euclidean nirvana, and in his mind, apparently, everything has to be absolute—and he pushes hard towards that end. With I guess the idea that his contribution will somehow transcend change. The problem with that is that it isn't real in the sense of actually existing in the world. I mean, that's not how the world is. Forgetting the garden thing—as I was saying the other day, things essentially have to really live in the world. And if you get the thing properly structured—all the really main elements, the scale and all the relationships and the order of things really properly put together—it has the strength to survive being lived in.

WESCHLER: *With all the unpredictability of that.*

IRWIN: With all the unpredictability. Exactly.

WESCHLER: *And the various ambitions and—*

IRWIN: And courting all that. Courting unpredictability. Courting surprise. Allowing it to happen. And when it happens, in my mind, it's better than what you can plan. That's where the real surprise comes in. There are just things that you ... Four plants will grow together in some unpredictable way—I mean, I've seen it. I looked and looked and looked and looked. And I liked this and I liked this and I liked that flower. But every now and then I'd see what somebody else would call a mistake, an accident, and they'd say, "Gee, we didn't really plan that, but these four plants grew together." And I'd say to myself, "That is more interesting, more beautiful, than anything else that we've been talking about." The plants really have ended up complementing each other in some truly surprising way. So the idea is that you aim at some overall resonance, you put all that in play, and sometimes things work, and sometimes they don't. But on the whole, once you've got the thing going, it always works. It's just whether it happens to turn out absolutely brilliant. Because when it's brilliant, it's brilliant, you know?

It's the other side of the ambitions of the fifties, the rush to plan the world. They tore down whole areas of the town figuring they were going to rebuild everything all brand new, they had this utopian idea that they could just build whole cities. It never came out very interesting. It was always very dull. And the reason is, it didn't have the real richness of a time-layered complexity. It didn't have real contradictions. It didn't have real surprises. Everything came from one kind of thinking. And I soon realized that, at least at this moment, nobody seems to be smart enough to do that, you know? Whereas, when a city develops over a period of time, and decisions are

made by different people in different periods of time, there's a kind of a richness, a kind of layering-in which you start seeing, one kind of aesthetic up against another, and that overlapping to me is much more interesting.

That's part of why I was drawn to the idea of doing a garden this one time—as opposed to all the other sorts of things that I might do—this idea that aesthetics is not something that is stylistically bound, that it really is a way of going. It's more like philosophy. It's a method, not an end or a final product or even a state of grace that one finally arrives at. It's a way of continuously approaching the world. You don't arrive with all your preconceptions and say, "This is my style, and I'm going to put my trademark on things in this way." Instead, you really deal with the situation. And I'm beginning to think that finally, in the end, two hundred years or three hundred years down the line, that's more the way artists are going to work. They're going to work more from an aesthetic base rather than a stylistic one. And once you have a developed aesthetic, it works everywhere.

**WESCHLER:** *And I imagine the natural place for staging that argument, or the best way, would be in botanical material, which is liveliness by definition, as opposed to a room of scrim, for example.*

**IRWIN:** Absolutely. Well, like I say, it's like bearding the lion in his den, because when you start working with plant material, you're working with something that's not only infinite in character but totally quixotic at the same time: it'll challenge you as much or more than anything you can possibly imagine. And just to keep up with it is a full-time occupation. It's a never-ending thing because…

I mean, look at the number of combinations you start having to think about: there's like five hundred right in this little teeny area right here. And you can keep working with making those combinations work. There's a particularly good one right over there. Look at this whole little set here. This bright green thing with the little—

**WESCHLER:** *So we're now looking down from the fourth bridge.*

**IRWIN:** Right. See where I'm pointing, how that plant's got the kind of swordlike shape to it? Then you've got the one behind it that is similar but different. Then you've got the really strong green behind that, we're like filling that in. Then you've got the really dark one with the sort of different kind of swordlike form. Then we've got those tall cannas standing behind there with the larger leaves. Then, on the left of it, you've got that variegated plant with the gray-green, or the bright green and dark green in it. Then you've got this plant in front of it which is real soft, but basically of the same character. I mean, that's a terrific area. For me, it's a sensational area. It's like a tapestry, all woven together, which is really the look I'm after.

In a different way, I once saw that taken to the greatest extreme imaginable in a Zen garden in Kyoto where they had, over a period of like 150 years, grown this hedge which is now like fifty feet long and twenty feet tall. It's not really a hedge, it's just a whole tapestry of plants that are all grown and intergrown, and they've taken the time to clip and manicure this thing, you know, over and over and over. So it's literally maybe fifty plants all growing together in this incredible tapestry. And it was so spectacular. It's like the Japanese will do: that kind of absolute maniacal attention to detail over long periods of time. That's real karma. But the thing is, that happens in nature naturally.

And another thing. Remember how back in the early days, when everybody was saying, "This is difficult and you don't know what you're doing," and I replied by talking about finding some really dependable plants for the mass plantings? Well, it was the same for down here: we needed some bulletproof plants down here as well, plants that we could really count on. The only problem, to some degree, was that they've been so successful, they've been used and used to such a degree, that people have tended to habituate to them. They've become invisible. So one of the ways of putting them back into play was to show them always in combination with things that are a surprise, combinations that you've never seen before, so the plant is suddenly rediscovered.

**WESCHLER:** *So, for example…*

**IRWIN:** Well, here, behind the bench, some of these have died off at this time, because it's winter, but this white rose here, which is called an 'Iceberg' rose—a lot of roses, as I say, don't have particularly good leaves, they

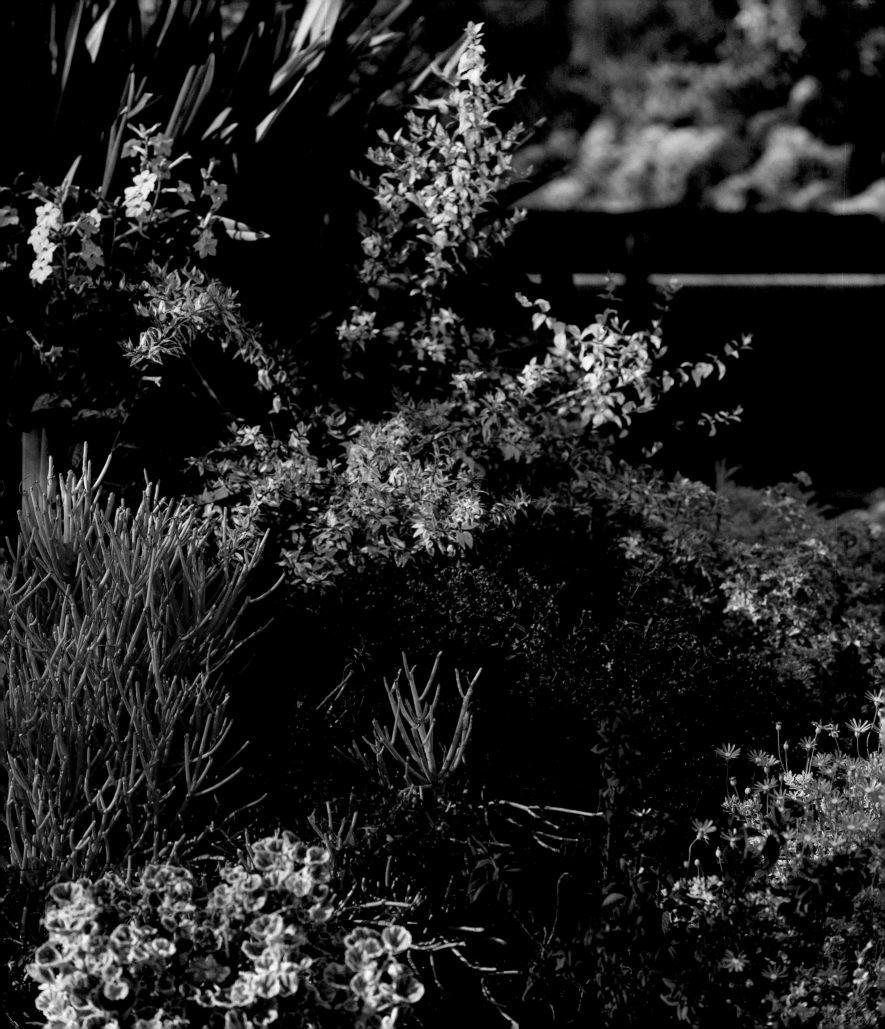

don't have particularly good structure, but this a really, really pretty plant in itself. It also has these beautiful white blossoms on it. And it blooms all the time. It just blooms and blooms and blooms and blooms. From the day I put this in, in the dead of last winter, it's been blooming and never stopped blooming. A great rose, but made common by overuse. But mix it with white bougainvillea, which has these shocking green leaves. And then, during the summer, intertwine all of this with this plant here, heliotrope 'Black Beauty,' with its almost black-purple leaves and its purple flower, and you're off to the races. Look at the color on that leaf.

WESCHLER: *Fantastic.*

IRWIN: Isn't that beautiful? And two weeks ago, this heliotrope was amazing. This plant took over the whole garden. It was just having its day. I mean, it's good all the time, but it became spectacular and was just the most important thing in the whole garden. And you put that up against that white rose and they were dazzling.

It's dying out now, it's winter, so we've clipped them back and hopefully they'll live through the winter. If not, we'll plant some more again in the spring. But it's a plant that's done very well for us, a highly successful plant. Sometimes doesn't live too long... So that's been kind of fun. Every now and then we get one that does really well, maybe just for us.

WESCHLER: *Here, by the way, we're looking back up at that original grouping.*

IRWIN: Right. And they're the perfect example. Look at how suddenly the ones behind them, the hebes, are really looking good from here. Now, they're really pretty, whereas the one in front is sort of dull.

FURTHER DOWN THE STREAM: THE CHANGING SOUND OF THE WATER; NAILING IT; GROWING CONFIDENCE IN CONDITIONAL WORK STYLE; NOT SETTLING FOR THE FIRST IMPULSE. THE HERRINGBONE STONE PATH AND TEAK BRIDGES: TENDING TO THE NATURE OF THE MATERIAL VS. MEIER'S OBLIVIOUS MODULARITY; THE BRONZE RAILINGS; THE TEAK BENCHES; GLORYING IN CRAFT.

WESCHLER: *Let's talk a little bit about the water here at the fourth bridge.*

IRWIN: Well, we have a long run between the third and the fourth bridge. There's a very large rock which the water has welled up behind. It actually has had to work its way around this rock and now is beginning to run quickly around a lot of smaller, scattered rocks. It's moving very fast now, not just splashing or coursing between the rocks but really barreling along. Stand here a second in the middle of the bridge and just listen with each ear.

WESCHLER: *How would you describe that?*

IRWIN: Well, it's much more throaty on the right, or on my right, than on the lower side. Like a deep tone. Whereas this is a higher tone. It's like two different instruments sort of playing alongside each other, one above the other. At this point, the up-tempo rhythm of them is quite similar. Whereas that last one was more a punctuated rhythm. This one here, they're almost the same rhythm. They're just two different tones playing essentially the same theme. And it's nice. It's a very good sound.

WESCHLER: *And again, when it was dry and you were putting the rocks here, were you pretty sure it was going to have this effect?*

IRWIN: Oh, man.

WESCHLER: *Or was it trial and error?*

IRWIN: No, no. I didn't have the luxury of trial and error: everything was getting set in concrete and time was a-wasting. But I pretty much nailed it.

WESCHLER: *Once you put the rocks in—*

IRWIN: —that was it. And I haven't moved a rock since I did it. But I nailed it. I nailed it good.

WESCHLER: *That must have been a thrilling day when you started the water flowing.*

IRWIN: Hey. Are you kidding? Man, it . . . And it worked. And it was like "Wow." Everybody saying, "It works." And it had all been guesswork. Everybody thought that I wasn't going to be able to do it, so much so that . . . Actually, no, they never broke my confidence. For some reason— I can't even tell you why—for some reason, all along I had no lack of confidence that I was going to be able to pull it off. And why? I have no idea, except that one thing has happened in these last few years: my confidence has really gone up. Maybe I've just been doing it long enough. And I realize I'm pretty good at it now: I can make decisions now in a way I never could before, you know, just bang-bang. I guess the years have honed my aesthetic.

Doing this whole thing was really also a kind of exercise in finding out whether this idea of conditionalist art actually works. And it was kind of exciting in the sense that, in the beginning, I really didn't have the answers to anything, and Meier had the answers to everything. Because he had a system, and he'd done it before. He'd done it and done it and done it. He repeats his things over and over. So the client felt real comfortable with Meier because they'd say, "Well, what are we going to do here?" And he'd say, "Oh. Well, we can do this, this, this, and this." While I'd say, "Gee, I've got to go home and think about that. I don't know. I have no idea." I'd have to think about it.

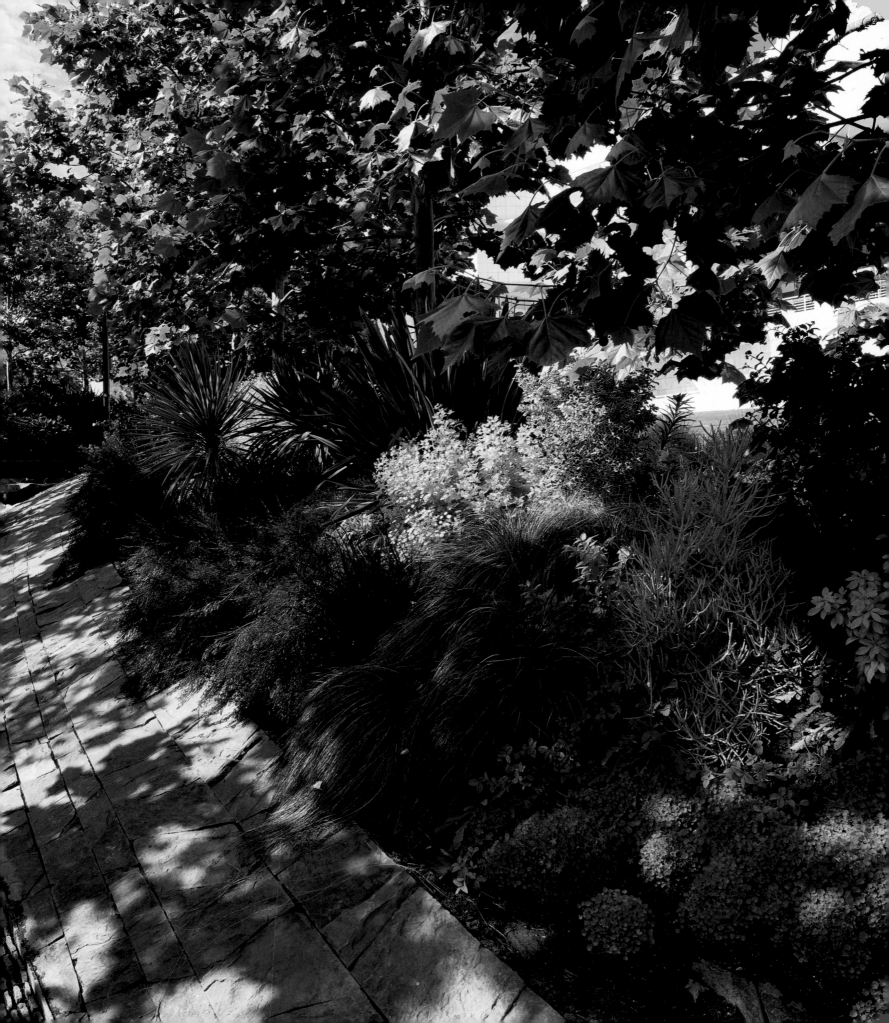

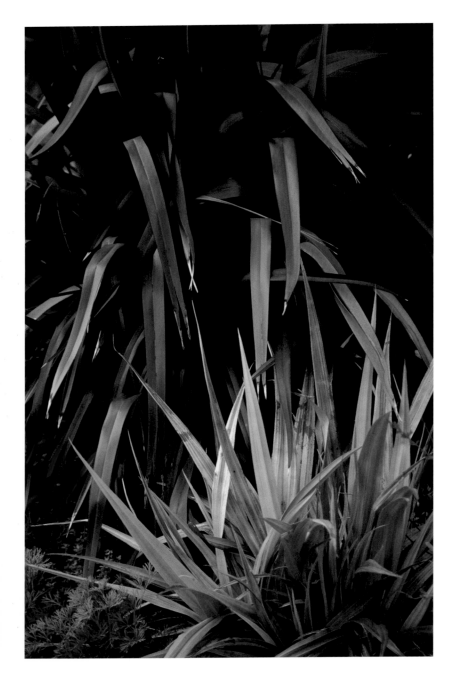

I actually always thought I'd be able to do it. I had been doing my own kind of over-and-over-and-over for a long time, working on my sensibility, on how to attend to things. In this sense it's all grounded in attending, and feeling. Understanding what I'm feeling and how those feelings can be translated into practice. It's a whole different way of working, in the sense that as you start determining some of the larger, overall issues, only then do the other, smaller parts reveal themselves, and finally, in the end, the details reveal themselves. But in fact it does work. You can work that way, even though it seems it's totally against the grain. Most decision-makings are front-loaded, whereas this process, in a sense, is rear-loaded, which, when you think about it, makes more sense.

**WESCHLER:** *One of the workers, when I was here before and you guys were putting everything in, made the comment that Meier has one solution for a million problems and Irwin has a million solutions for any single problem.*

**IRWIN:** Well, part of the bane of my daily existence in growing up was that in every single situation, I never settled for my first take. There's that idea that your first idea is the best idea, but that's only partially true. I mean, okay, there's a good intuitive sense, and sometimes with experience you hit it right on the nail. But you don't learn anything that way, you don't discover anything. I always assume that if I take the thing apart and play with it from all different angles, that I will find something that I've never known before, that'll go beyond what I know, that it'll take me a step further. And that's turned out to be true. Once in a while, I come all the way back to my initial response. But I found that the more I work with the thing and the more I experiment with it, the more I—I already know what I can do. It's the things I don't know how to do that I'm interested in putting into the work.

That's the thing that fascinates me when I'm looking at work by other artists. Most of the time I look at work and, yes, the work is interesting. But I also know exactly how it was arrived at, I know exactly how all the decisions were made. I know where they come from. I understand the aesthetic. I understand the process. But every now and then, you see something and you say: "Hey. Wait a second. There's a whole different thought process involved here. Decisions are being made and fueled from a different point of view. There's a different set of values involved here." Now you're really learning something. Now something is being revealed to you. Not just the perfection of the object, but the idea that the human mind is actually developing and extending and expanding the way in which it makes those kinds of decisions. And that's the real fun. That's when it really starts being Art with a capital A to me.

**WESCHLER:** *Let's talk about something we haven't talked about so far: the herringbone path itself [p. 74].*

**IRWIN:** Okay. Well, because of its steepness, the path could not be decomposed granite. The path had to be a hard material. I had a look at the idea of concrete or macadam and neither of them was very—I mean, I've seen really beautiful concrete work, but I couldn't get anything that I thought was good enough; there didn't seem to be the necessary craftspeople around. So I banned the concrete fairly early on in the thing and went to the stone because I thought it was a good place to spend the money, given the way that stone gives you a kind of richness, which adds to everything.

**WESCHLER:** *What stone is this?*

**IRWIN:** This is actually a limestone. It comes from the Pennsylvania area. And it's a really nice stone in that I didn't want a stone like those over there, with their terrific variations and darks and lights.

**WESCHLER:** *The facing on the watercourse.*

**IRWIN:** Right. Whereas this is very monochromatic. I wanted the thing to have a richness to it, but a quiet richness. Just laying the stones straight wouldn't have been interesting enough, so I played with a lot of different patterns, and finally I came up with this actually quite simple herringbone pattern.

**WESCHLER:** *Is it referencing any of the surrounding shapes?*

**IRWIN:** No, not really. Rather, it's playing off of the energy of the downward direction. You'll notice when you walk down, it's driving downhill all the time. So it's like an energy flow in a way. The stream is flowing down, and the path is flowing down. But it's very, very understated. Very quietly understated.

Also you'll notice you have the Cor-Ten steel on both sides. The thing is, you run those two materials right up against each other, and they really look clumsy. So it needed to have that relief.

**WESCHLER:** *That space between the limestone and the Cor-Ten along the edges.*

**IRWIN:** Exactly. And that space now is also a drain and a nice detail. But just that little bit of distance makes all the difference in the world. They're not materials that want to be cheek to jowl.

**WESCHLER:** *And what about the bridge itself?*

**IRWIN:** Yeah. That's teak, and it's exactly the same pattern as the stone path, except that you'll notice that each piece of wood is only six inches wide, whereas the

*Robert Irwin's original collage for Area Four of the stream garden.*

limestone slabs are one foot wide. And the reason for that is real simple. In other words, it wasn't to make it more interesting—which it does—but it was because stone, with its weight and its ruggedness, at that narrower width, starts looking all wrong. It doesn't want to be that thin. It wants to have more heft to it, more weight, more solidity, more scale. And just the reverse for the wood: you make the wood that wide and it starts looking really clumsy and awkward. So the difference is dictated by those two materials, by their natures.

And that's the one real criticism I have allowed myself of Meier's method. Meier was asked this time not to use his signature material, which is this white metal, which he really does use well. So now he's forced to find a material which is close to but not white, which would be acceptable. And he comes up with quite a beautiful material— the travertine. He uses it, and then they allowed him to go back and use his white material as well wherever he could after all. Instead of really, say, maybe taking on the challenge and going away from his most familiar material and expanding his aesthetic: he didn't do that, he passed up the opportunity.

So I've got a problem with him there. But aside from that, what happens when these two materials of his come together? How are they related?

**WESCHLER:** *We're looking up, for example, at the flank of the research library.*

**IRWIN:** Okay. How are the travertine and the white metal related? They're actually related only on one level. Everything has that same three-foot-square modular dimension.

**WESCHLER:** *Right.*

**IRWIN:** In other words, he didn't allow for the fact that the character of the stone is different from the character of the metal. He didn't let either one of them speak. And they don't speak to each other. They just sort of— one begins and one stops. They don't ever interlock. There's no dialogue between them, no give and take.

**WESCHLER:** *And, on the other side, the pillars holding up the Museum.*

**IRWIN:** Well, when you look at those pillars, you look at the scale of the stone and you look at the scale of those pillars, and it looks all wrong. It *is* all wrong.

**WESCHLER:** *As if they can't bear the weight.*

**IRWIN:** Exactly. They do not look right. I mean, if those were steel beams, say, which they really are, they would have the right look to hold up that huge cube on top. But with the travertine cladding, what you've got there is something which is totally out of character for the material, and you can see that it's a lie. In other words, you know it's got to have steel under there because those stones are not going to hold that up. So they're revealed as a facade.

Again, it's this question of the phenomenological. It's looking at what things are and then thinking: "Okay. These things have got to live together. And how can they do that?" Most people think of that as just craft in a kind of low sense. That's the high level of craft: when you look at materials and understand that all materials have to be worked in a certain way because that's the nature of the material. The people in the steel world, in the art of bridge-building, for example, they've learned how to join steel in the most efficient and really quite spectacular way.

So all the details in the garden are all done on that level. They're all done on the level of: What is the nature of the material? What is it doing at this point? How, in a sense, does it act and interact with the other materials? And when you put them together, they tell you why and how and in what way. If you pay really close attention, these things have their own voice.

**WESCHLER:** *Can you cite any other examples?*

**IRWIN:** Well, for instance, here, the way the stone path lines up with the teak bridge [opposite]. As you can see, they don't just run into each other. At the edge of the stone, there is an inlaid three-quarter-inch bar of Cor-Ten, then a band of stone which slows the visual flow of the walk and sets the drain running in the same direction, then another stone laid in the same direction and a double line of Cor-Ten to set off the occasion of the teak bridge's beginning. It's a little less complicated on the other end because you don't need the drain. But everything is doing double duty: practical/structural and aesthetic.

**WESCHLER:** *In this context, can you talk a little about the detail work on the railings?*

**IRWIN:** Well, as you can see, the railings are as minimal as they can be. One thing about doing railings in a garden nowadays is that you're extremely limited in the sense that there are all these rules that you have to follow. They have to be a particular height. They have to have a particular diameter. They have to have this rather awkward thing at the end of it, that flat spot, one foot of flat spot at the end so if somebody is blind and they're coming down and they are having their hand on the railing, that flat spot tells them they've come to a particular set of conditions: the landing. And that has to be at a particular height. So, in a funny way, it's gotten so, what with the bureaucrats administering everything, you can't do all that much except follow the rules.

Fortunately, I felt that rails in a garden should be minimal. They should be secondary and just blend in. In architecture, I think it's legitimate that you make of them a much more elaborate concern, which Meier does. And rather successfully in some places: his rails.

Another thing we should mention in general: I decided to use materials that would only get better in the garden. In other words, the stone is just going to improve with age. The teak is going to improve with age. These rails are all just plain bronze. And, for instance, if you look at that one up the hill a bit—see, at the corner between the second and third bridges?—everybody was saying, "Oh, you better worry about this, because that surface is going to get rubbed off." See how it's rubbed off on the corner? And it looks terrific [p. 82].

**WESCHLER:** *Those are bronze?*

**IRWIN:** Yeah. See the little T-joint there, how it comes up to a T there? If somebody wants to look at them, they're really nicely crafted. If you look at the way they go into the ground: they don't just stick in there, and they're not just attached to the wall. They slip into a sleeve, and the sleeve slips into the stone [p. 81]. I mean, that was a complicated detail to work out. But very understated. You're not even aware of it. But to somebody who's interested in that sort of thing, they could come back on their third or fourth visit—or if the guy's an engineer by trade or something like that and he's not interested in the plants, he could look at that and say, "Hey, you know, that was really nicely done."

And feel that: the thing is really solid. It's not rickety-rack, even though it is very slim and very subtle. It's got a good feel to it handwise when you run your hand along this thing. It's really tactilely very nice.

And what I'm saying about something getting better, patina-ing with age . . . it seems to me that a garden should have that kind of flexibility to it. And this is a classic example in terms of the rail. It really looks good, it looks lived in. Same with the wood benches, the teakwood benches, which can only improve with age.

**WESCHLER:** *Let's talk a little about the teak benches as well [p. 83].*

**IRWIN:** Okay. Well, I needed a couple of benches on the way down. And again, like with the railing, there was a temptation to overdesign everything. But, ultimately, the plants are the pièce de résistance and the beauty of the place, so I was trying to hold down those details, keep them very simple.

The vocabulary for gardens is pretty much defined. People have been doing gardens for hundreds of years all over the world in different cultures. And there's certain elements—benches, arbors, paths, bridges, railings—I mean, these things have been looked at and worked on by all kinds of incredibly brilliant people. You're not going to reinvent the wheel there. So what you've got to try and do is deal with it in your specific situation.

The bench is really formed, and it's a very comfortable bench. It's a bench to be sat on. It's not a revolutionary bench, but on the other hand, you look at it and you realize that every single one of these pieces of wood was actually hand-shaped. Now, most people don't pay that much attention. Benches right now are basically just manufactured: Everything is done and then it's assembled. No one ever goes to the trouble to shape all the wood like this so that it actually—I mean, feel that. All the way down. This is really a piece of craft in the best sense. The guy who did all the woodwork—did the bridges and did these—was an incredible craftsman.

**WESCHLER:** *What's his name?*

**IRWIN:** His name is David Frisk. He's down in the San Diego area. And once I found him, I changed my mind about benches altogether, you know? In other words, I was thinking this way and that way, and then I found this guy and started realizing what he could do. And what I really did was design a bench with him that played to his strengths.

**WESCHLER:** *So, in a way, it's again talking about what plants can do, what material can do, and what craftsmen can do.*

**IRWIN:** Absolutely. In other words, if I had not found a guy who had the ability and the willingness to really make this bench, I would've probably gone in another direction. But, to me, the beauty in this bench is not how it's designed; the beauty in this bench is how it was made. And I didn't make this bench, you know. I occasioned it.

**WESCHLER:** *It's another example of providing the occasion for a thing to express itself.*

**IRWIN:** Exactly. And same thing with the patterning of the stone on the side of the stream. Yes, I came up with that and I really sweated that one out. In fact, all the people I was working with thought I was wrong about it. I don't think they think so now. But I really felt that it had to be that. And finally, in the end, it was an exercise of craft. That's what makes the thing work. When I found Carnevale & Lohr—this nice guy, Louie Carnevale—and when I saw what they could do, I put it in their hands, and the guys that laid that stone are what made that stone work.

I particularly like this being curved like this in two different directions. This was really a hard bench to make: all compound curves. Each piece of wood in here had to be shaped on all four sides to fit together and to make this flow. And if you're somebody who's interested in that kind of thing, it's there. It doesn't demand attention for itself—it shouldn't, that would be disproportionate—but it pushes the parameters of working with wood.

**WESCHLER:** *Right.*

**IRWIN:** I tried to make all the details in the place understated so they flow, so you flow through the garden, and you attend to the garden as a whole. But if you wanted to or if it was your particular bent, you could return again and again and each layer would be satisfying. It's this layered wholeness, like we talked about in a painting, that gives the thing real authority.

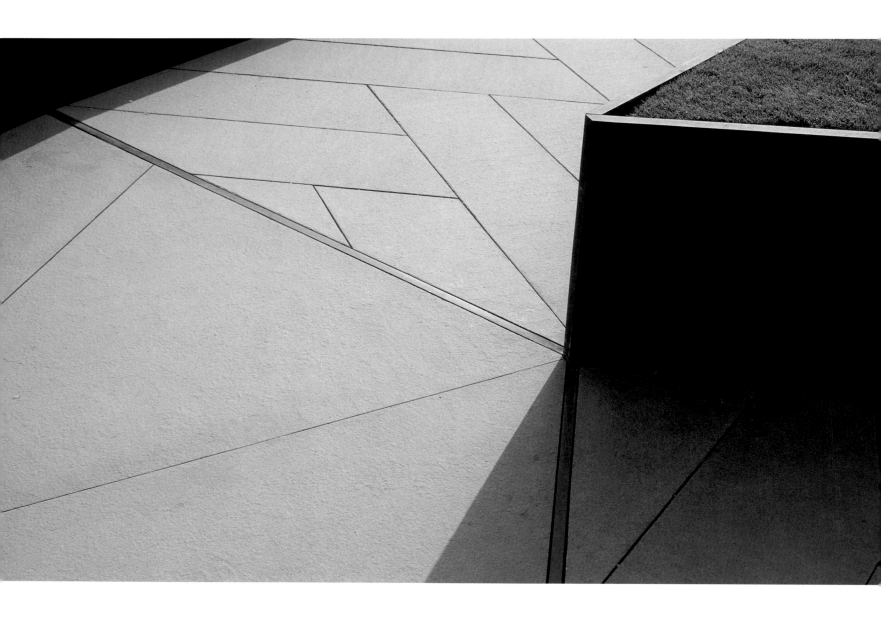

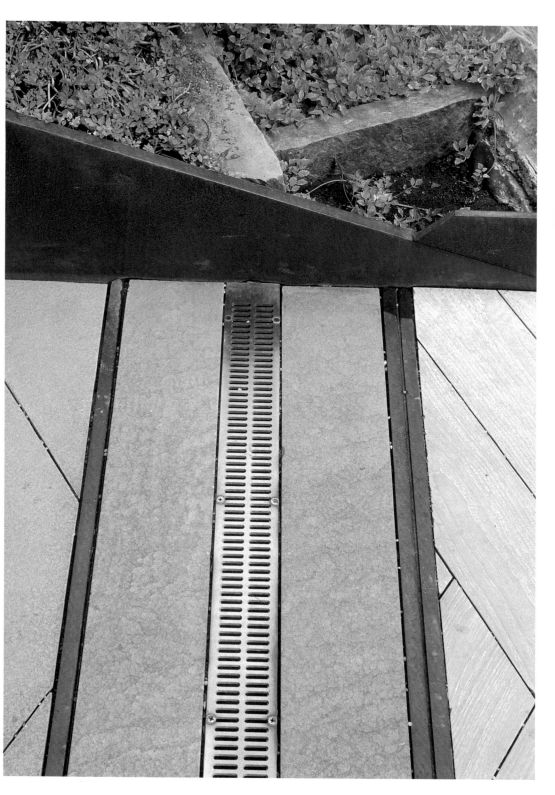

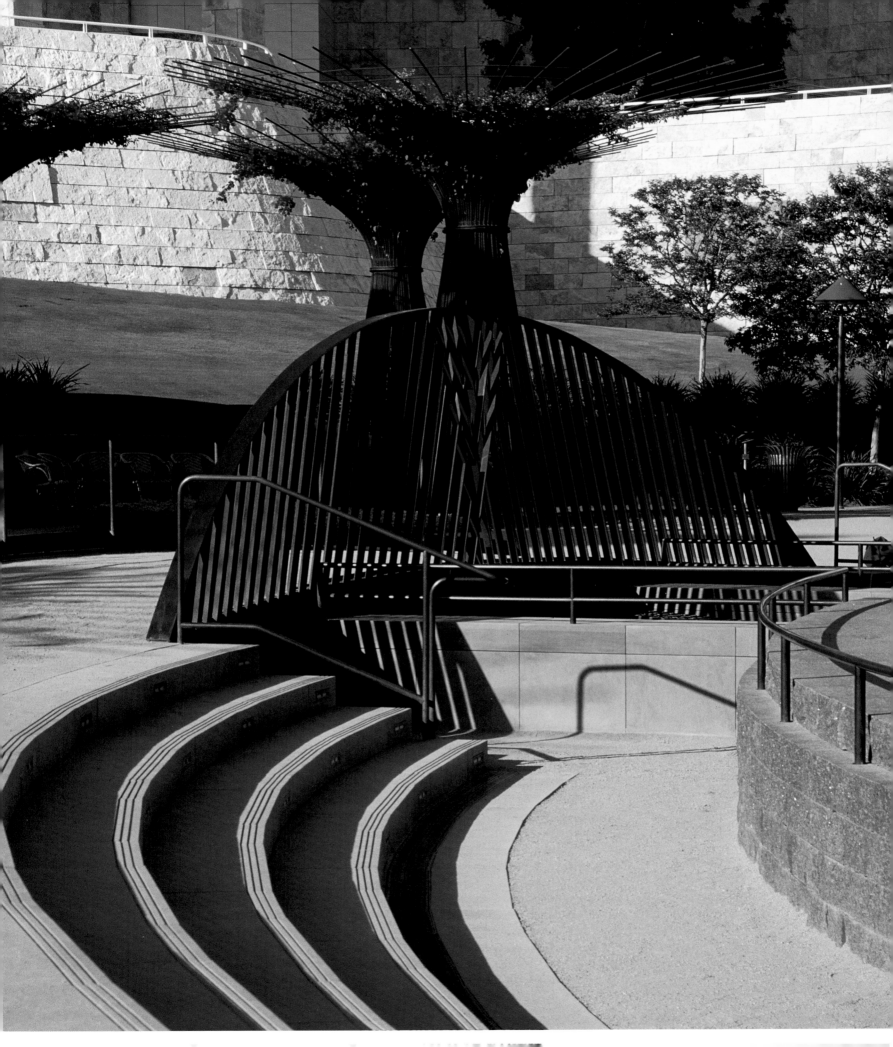

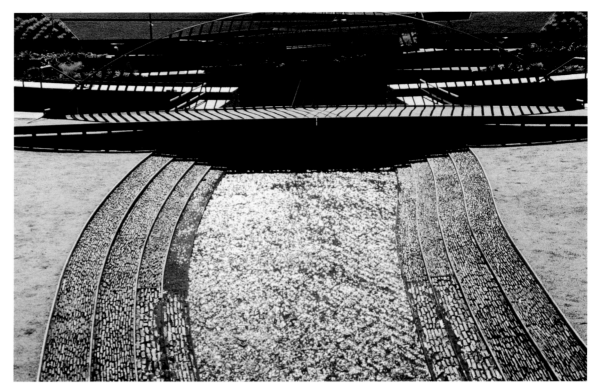

into the pool and the drains and all that. So actually there's a whole mechanism in here under the bridge, whereby the stream actually drops down, gets mulched —I mean, all the leaves, all the stuff gets taken out of the water, the water gets cleaned out—and then it gets pumped back up and proceeds on down the falls. And you have the illusion it's just passing through under the bridge. Now, we had to get the water to come and drop into this thing but not make any noise.

**WESCHLER:** *We're here on top of the bridge, and, you're right, you really can't hear any of that.*

**IRWIN:** You absolutely have no idea that this water's not just passing all the way through. So it's little things like that.

We had this water engineer named Chuck Schardt, very frail old guy, who is just the best. I found him because—you know, so many of these things fail: you go around to places all over and invariably the fountain's not working—they're notoriously badly engineered. This guy basically is famous for going around and fixing everybody's failed projects. And he actually makes all of his own machinery himself—handmakes it, so it really works. He says nobody manufactures it right, so he does all of it himself. And this thing was very tricky because it had to have so many square inches of edge baffle to handle the water, which would be coming under such-and-such much pressure.... See, look underneath there. By the way, that little rod is to keep children from crawling under there—a possibility which is deeply remote. I mean, odd-ball things like that that you have to consider.

The other Monday, when the place was closed, they were testing the stream, and the water was coursing only as far as this bridge and then seemingly just disappearing—not coming out the other side. Very surreal. And then later—even more so—they'd turned off the upper watercourse, that was dry, but water was pouring out from under the bridge and down the falls.

**WESCHLER:** *What about this Cor-Ten bridge itself? [opposite]*

**IRWIN:** Yeah. I think it's kind of a nice, fan-shaped element, another of these fairly substantial sculptural elements in their own right, which the people here wanted: some actual objects they could point to if nothing else worked out.

**WESCHLER:** *Your contract called for some actual sculptural objects.*

**IRWIN:** Yeah, at least three, as a kind of insurance policy in case I failed to pull the garden off, a prospect which admittedly was off the boards in Vegas as we were setting out. Anyway, this could be classified as one, the stream as a second, the arbors as a third. Actually there are a couple more such elements which I'll deal with when we come to them.

But the plaza was a great place for a focused element in any case, and this bridge rail did the trick. In the summertime, I let the plant material from those two planters there grow up on this thing. Last year we had morning glories growing up on it. I didn't think they were as successful as I wanted them to be. Back at the nursery, we had a really incredible climber which I'd have to ask Jim

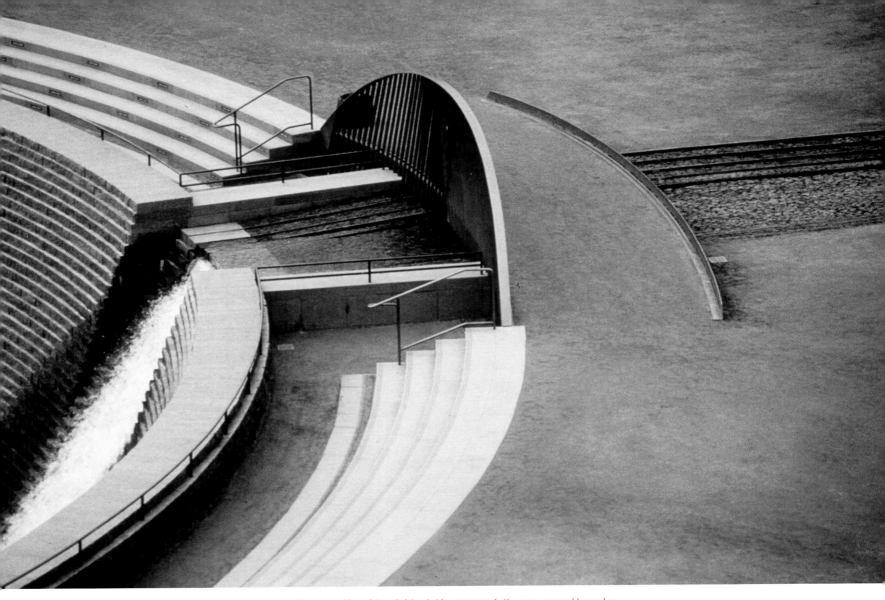

the name of—a climber nobody has ever seen. It was spectacular. I'm going to grow that up on here next year.

Another thing about this plaza ... I wanted you to not have anything between you and the edge at this moment of arriving at the wall. So you'll notice that the wall is at exactly the same height as this plaza. At the last moment, you go down some steps to get to the wall. So that when you're still standing here on the plaza, and you're looking straight out, there's nothing sticking out between you and the edge. And then you go down here, and this really becomes a nice moment where you look out and suddenly you discover the azalea maze, which is—

**WESCHLER:** *It's a total surprise.*

**IRWIN:** Which is a total surprise.

And a lot of people said it couldn't be done: blah-blah-blah—azaleas, water, open sunshine, the whole thing. Well, there it is, and it's working, and it's even going to work better.

Another reason, by the way, for bringing people down these steps here, was something that I really like: bringing you down to the same level as the stream water,

like this, right at the moment it goes over the edge. Nice, huh?

**WESCHLER:** *So that where you're standing is lower than the top of the chadar.*

**IRWIN:** Right, exactly. So you could almost reach out and touch the water. It's another nice little event with the water. So now the water has gone through six or seven events as it's come down. It's just one stream, but in a very short period of time, it's gone through a lot of different things. And yet, I don't think self-consciously so. You don't say, "God, he's just done too many things, it's too tricky" or whatever, that kind of thing. It could have felt that way, but it doesn't because of the fact that you see it and then you're taken away from it and then you're brought back and it's not that different each time. But it is different— I think we made a fairly rich event out of the whole thing.

**WESCHLER:** *Let's talk about the whole curving chadar wall here.*

**IRWIN:** This whole interlocking curving wall is made out of a really nice stone. It's called carnelian granite.

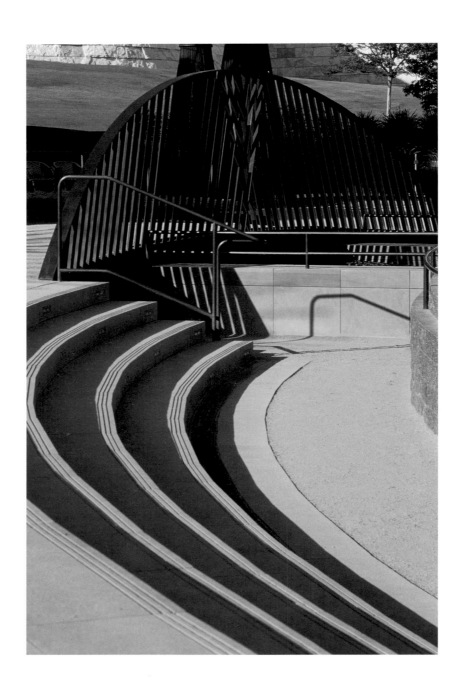

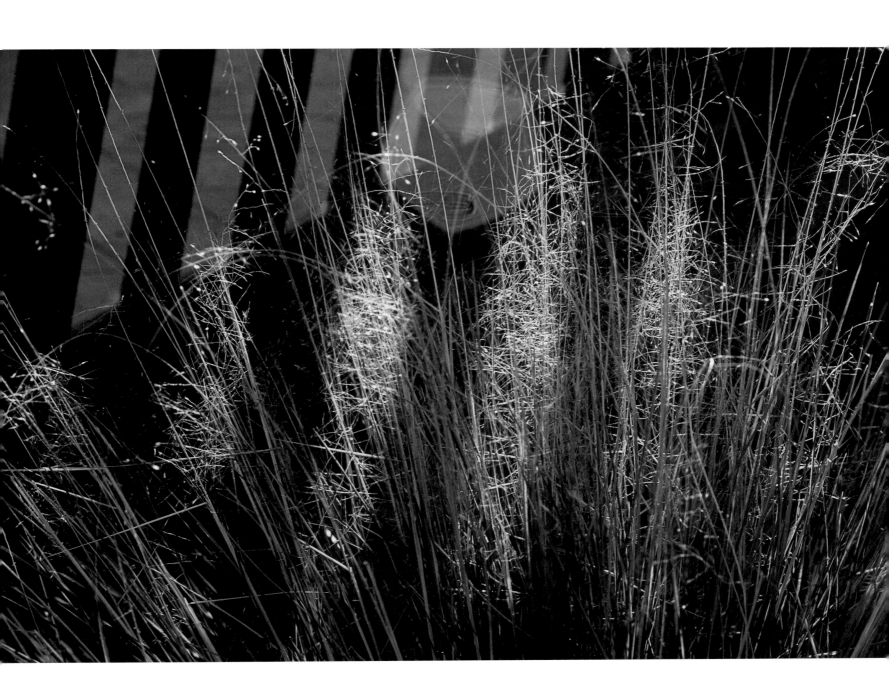

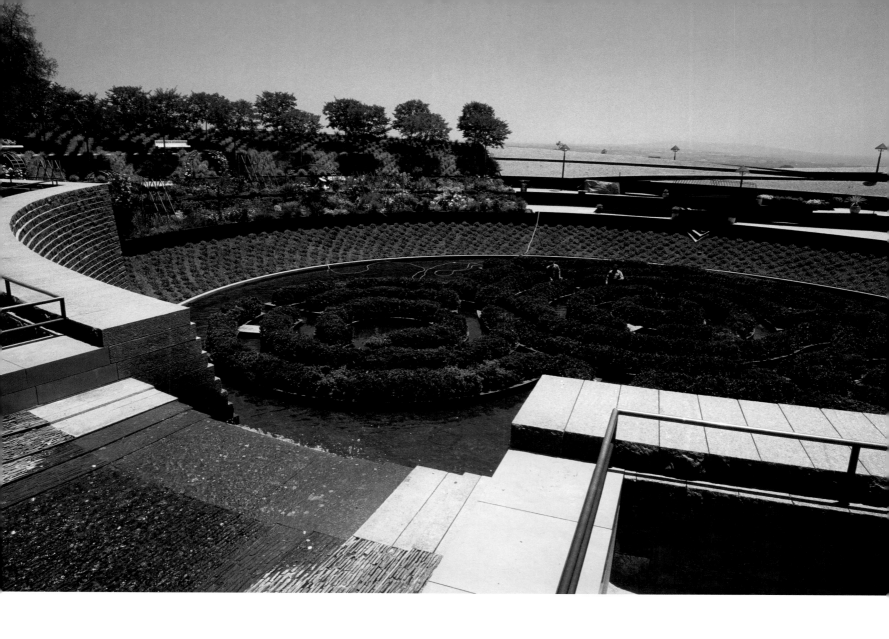

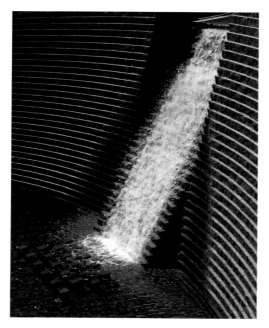

**WESCHLER:** *Where does it come from?*

**IRWIN:** South Dakota. And you'll normally see it polished; it's a very dark rich red when it's polished. For instance, the Bank of America building in San Francisco—big, dark red building. Anyway, I think it's a particularly nice stone. It's what I wanted.

I wanted its strength because this is really a powerful moment. Probably the largest single sculpture-type item in the whole garden: the whole wall, with the chadar that falls down the middle of it. But I did not have the money to do the kind of thing Meier was able to do with the walls of his buildings—which is every one of those stones is cut and fit. All I had money for was like a simple brick technology—small stones stacked. Which to me was totally out of character for this: it needed to have much more weight, much greater strength. It had to be a real strong element.

So what I did—besides choosing the right stone and deploying it split-faced—was two things. To begin with, as you can see, where the wall starts over here and over there, along the ends, it's straight up and down. By the time it gets to that corner over there, it's tilted back 5 percent. And then on to this corner here, where you can see it's tilted back 7.5 percent. And then it goes from 7.5 percent, and by the time it reaches the edge there in the center, it's tilted 23 percent. Okay? And what that allows is that although it's just a bricklike arrangement, it becomes rougher and rougher, more and more articulated, as it goes. Instead of just being the same flat surface, it's getting more and more and more and more extreme.

And then the second thing is—see the big stones on the side of the waterfall and here along the top of the rim? They're all laid on their face, in this direction, creating the illusion that everything beneath and inside is all the same sorts of big pieces of stone stacked. Almost like you were stacking railroad ties or something, something of real weight and scale. Which gives the wall this illusion of having power to it.

**WESCHLER:** *Whereas actually it's just these little narrow stones?*

**IRWIN:** Yeah. Six by nine inches. Exactly. Little oversize bricks is all they really are.

And then what happens, the chadar is made of the same material, and it's tilted back 32 percent. The sense is of this piece of the wall's just being tilted back further— you'll notice it even sticks out some at the bottom. And see how the stones are stepped along the edge: that's so the water won't run across this way here. In other words, it keeps the water sort of channeled. And stuff like that all had to be tested and worked out.

**WESCHLER:** *Can you talk about the azalea ring a little more?*

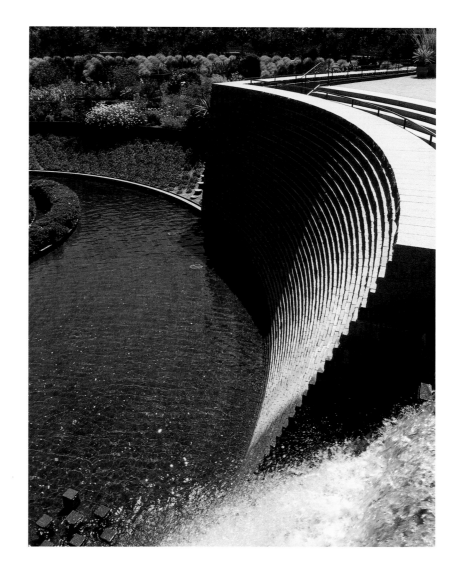

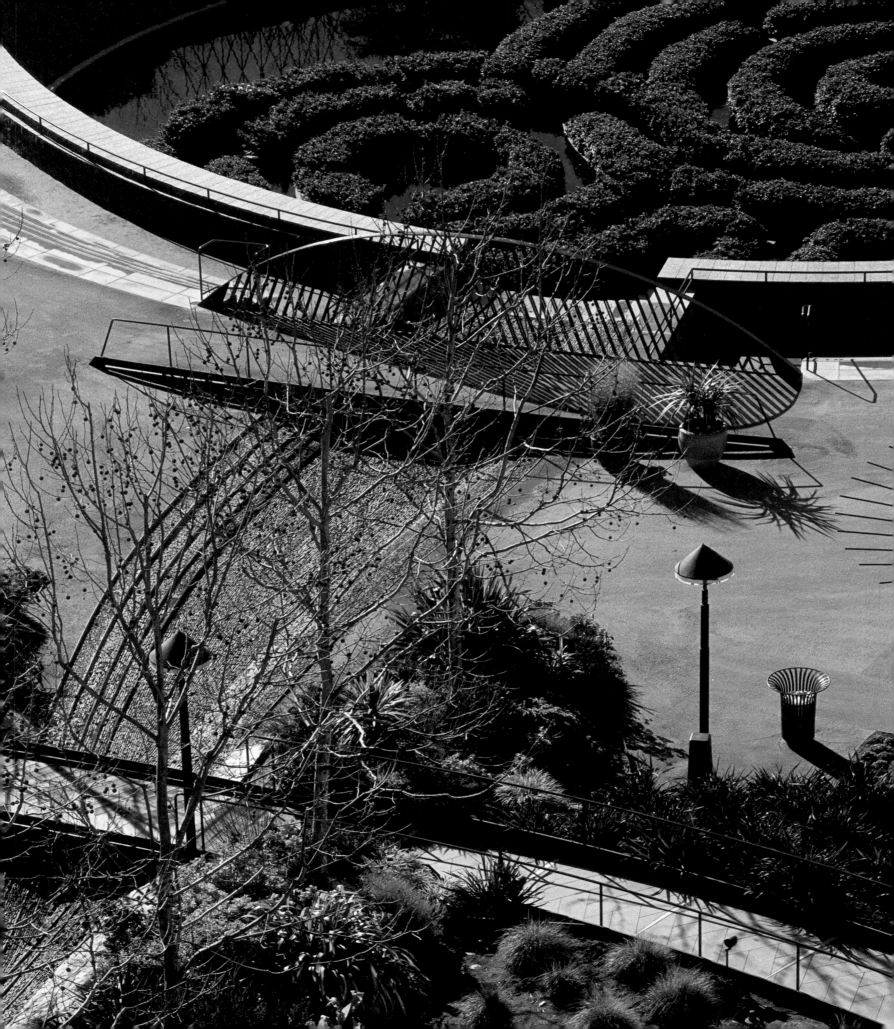

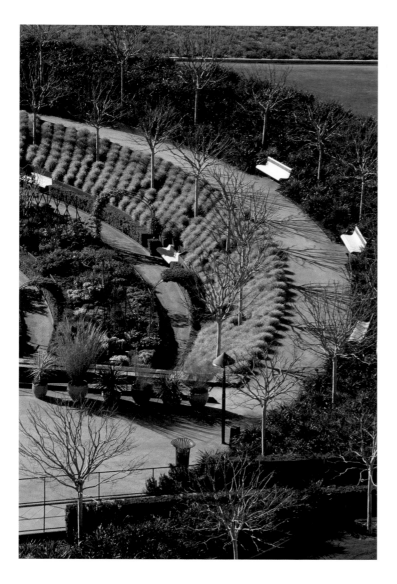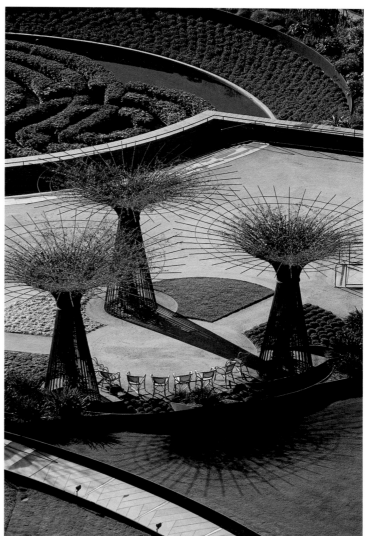

**IRWIN:** Well, the azalea ring, obviously, is sculpture number five. My original feeling about the thing was, okay, I've brought you all the way down here and when you get here, there had better be a compelling reason for you to have made the trip. A real event, a real surprise, something you've never seen before.

Originally I wanted to have what are called kurumes. They're a smaller azalea, much tighter-leafed. They grow all the way, right down to the edge, naturally. They are much heartier, and they blossom like crazy. They just become solid blossoms. But they didn't have enough of them. So I bought these because this is what the Nuccio Brothers recommended, and then we spent two years getting them ready to go in. We laid out the whole configuration full-scale in Malibu, and we're doing the same thing with the karumes right now. And at the end of five years—since nobody knows how long these things will last in these conditions, no one's ever had them in this condition before…

**WESCHLER:** *In water with all the reflection?*

**IRWIN:** With all the reflection and being in planters. Actually they're prospering very well right now. But no one knows. They are a plant that can live thirty years, even fifty years, in containers, and they take to being hedged and shaped. But I wouldn't have attempted this without the help of the Nuccio Brothers. No one really knows, but these guys have been raising azaleas for three generations, and I'm doing everything by the numbers.

You know how people go all the way to Washington, D.C., to watch the cherry blossoms? I wanted to have something with that kind of spectacularness to it.

**WESCHLER:** *An event.*

**IRWIN:** A real event. Same with the trees, when they become forty-five-foot tall and have this feathery square.

Did I ever show you that photograph of the one tree up at Filoli, that garden we visited up near San Francisco? [above] They have a couple of olive trees in drum shapes It's just—it's spectacular. You look at it and say, "Wow! Look at that." It's worth the whole trip.

Okay? Can you imagine what this whole stand of trees is going to look like if we pull it off? This is going to be spec-fucking-tacular! For anybody who's interested in this sort of thing, you'll come from anywhere in the world to see it. It's going to be a once-in-a-lifetime thing. And it's going to be the single most spectacular event in this garden.

**WESCHLER:** *The line of trees?*

**IRWIN:** The line of trees. If it looks the way I want it to look. And I want it to look like the Filoli tree. That's going to be a major event. The chadar falls here will be a major event, the flower garden in the bowl once it really gets going—and then, as I say, these azalea rings.

**WESCHLER:** *Can you talk a little bit more about the idea for the azalea maze—why a maze? How did that came about?*

**IRWIN:** Well, it was again one of those conditional things. When I first entered into the project, the garden ended right at about where that path is there.

**WESCHLER:** *The path that goes across that last gravel bridge back there.*

**IRWIN:** Right. See where that door is over there on the Museum side? And that other door over there on the Research Institute side? Draw a line between them and that was going to be the end of the garden. And there was to be a fire road curving up to here from down below, a half-circle right by here—

**WESCHLER:** *Where we're standing.*

**IRWIN:** Yeah, and then on out.…And the whole area we're looking out over was supposed to be a down slope. Like it now is out there on the other side of the bowl.

**WESCHLER:** *It would have been a spectacular view.*

**IRWIN:** Well, yeah, but there were already plenty of those. And beyond that, I had a feeling. When they told me what they wanted the garden to do, how people were supposed to use it and how many people—which turned out to be really true—I knew that the space wasn't going to be big enough. I mean, this was going to be way too small. I started arguing that in terms of what they were telling me they wanted and how they wanted it to be used, that it really couldn't all happen in that area. So instead I proposed essentially taking that fire road and flipping it around and capturing this space in here, putting the road out on the backside like that, and slotting the bowl in the middle. And in some ways, gaining this space was maybe the single most important thing I did.

So in the beginning, they kind of were halfway going along with this, but they were reluctant to administer all of it, have guards and have people going that far afield. Which was silly. But they felt that way in the beginning. So in the beginning, I talked about this as being like a secret garden—in the sense that you'd come here and look down on it, but you wouldn't go down into it.

Hence the idea of the maze. First of all, the idea of finding something strongly graphic to look down on, like a Stella painting, okay? I needed something that had that quality to it. And the second thing, when I got to designing such a maze, was that I figured, since nobody was going to be walking in it anyway, the paths could all be water. And voilà! Even surprised myself, which is one of the great pleasures of working conditionally.

By the way, somebody has since sent me a book on mazes, and there is no maze like this anywhere in the world. Turns out, there's a lot of people that are into

making mazes, but a circular maze is quite unusual, surprisingly, and it seems that having one on water is something nobody's ever even considered doing.

**WESCHLER:** *Also, by the way, in terms of its graphic elements, it plays off of some of Meier's circles, doesn't it?*

**IRWIN:** Which is something that becomes even more clear now from below, looking back up from the place I call "The Power Spot" [pp. 134–35]. Which we can talk about when we get down there. But anyway, that's how the maze came about.

And pretty much everybody predicted that it wouldn't work. But I rolled the dice and said, "Man, I want it, and I'm going to take the gamble." And it was a big gamble—if it had failed, shame on me. But look at it. You know, we're in the dead of winter. And man, those red ones especially are blossoming. This is totally their dormant time. So they're not doing bad. And I'm noticing that, if anything, they're getting better.

**WESCHLER:** *The three circles will each be different colors?*

**IRWIN:** Yeah. The center rings are 'Red Birds,' and the dark pink over there are 'Duc de Rohan,' and these over here are called 'Pink Lace' [p. 107]. Later the three kurumes will be 'Hino-crimson,' 'Apple Blossom,' and 'Snow'—I think a little stronger color combination. They're all full-sun azaleas, and tighter-knit, with a habit to grow right down to the ground, or in this case, the water.

**WESCHLER:** *You were going to talk about the stonework also inside the pool [right].*

**IRWIN:** Oh, yeah. And that'll be the last thing today maybe. To me, one of the biggest challenges—you don't see it right now because of the glare, but the bottom of the pool . . . bottoms of pools are the worst. I mean, I went and looked and looked everywhere, and the bottoms of swimming pools, the bottoms of reflective pools—man, they're just a disaster: they all turn bad colors, the paint chips away. There seemed to be no really successful solution. And here, you're looking straight down on it. (By the way, the water is only fifteen or sixteen inches deep. You can't have anything more than eighteen or you have to have a lifeguard.) So you have a shallow pool of water, you're looking straight down on it, the bottom's a surface which is going to affect the overall picture, and it's a surface which could've been a real disaster.

So for a long while, I really sweated this one. I had no idea what to do. But while looking for stone up in Montana, one day, I saw this slag pile—literally as big as that building. Tons of that stone. Just little pieces that had been fracturing off a cliff for like a thousand years. And I thought, "Here it is." And it was basically free. Nobody wanted it; they'd sell it to me for nothing. It would take a lot of money to put it in, but I got the material for almost nothing. All I did was get Laddie to hire some high-school kids, and we just sorted the stone and put it in sacks and brought it down here and got Lou Carnevale and his guys to lay the stone in.

**WESCHLER:** *And to lay it vertically into the ground on end, rather than flat and horizontally.*

**IRWIN:** Yeah. Exactly. You want to lay it vertically so it has some texture to it, some depth to the surface. It's inlaid. It's all laid in a continuously circular pattern . . . a very tedious job.

And also, I rather like that. . . . For a garden at the Getty, it seemed to me there had to be one point where somebody could say, "Jesus Christ! Look at the trouble they went to!" That had to be somewhere in the mix: "Only the Getty would do something as nutty as that." They were going to say it anyway, so I wanted to give them something to really talk about.

That sets a tone, you know? And I wanted to set that tone. It's like with the chairs being totally casual and relaxed and comfortable. They set a tone. There's things that you have to do to get the right feel, where it's all already there, but then, you know, "Bing!"—there's a moment of recognition.

**WESCHLER:** *Well, on that note . . .*

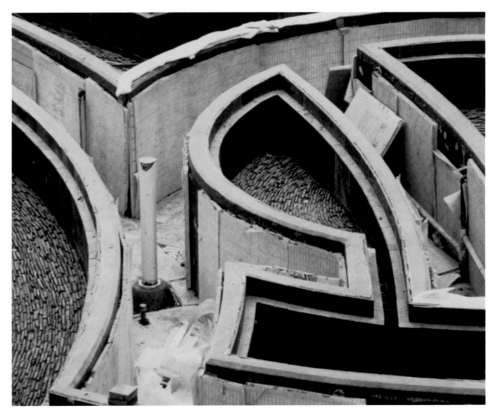

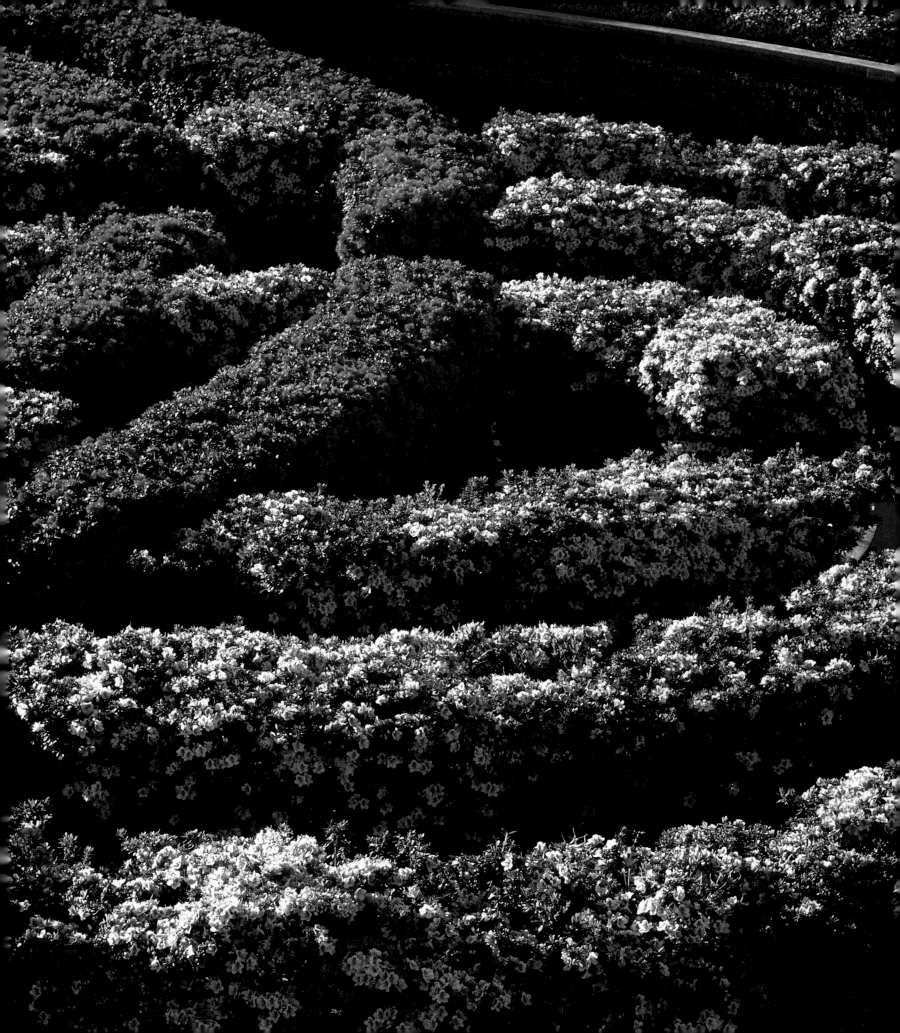

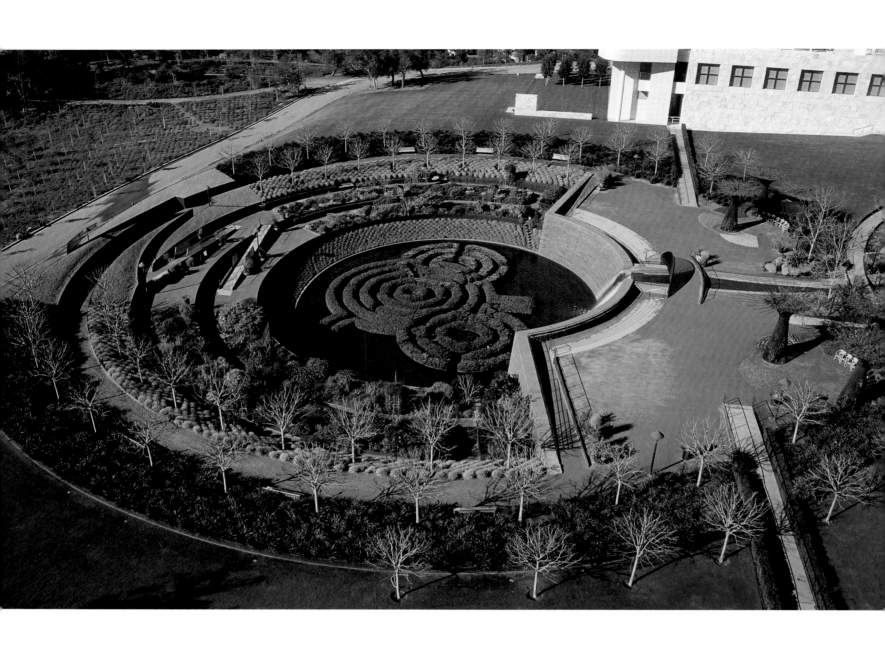

SEASONAL VARIATION; COLOR IN NATURE
AND AT THE DIA; A COUPLE OF DEEPLY
SUCCESSFUL PLANTS: CHANGING THE RULES
OF LOCAL GARDENING.

**WESCHLER:** *Okay, so today we're in mid-April, it's several months since our last conversation, and we'll start by quickly walking down the zigzag path through the stream garden and the plaza to the cusp of the bowl garden, where we'll take up where we left off. As we go, maybe you could describe where we are in terms of season.*

**IRWIN:** Well, it looks like the trees have nearly budded and are about to burst. So spring is one warm week away. Normally we would already have had spring. We're having a late rain this year, it's fairly intensive, and we're probably having more cold than usual, which I think has probably retarded the garden a little bit in terms of spring happening.

In terms of the flowers, surprisingly enough, there's a lot of plant material already in bloom.

**WESCHLER:** *Have you been doing much planting recently?*

**IRWIN:** Just about three weeks ago, we took out all the special winter material that we were using as annuals: the dogwoods, the sticks, and some of the berry plants that we brought in. And we put in a lot of spring material, some of which we'll maybe see down in the bowl.

**WESCHLER:** *Can you talk generally about spring transformations compared to what it was like in winter?*

**IRWIN:** Well, spring is really probably the most glamorous and the most exciting of all the periods of planting. New growth, of course. A lot of delicacy, a real brightness in color but not full saturation. A younger, more open feeling to it. Whereas in the summertime, things become more mature: the plants get larger and more intertwined, the colors become more intense. And then you go into the fall, and the colors get richer, darker—more reds, browns, grays, less of the yellow-greens, blue-greens, blue-gray greens, and that sort of thing. Pfew! Look at this one [*Athanasia*].

**WESCHLER:** *We're right before the second bridge.*

**IRWIN:** It's almost taken over completely in this area. It's amazing. Every time I go through here, a different plant seems to be having its glamour day. And this one is absolutely—in fact, it's really on the verge of having to be cut back a little bit.

I'll tell you another plant that's really on its best behavior right now—that grass, over there [*Carex testacea*; p. 48, left]. Look at it: it's got a little green at its base and then the spikes are bright orange, with kind of a silver, almost like gray hairs within it. We mix it with a *Libertia peregrinans*.

**WESCHLER:** *Looking up from the second bridge.*

**IRWIN:** Okay, and now look at this one here —euphorbia— and, man, is it on its best behavior, too.

**WESCHLER:** *Now moving on toward the third bridge . . .*

**IRWIN:** Look inside, look at it up close. Isn't that amazing? You have this bright yellow, okay? And then for some reason—why!?—the sheer genius of nature—it's exactly the right color: a little bit of magenta right there at the base of it.

**WESCHLER:** *You know what that reminds me of, actually, is what happens in your recent scrim-and-light installation at the Dia Foundation in New York—the way you wrapped those fluorescent shafts in layer upon layer of theatrical gels, resulting in band upon band of the most uncanny colors and in the most uncanny combinations.*

**IRWIN:** Absolutely—ha!—and that's not accidental. I had a great teacher. What nature does with colors is invariably—the palette of nature is twice as complicated, at least twice as sophisticated, as anything any artist can ever come up with. On a couple of levels.

To start with, there are these amazing combinations of colors, filled with surprises and almost never wrong.

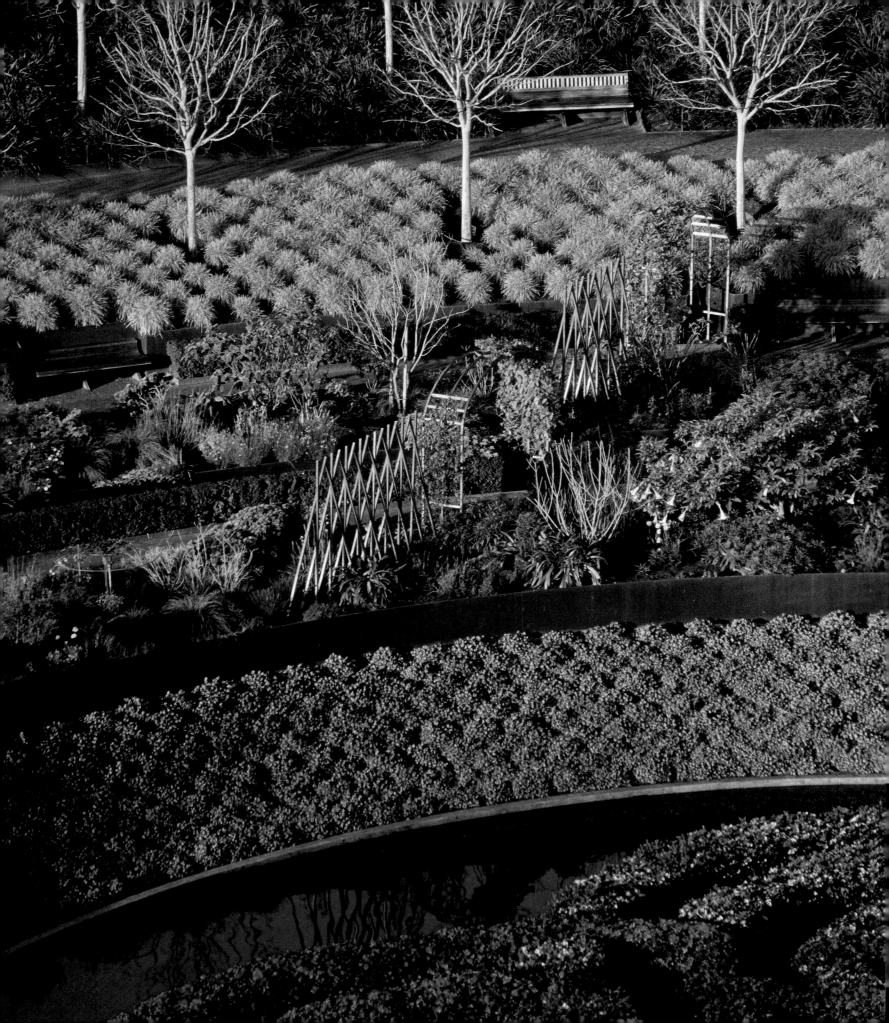

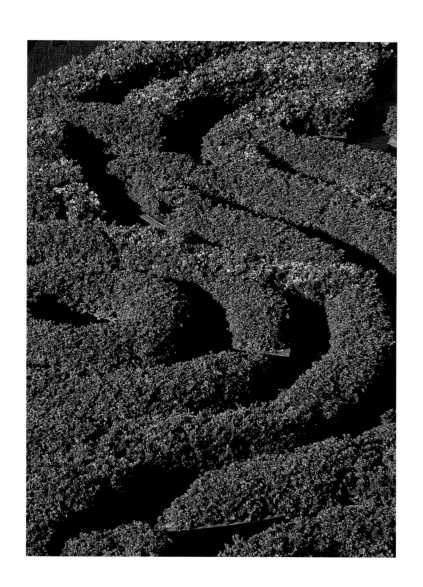

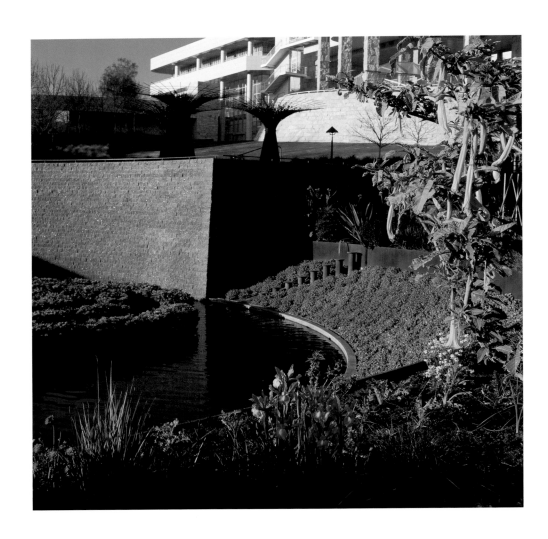

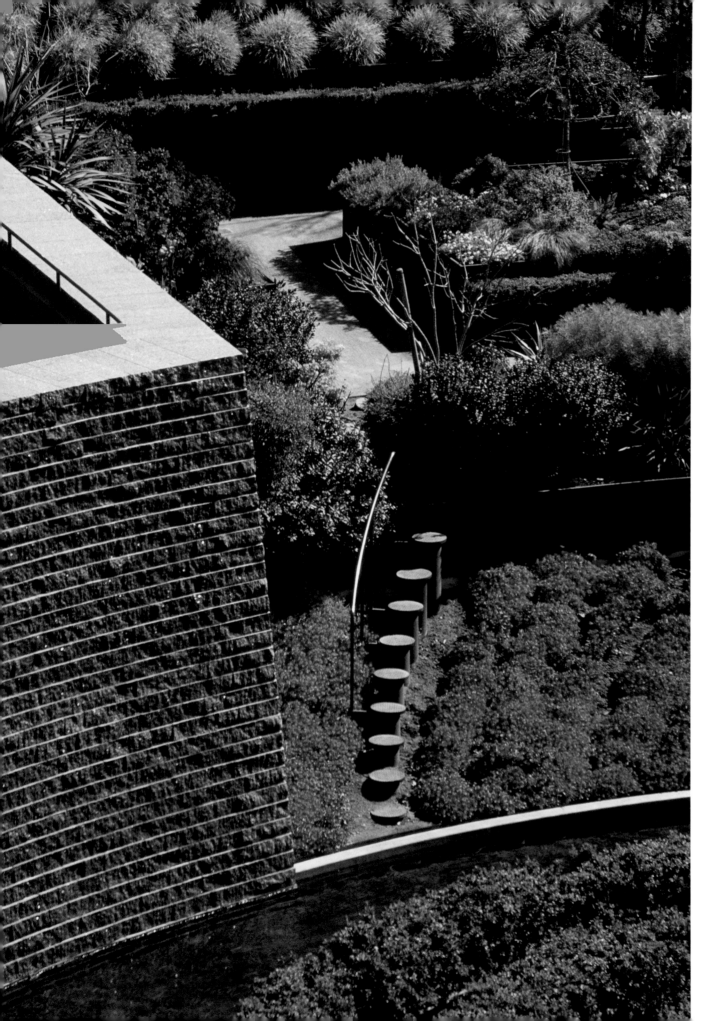

I don't know how Nature ever conceived to put, say, those together. But, boy, are they right on the money!

The second is that color in nature is made up as much from texture as it is from the actual color itself. You have a color that's made up of, say, fifty points of light, rather than on a painting, where it may be a single smear of color. Even in a pointillist painting, where you may be trying to approximate those fifty points of light, you're never going to get the complexity and richness which you get here in nature. Take that plant there, where the yellow-green sort of goes into blue where the leaves . . . —and it's just vibrant. I mean, some thousands and thousands and thousands of individual points of color, each one of them not only bright on the front edge, say, but rolling over into darkness further back, so that each one of them has its own chiaroscuro, and every single little element has it, not just the thing as a whole.

And the thing at Dia likewise attempted to invoke some of that quality of color in nature, because it was dealing with light and there was very little matter involved; and you were dealing as much with energy. You weren't just seeing the color; you were seeing the color as energy. So it was pulsating; it was alive.

Look at the head on that one [*Geranium maderense*; p. 65]. Look at the size of that one. Have you ever seen a bouquet of flowers any bigger than that? Now, there's a plant right there that obviously profits, totally profits, in this environment. Okay. You've never seen it. You can't buy it. It's not around.

WESCHLER: *The geranium?*

IRWIN: Yeah, the common name of it is geranium. Is there anything more common than a geranium? I mean, this is the most nickel-and-dime, ordinary, everyday species of plant. But here's a geranium that is absolutely spectacular. And why isn't anybody growing it around here? That's why I say this garden's going to change things—both those plants, the euphorbia and the geranium, which are growing brilliantly here—nobody knows those plants, but now they do. And we've found some other ones—we're going to try to bring in some black ones next year, believe it or not, these silken black flower heads that seem to absorb light.

Anyway, those two plants—anybody wanders through here who's really interested in gardening, they're going to want those in their garden. That changes the rules of the game; and we've got fifty or one hundred of those surprises.

Look at the heather there. And look at our lilies down here.

WESCHLER: *We're approaching the fifth bridge.*

IRWIN: That's a spring plant. When I was here two weeks ago, those were not blooming. In fact, they weren't even there. So they're really coming in.

Here's a plant that's suffering badly right now. But in the late fall, this plant was so glamorous, it took over the entire garden —heliotrope 'Black Beauty.' Like I say, it's struggling now because it's over its season, and it happens to be a plant that gets very raggedy when it falls apart. And it's true, sometimes it doesn't live too long. But in late fall, it did brilliantly in this garden, and anybody who was here when that thing was doing what it was doing, you'd absolutely have to have it in your garden. One of those absolute musts. You'd hear people: "What is that? It's so beautiful." Look at it against the other plant. There's no plant like it. It's almost like a black hole in there.

WESCHLER: *Black and purple: it again reminds me of some of those astonishing colors you began contriving for your light-and-scrim installation at the Dia.*

MORE ON AZALEAS; THE CRAPE MYRTLES. THE DIFFERENCE BETWEEN THE STREAM AND BOWL GARDENS; KEY GARDEN STAFF, INCLUDING JIM DUGGAN; FOLLOWING THROUGH OVER SEVERAL YEARS. THE UNDERLYING STRUCTURE OF THE BOWL: HOLDING CHAOS AT BAY. TRELLISES AND BOWERS. RHAPSODY ON COLOR PERCEPTION: INTERWEAVING HUE, VALUE, INTENSITY, PROXIMITY, AND AMOUNT; COLOR AS ENERGY.

WESCHLER: *Anyway, this is where we got to last time: we're crossing the plaza and the last bridge and we're now overlooking the garden.*

IRWIN: One thing I should mention while we're here. In the early spring—March—the azaleas go off and bloom. That's their big season. They'll bloom periodically and they'll come again a little bit later in the year, but that was their big season.

WESCHLER: *So this was a few weeks ago.*

IRWIN: Right. So now we're into April, and you'll notice that the first ring, the one immediately circling the pool, is currently in bloom.

WESCHLER: *The purple ring around the azalea pool.*

IRWIN: The lowest ring, which is *Kalanchoe pumila* [p. 76, right]. Now, May or June, depending on the weather, the kalanchoe will fade out, and the next ring up, the tulbaghia, will go into full bloom and become a solid ring of color. And then in midsummer, the trees, the crape myrtles, on the circling path above them, will go into bloom. So that the color rises up from the pool, a ring at a time, from March to the end of the summer.

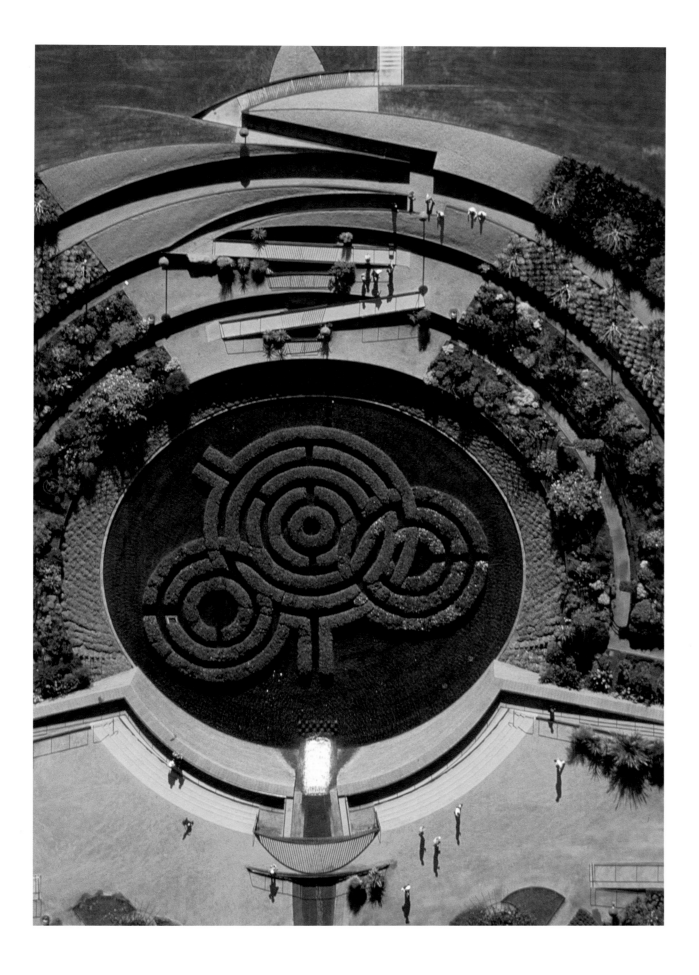

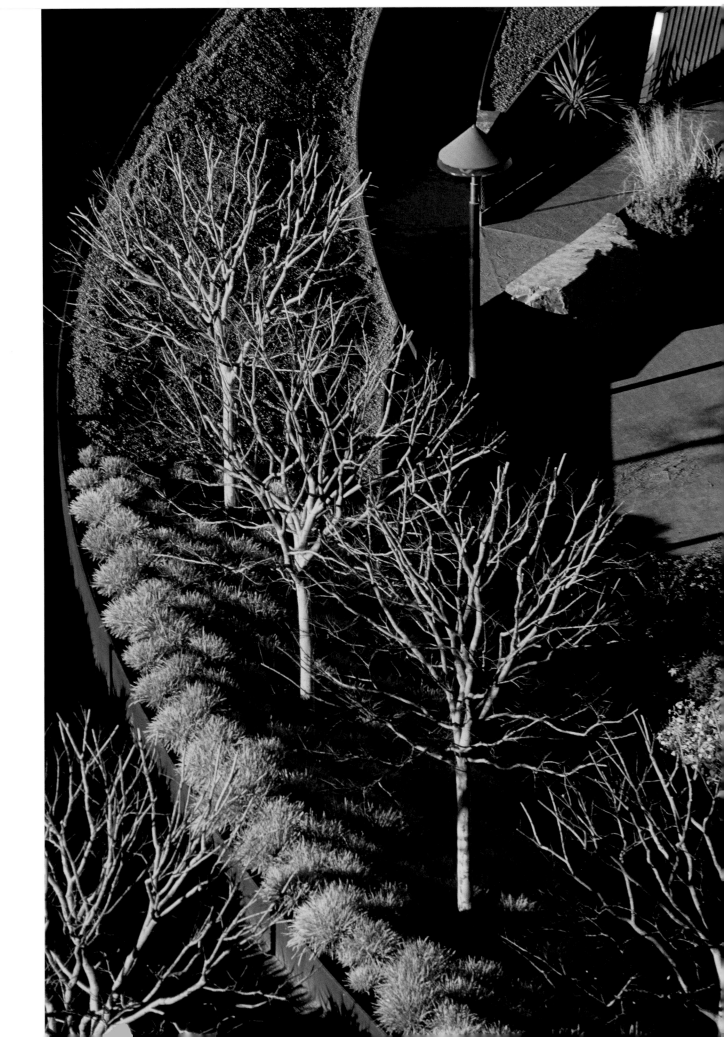

**WESCHLER** : *By the way, you haven't really talked about the crape myrtles yet.*

**IRWIN** : Well, here I was compromised a bit, because the tree I wanted, a Muskogee crape myrtle, which fit all the criteria in terms of scale, habit, color, and resistance to mildew—the only ones available had been turned into little lollipops, you know, which is one of the things nurseries do to corrupt trees. Little round things sitting on top of their narrow trunks. So we had to get those. But we've been working with them for several years now, and they're beginning to—like this one here is starting to have a really nice shape. But it's still got a ways to go: in another couple years, they're going to be really quite handsome trees. Actually, they're a really nice tree: sensuous with a fine exfoliating trunk—the same as with the London planes on the stream above. Again, a tree that looks as good or better when it's bare—a fine, sensuous, sculptural look.

It's funny: both the crape myrtles and the London plane sycamores have these beautifully patterned trunks, Their structures are entirely different. The crape myrtle has this quite sensuous trunk, and the London plane is quite formal. Great character. It's kind of amazing to choose these two quite different trees, each for a particular situation, and then they turn out to have so much in common on another level.

Anyway, those crape myrtles will flower all summer long and look really beautiful.

So that, as I was saying, the color rises up over the course of the season, and each time of the year when you come, one of the large elements will be in bloom. There will always be a feature element going on, because, as I say, this is not just a garden, like the Tidal Basin in Washington, where everybody comes just in the spring. People come here every day of the whole year.

**WESCHLER:** *Now, talk about this bowl garden as opposed to the garden along the stream.*

**IRWIN:** Well, the biggest difference between the two is that the stream garden is essentially a perennial garden and the bowl garden is essentially an annual garden. Now, there are perennials in the lower garden and there are annuals in the upper garden. But the upper garden is there all the time. It's not as much of a flower garden. It's more of a constant, all-year-long kind of garden. So that one of the really critical differences in approaching them is that the upper garden is approached totally in terms of leaf color and texture—allowing nature to supply the flowers, the surprise, but not planting it with the idea of the flower. So that color's there all the time. Whereas this garden down here is a go-for-broke flower garden, with the intent that the slowly escalating use of color comes to a climax at the far end of the bowl. I mean, I want the color to dazzle you as a kind of last reward for making the trip all the way down with me.

**WESCHLER:** *Just now, we're standing, by the way, on the right side coming down, just at the top of the—*

**IRWIN:** The west side, right.

So the garden down in here is really a flower garden in the most intense way imaginable. We go through three major plantings a year. And in between those, we're always putting in new things and taking out others.

Early on in the project I realized that I wasn't going to be collaborating with Richard Meier anywhere near as much as I was going to be with Richard Naranjo, who at the time was the head gardener at the old Getty out in Malibu, where he had been since its beginning. It took me only one trip out there to realize how valuable he was going to be.

So from that point on, I checked everything with him. Richard began raising the azaleas, for instance, and the bougainvillea for the arbors, and we began to double check everything with an old-time horticulturist named Bill Paylen who, as luck would have it, lived less than a mile from the site and had his fingers on the pulse of all the plant life in the area.

**WESCHLER:** *You were also working with some landscape architects, right?*

**IRWIN:** Yeah. Spurlock Poirier. Actually, I had fourteen consulting firms and three engineering firms, plus Russell Hurst, the magician surveyor. I mean, it was just a garden, but some days the site looked like D-Day at Normandy.

Anyway, besides doing all the documents of record, Andy Spurlock and Wayne Takasugi helped organize the forced march. On top of which, Andy was a good plantsman with a nice aesthetic, not to mention a quirky sense of humor that kept me on my toes.

Over the life of the project, Richard Naranjo graduated from being just a gardener with a shack in the back to taking over management of all the grounds both in Malibu and Brentwood, and he is really good at what he does.

As things progressed, we were confronted by a huge logistical void, which is to say, how do you find, gather, organize, and hold all the plant material while you're trying to decide on what's going to be used? Our problem was compounded by my need actually to see and pick every plant, and my own ambition to head off the beaten track, which meant that we would only be buying a few things here and a few things there, so we weren't going to be able to expect the kind of service we might have if we were placing big orders with a single large commercial nursery.

**WESCHLER:** *So how did you fill that void?*

**IRWIN:** With pure luck. My old dipped-in-shit-come-out-smelling-like-a-rose luck. One thing had become very clear: you can't have a garden like this without a real

hands-on, down-on-your-knees gardener. And no sooner had I begun to recognize this than I happened upon Jim Duggan, who as luck would have it had his own half-nursery, half-personal garden, a passion he was managing to support at the time by scratching out a living laying tile. And he was willing to spend the time going from nursery to nursery to nursery to look at plants with me, to educate me regarding what might work and what might not, and we indeed started going to nurseries everywhere.

**WESCHLER:** *Like where?*

**IRWIN:** Well, mostly from here to Northern California to Oregon and Washington. We'd just rent trucks with built-in shelves and drive up and down the coast, picking up plants along the way. Interestingly enough, it seemed the farther north we went, the more we found, but the more, in turn, I needed Jim to keep me from buying things that couldn't possibly work for us. At the same time we did bring a lot of marginal things back and put them in Jim's growing grounds, and a lot of times things turned out to work that everyone assured us wouldn't. Like those hellebores I showed you last time.

And the process continues to this day. The Getty people, in their wisdom, have recognized the complexity and richness of the creative process, and they've given me three years to work out the planting program for the garden, with Jim remaining intimately involved.

**WESCHLER:** *For example, in what way?*

**IRWIN:** Well, one thing that Jim's been doing as we go through the year is, he lists every single plant. We've been walking through the garden together on an average once every two weeks, and he takes notes, giving each plant a rating, like one star, two stars, up to five stars. In January, a plant might get one star; then it's a two star and then it's a three star and then it's a four star and then it's a five star—it stays five stars for whatever, and then it becomes a four and a three and a two and we plan its replacement and then we take it out.

But every plant, you know, he's recording their span. When they come into bloom, when they go out of bloom.

**WESCHLER:** *It's like a slow-motion fireworks display.*

**IRWIN:** But what we'll do after we've done that for a couple of years is, then we'll know when this plant is coming into bloom, and what else is coming into bloom alongside it. We have to know at what point it's going to need to be replaced and by what. We have to know how many months in advance we have to prepare that other plant, and whether to propagate and grow it ourselves or else go out and buy it from one of our sources. You have to know that this plant here, say, is being propagated in January and February so that it can be dropped into the garden in June, August, or whatever.

So to map that whole thing out with all those interplays—the biggest challenge is simply not to drown in the possibilities. And part of the key to avoiding that fate, here in this lower part of the garden—but in fact for the garden as a whole—is all the geometry and structure we've been talking about.

If this were all just continuous, it would be total chaos. But first of all, it's very carefully inscribed—there's a very strong geometric element in terms of the two quarter circles on each side. They're very clearly there. The paths on both sides, the African boxwood hedges along and against the Cor-Ten wall. All that provides a little bit of formality. In addition, each quarter-circle is divided into four sections, starting with a dark section up against the carnelian granite walls, rich greens, browns, and violets, with hot red accents; next to that, heading toward the back of the garden, is an area that is predominantly grays with low-key yellow-and-white accents; and then comes a large area of mostly blue, blue-violet, and violet-with-orange accents on the east side of the bowl, and sharp magenta-to-red accents on the west; and finally, at the very back of the bowl, an area of full-out, full-spectrum intensity as the climax of the entire garden. So, there's all that subtle ordering, as well as the sculptural structure of the landscape.

**WESCHLER:** *And basically the same on both sides?*

**IRWIN:** Yes. But it's having those levels of structure that allows me to get even more adventuresome, to take even greater risks with the numbers of combinations and the kind of things that can happen.

Now, last year, admittedly, things got a little out of control, but part of that was because we put a lot of plants in just to fill in the garden so as to get us through that first winter, when El Niño almost washed us off the entire hill. This year we're going to discipline it a lot more, pick and choose our plantings and be a little more careful. Last year we didn't yet have that luxury, but part of the reason why it still worked and looked okay is because the structure is there.

Granted, there was a sort of built-in necessity for all that geometry, supplied by the context, Meier's and what have you, but also by the fact that the paths were going to have to serve as emergency exits to the fire road out back and be accessible as such. So all that created, in one sense, you could say, a limitation. But the key is to take that limitation and take advantage of it.

**WESCHLER:** *Could you talk a little bit about the bowers and the trellises [opposite]? There are four sets of them, right?*

**IRWIN:** Right. And the key to the trellises is threefold: one is to divide the various areas—the dark area, the gray one, the purple one, and the bright one—we put a couple of divisions in there to maintain that clarity. Then also to be able to get material up high so it can act

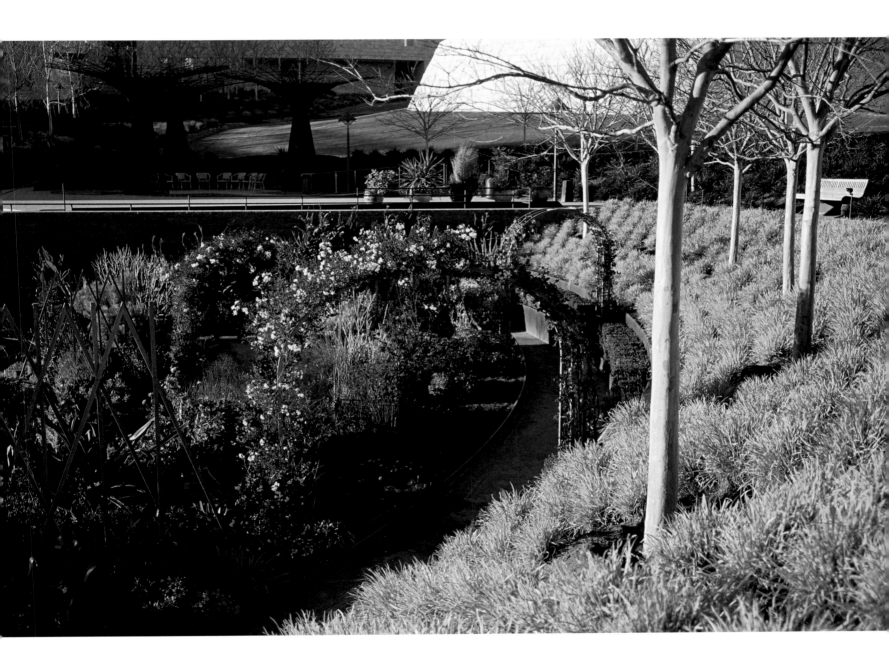

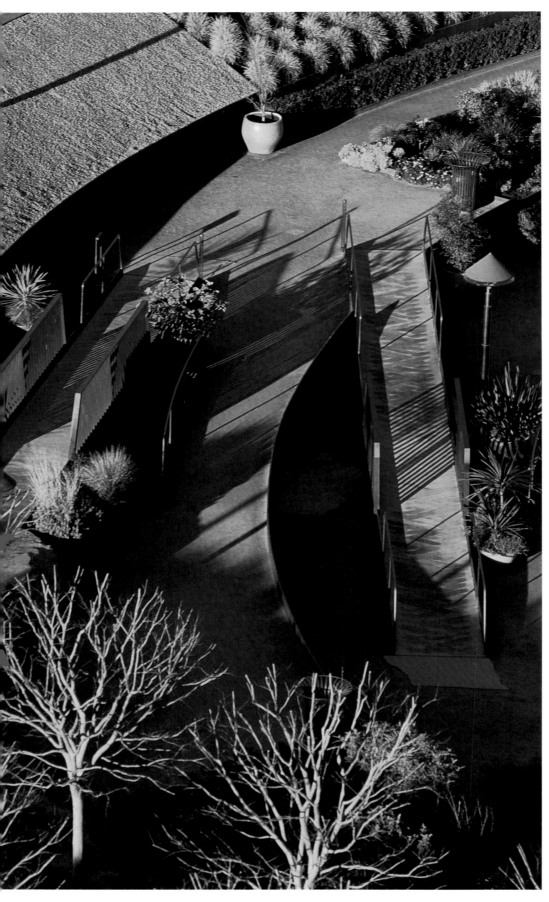

as background. And then, as you walk between them, so that you can get a sense of everything's being as if inside. In this way each section becomes almost like its own room between its two trellises.

Now, another way in which we're holding chaos at bay is by interweaving the plant material—the leaves and flowers—in terms of hue, intensity, value, amount, and proximity. For example, if you hold all five to be similar, the color becomes very tightly related, they're tightly knit, even though they may have substantial other differences. And then, if you want to create an area that has a little more excitement to it, maybe you make one of those things different: for instance, vary the hue while maintaining the similarity of the value and the intensity. Or you can have the hue and the value the same but make the intensity and proximity change. Or, third, make value the difference. Okay? So you have many different ways to activate this thing or to maintain a level of cohesion.

Sometimes it can get to being almost too much when you get all of them—hue, value, intensity, etc.—acting in full-bore contrast. It can really rattle your teeth, which has indeed unnerved some of the garden critics but was exactly the kind of abandon I was aiming for, especially toward the end of the garden.

And that's another thing: I'll put color combinations together which really shock each other, you know, where traditional gardeners will say, "God, you can't put those colors side by side. I hate those colors together." But those kinds of biases about color have nothing to do with color at all. One of the things that an artist does, in a way, is you fall in love with Color. It's one of your tools, but it's also something—it's viscerally really rich for you. And you don't have biases about it. I mean, depending upon what you want to have happen, there are no combinations, there are no things which are not doable. And that's another thing that maybe I will play with a little bit: cubing it. A lot of other artists also deal with that sort of thing, getting colors that really rock off each other and colors that blend with each other or colors that affect or change each other, like grays. There are all these different strategies. It depends on what you want to do.

So you can't look at it and say, "Well, I don't like orange against blue." It depends on what you want to have take place in that situation. Such people are often just thinking of limited things: they don't like certain colors, so they won't put it in their garden, they want to stick with the colors they think they like. But look at Nature: she holds no such biases.

It's like they're playing "Chopsticks"—you know what I mean?—when there is a concerto that can be put together, what with all the subtleties and complexities.

WESCHLER: *This a bigger palette, at any rate, than you can get at Utrecht's.*

**IRWIN:** I don't think there is any bigger palette. And the fact is that color is not just in the color. The color is in the texture and the juxtaposition. I mean, when you make color, like, you can paint a wall orange or you can take the same orange and put it on fifty thousand pinheads and put them all on the wall. Granted, each one of those pinheads is orange, but they each stick out a little bit, and you will have blue in the shadows behind them, and each one of them curves just slightly over. Suddenly, a depth of color supplied by the texture comes into play, and not just texture—add the quality of the surface, whether it's refractive or absorbent—and you approach that chiaroscuro effect where you're going from light to dark, each one of those colors is going to its opposite at the edge (in the case of orange, to blue), and a myriad of colors in between, rolling from bright to dark and from refractive to absorbent. Think of the rich compounding involved: all of which you miss, at least in part, when you let the veil of a literate bias come between you and the pure experience: orange. Because now you have an orange which has greater volume to it, greater weight, greater energy, is much richer in terms of its vibration. Color is above everything else a vibration, just as the eye before everything else is a kind of infinitely nuanced vibration detector.

God, it can get to be like going from the lowest setting on your speaker and turning the volume all the way up to the highest.

**WESCHLER:** *"Volume" in this context turns out to be an interesting word, because it implies both sound and weight.*

**IRWIN:** Right, and in a word: energy. As with this plant right here: orange, orange, orange, and they call it Cosmos 'Sunny Red.' It's so vibrant that they call it red when it's obviously orange. But it's hard to focus on: it's pure visual energy.

Or look at this plant right here, which is green, but it's not just green: every single leaf has a white edge on it.

**WESCHLER:** *What's it called?*

**IRWIN:** This is tulbaghia, also known as variegated society garlic. And a few of the leaves are turning a little yellow, and there's a purple flower that's gotten into it. The color goes down inside, it gets darker and lighter and brighter and almost like blows off on the top, so your eye can hardly focus on the leaf at all.

So you go from a wall, and then to painting, like an artist paints on a canvas, and then keep adding these dimensions and these complexities—because, of course, in the garden you're not just dealing with a wall or a canvas, a flat expanse, you've got leaves one in front of the other, plants one beside the next, and they're rustling in the breeze, moving in and out, in front of each other and then falling behind—so that you're not talking about color per se anymore, like "orange" or "green."

You're talking about resonance. You're talking about weight. You're talking about physicality. You're talking density. You're talking about energy. You add all those things in and now the palette really gets going.

When I talk about a tactile world, I'm really talking about energy. Tactility, in a sense, is really a resonance—that's how you receive it. It's actually a tactile read you're making. Forgetting about the whole thing of not making a literate, or literal-minded, reading—giving it a name or a conceptual category, and everything that comes with that. Just sticking to the realm of phenomena. You start talking about tactility and you're talking about the feel of a thing: feeling weight, feeling hot or cool, feeling the resonance of orange—in that example back there—feeling something being guttural, something being nasty, something having real tooth to it. You know, I'm rubbing my hands together, trying to show this to you, because that's really how you're reading it. Your eye's doing this; your eye and then your mind are doing this. And it's doing it long before you find the word for it, orange.

Things like painting, the camera, television, the computer for all its virtual reality and cyberspace—finally, they're all simple-minded when compared to the splendors, the dynamics of human perception.

**WESCHLER:** *There's the story about the Hollywood lighting director who's out watching a sunset on the Palisades —the clouds all turning pink and purple and mauve—and finally the sun dips below the horizon, and the fellow sighs, "Incredible the effects That Guy gets with just one unit."*

**IRWIN:** Exactly: only it's not God, it's Nature. And, even more incredible, it's us—our capacity to perceive all of that at all!

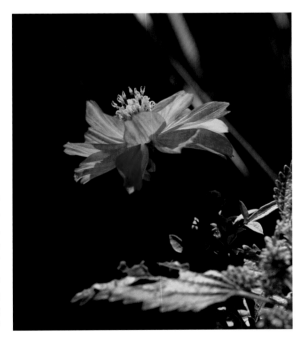

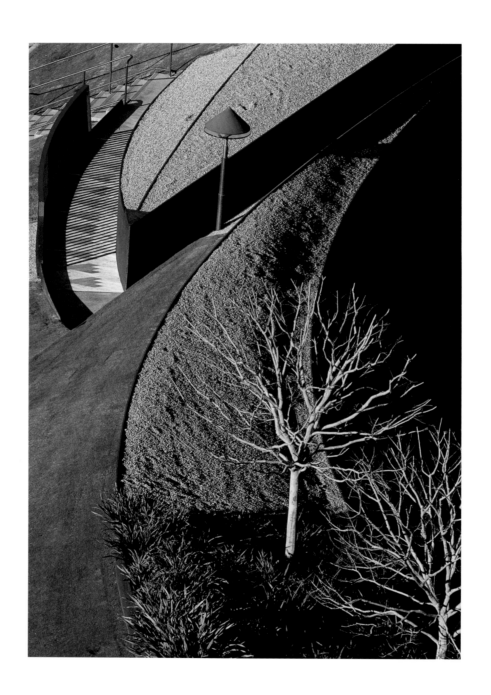

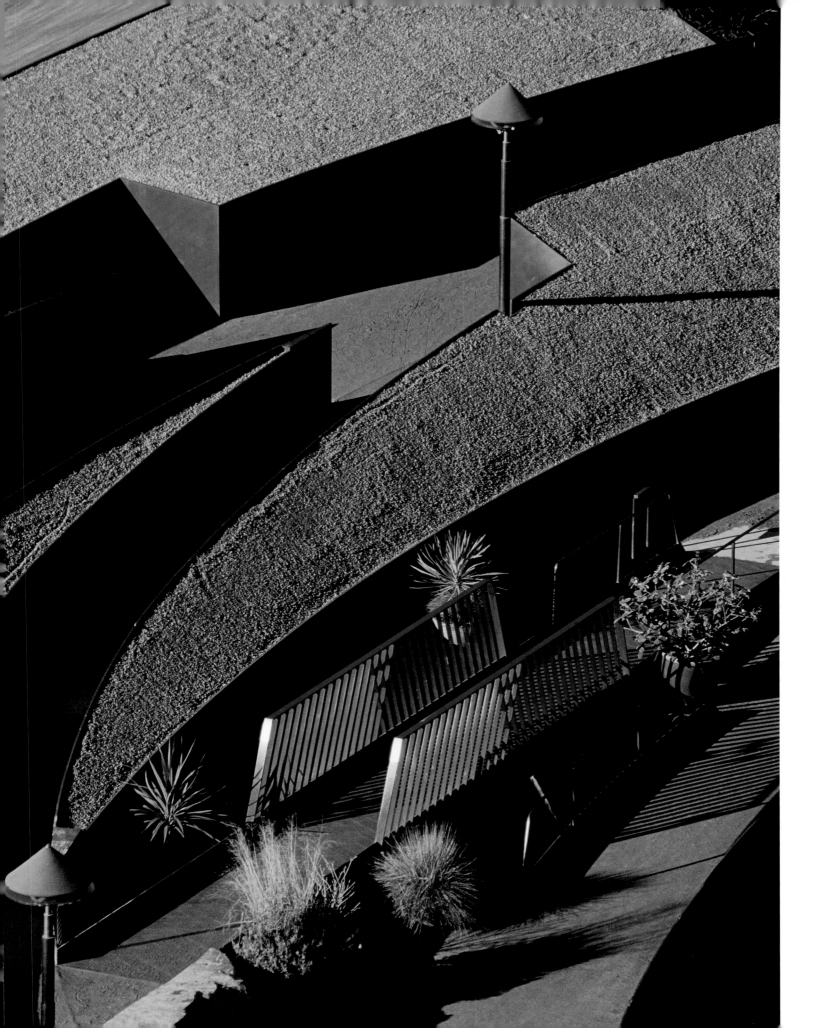

## AN INTERLUDE WITH JIM DUGGAN

VARIOUS PLANT IDENTIFICATIONS, AND
A SPECTACULAR IRIS; NOT GETTING WHAT
YOU ASK FOR. WHEN NATURE'S CLUMSY:
GREAT COLOR BUT THE BUSH SUCKS. PASTEL
COLUMBINES: NO RULES. THE DISTINCTION
BETWEEN LANDSCAPING AND GARDENING.

*{At this point, Jim Duggan, who's been laboring
down at the bottom of the bowl, slowly ambles up
to join us.}*

IRWIN: Now this is a very subtle grouping over here. Come over here for a second. Look at that little variegated leaf and then the color of that bloom. The whole thing just sort of dazzles and dances, but subtly. What's the name of this plant, Jim?

DUGGAN: *Variegated marguerite daisy.*

IRWIN: Variegated marguerite. But look at it, it's just subtle, but if you stop and look at it, it's dazzling. I mean, it's dynamite all by itself. Then you put it next to the real dark leaf of that rose. And look at this little thing right here. What's this little annie-plant here, this little dark purple in the center, little yellow petals around it, real delicate little thing?

DUGGAN: *Oh that's* Linaria *'Flamenco.'*

IRWIN: *Linaria* 'Flamenco.' I should have him around all the time just for the names! The names are fun! But this thing all by itself—and then you start getting these combinations, linaria with this lovely blue flower over here, Cupid's darts—you can see what potential it has. It's the most amazing palette imaginable.

By the way, Jim, come over here, I want to show you something. Look at this area right in there—all the stuff that's just about to happen.

DUGGAN: *The irises?*

IRWIN: The irises, yeah. I'll tell you right now, that the yellow one is about five times better than the blue one, don't you think?

DUGGAN: *You know, every bulb that those guys gave me is not the one that I wanted.*

IRWIN: That's a real pain. But I'll tell you something, you can use the yellow one again. The yellow one is absolutely brilliant. Look at the gray, gray-green that's on the top of that yellow one on the left.

DUGGAN: *The problem is, I don't know what it is. It's not the one that I ordered.*

IRWIN: Well, let's get a real good photograph of it, and let's send it to them with a little note that says, "Last year, I asked for X, X, X, and X, and you sent me none of them. The point is that within the ones you sent, I found three or four that I don't like at all—and I'd appreciate it if I could get what I asked for. But I also discovered one or two that are absolutely . . . "— because that's a beauty. That's one of the best ones I've ever seen. One of the most natural. Look at the shape of that one on the left.

DUGGAN: *That's a good one. To be real honest with you, the one that we had last year, I tried to get it because you liked it, but I don't really care for it as much as I like this one. This is a wonderful combination.*

IRWIN: I can tell you right now, I like that the best of any I've ever seen. That one on the left is an absolute brilliant flower.

DUGGAN: *Yeah, it's pretty good.*

IRWIN: Ah, yes.

DUGGAN: *It's beautiful.*

IRWIN: We need to nail a really good photograph of it and just send it to the guy. Tell them to stop messing around, send us the right—send us this one next year.

DUGGAN: *We want that one.*

IRWIN: Can it be propagated?

DUGGAN: *No, you can't: you need to buy them. They'll come back every year, but we need to buy more. And the problem is that, meanwhile, some of the others are in the wrong place, and I don't want them to come back. In fact, I'm going to dig them out. Over there, they're supposed to be purple up against the wall, and they're blue. And I didn't put blue there. I pulled the ones out of the purple bag, and I got the blue.*

IRWIN: Well, there are a lot of people in that industry— which is very surprising—they seem to be somewhat color-blind. You know? They actually think something is blue or red and it's not red at all. Orange is especially one they have trouble with. Sometimes they just don't seem to know what they're talking about. Either that, or they just don't give a damn about what they send you.

There's a clumsy one over there.

WESCHLER: *This is the first time I've ever heard you describe something that nature did as clumsy.*

IRWIN: Look, this is a very famous iris, this is one that all the artists use, but I think the yellow's clumsy. Nature's almost invariably right. Very rarely wrong. But every now and then, I just don't think it's dead on. Nature makes mistakes like everybody else.

*Opposite:* **TOP** *Jim Duggan in the 'growing garden,' San Diego. Photo: Robert Irwin.*
**BOTTOM** *Duggan in the bowl garden. Photo: Andrew Spurlock.*

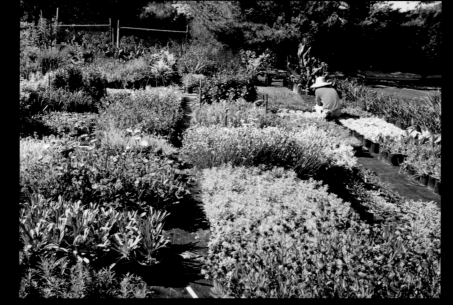

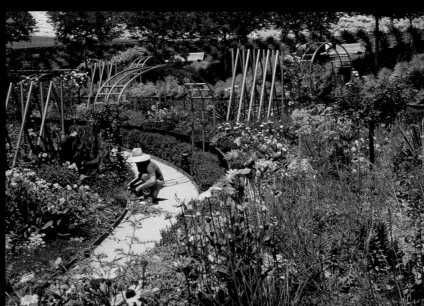

wonder whether art has a higher function than to make me feel, appreciate, and enjoy natural objects for their art value?
So as I walk in the garden, I look at the flowers and shrubs and trees and discover in them an exquisiteness of contour,
a vitality of edge or a vigor of spring as well as an infinite variety of colour that no artifact
I have seen in the last sixty years can rival.... Each day, as I look, I wonder where my eyes were yesterday.

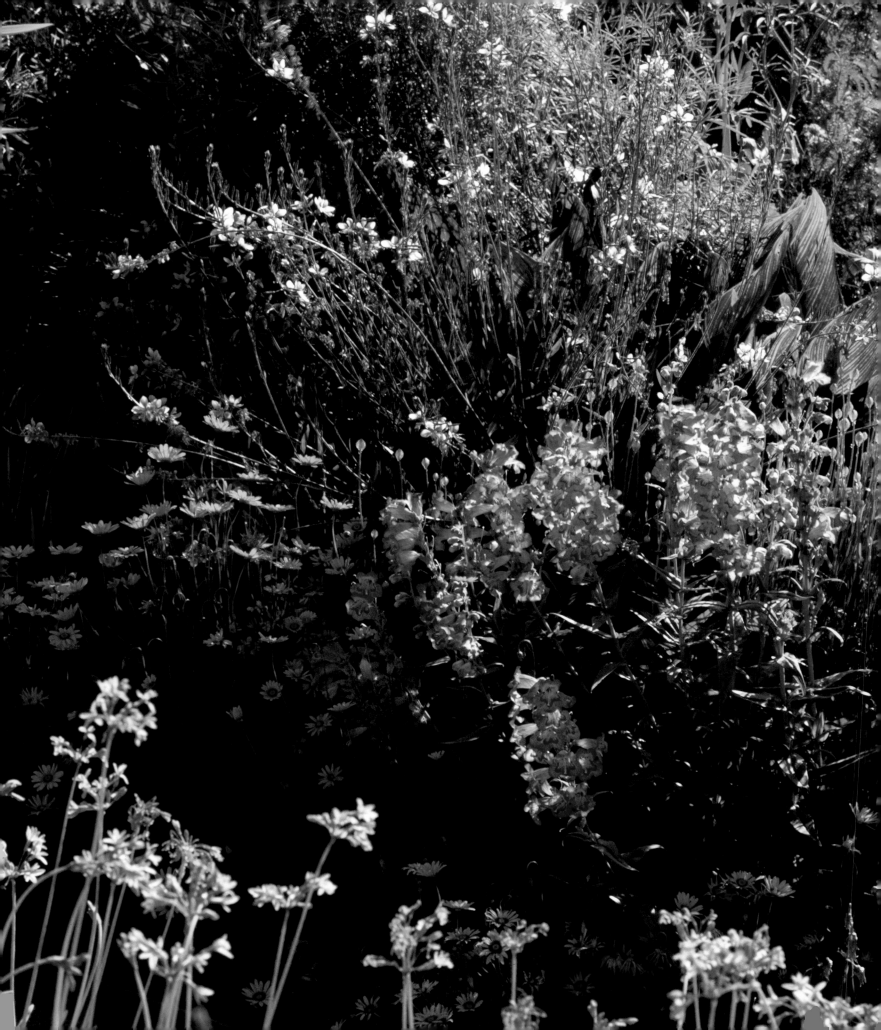

**WESCHLER:** *Talk a little more about that.*

**IRWIN:** Well, let's go back over there where the two are together, side by side, because there's one that's just brilliant and one that's clumsy.

**WESCHLER:** *You know the old graffiti: somebody writes on a bathroom wall, "'God is dead'—Nietzsche"; and somebody else writes below that, "'Nietzsche is dead'—God."*

**IRWIN:** (hearty laughter)

**WESCHLER:** *Well, "This flower is clumsy"—Irwin.*

**IRWIN:** Yeah, and "Irwin's clumsy." Never mind God!

 Seriously, though: in all humbleness, I realize now that I have never invented anything; everything I know comes from nature. Still, having said that: here, look. I mean, see how the yellow is a piece and a part of the whole plant? And how on the blue one, the flower, which is quite beautiful in itself, seems to separate itself from the plant? The world of roses has become like that, too.

**DUGGAN:** *There's a great color rose right over there, but the bush sucks.*

**IRWIN:** Exactly. The plants are inbred to produce these large, showy flowers which are clumsy on the plant. Incidentally, that's the first thing I look at, is how a plant reads as a whole—habit, structure, leaf, and flower.

 Anyway, nature's constantly giving you these little surprises. Doing a color that you wouldn't expect to be there but really fits. This is one I don't think fits that well, and it's primarily an issue of proportion. That's what makes it clumsy. There's a wrong amount of yellow with the blue in that flower.

**DUGGAN:** *And yet the yellow and gray one next to it.*

**IRWIN:** Oh, that one there, look at that—look at the color, there's a gray for you. Look at what that gray's doing in there. Man, it's just multifaceted. When you stop and look, that iris is absolutely—it's everything.

 Here's another nice plant in here, by the way, also. That purplish one, purple and yellow.

**DUGGAN:** *Yeah—the columbines—and again unexpected. I only put in yellows, and I don't know how the other one got in there.*

**IRWIN:** Well, that one's prettier than the yellow one. There should be three of those and one of those. That color's got just enough yellow—the yellow will really make those dance even more—and that's a particularly pretty one. Now, there's a combination that's a really good . . .

**DUGGAN:** *Of course, I have no idea what that one is.*

**IRWIN:** You don't?

**DUGGAN:** *No.*

**IRWIN:** That just pisses me off.

**DUGGAN:** *I mean, it's just an unexpected one that came out.*

**IRWIN:** You're trying to plan something, and he says to me, "Well, none of these is the one I ordered." How do you plan that, you know?

**DUGGAN:** *You can't plan that.*

**IRWIN:** You can't plan that. Anyway, it's nice, I love those little tails on it.

**DUGGAN:** *Yes, the columbines are just—you can't have spring without columbines.*

**IRWIN:** Well, that's my favorite columbine. And by the way, note that those are real pastel colors.

**DUGGAN:** *I know, they're totally wussed out.*

**IRWIN:** But see, what with the strong stuff all around the—how they just float.

**DUGGAN:** *Thing is, you've got me afraid to order pastel plants. If I actually did that deliberately—*

**IRWIN:** But now, think about—in other words, what I'm saying is that there are no nos—it's all about combinations, it's all about relationships. You put that in that real strong green backdrop, and it's a beautiful, delicate little plant. The thing that pastels have going for them is delicacy. They also become wussies, you know, so you have to stage them so that that delicacy gets in there and floats, like an aroma almost. Just a soft smell in the air. Those are just really pretty.

 But I have to say, the surprise of the spring, so far, is that gray and yellow—

**DUGGAN:** *That iris.*

**IRWIN:** That iris is an absolute, freaking winner.

**DUGGAN:** *I'll try to get you another one. But don't hold your breath. It's all part of that point I keep making about the distinction between gardening and landscaping . . .*

**IRWIN:** That's a real distinction.

**DUGGAN:** *. . . where landscaping is something that is not an active thing—it's like, you're putting in a new kitchen, or you've painted your house. Whereas gardening is something you deal with every day, and you want to deal with it every day. There's an activity level in gardening that is different than landscaping. Not to put landscaping down— it's a wonderful thing to have, you don't want things to be just concrete—but it's different from gardening. Speaking of which . . .*

{At this point, Duggan descends back into the bowl to resume his work.}

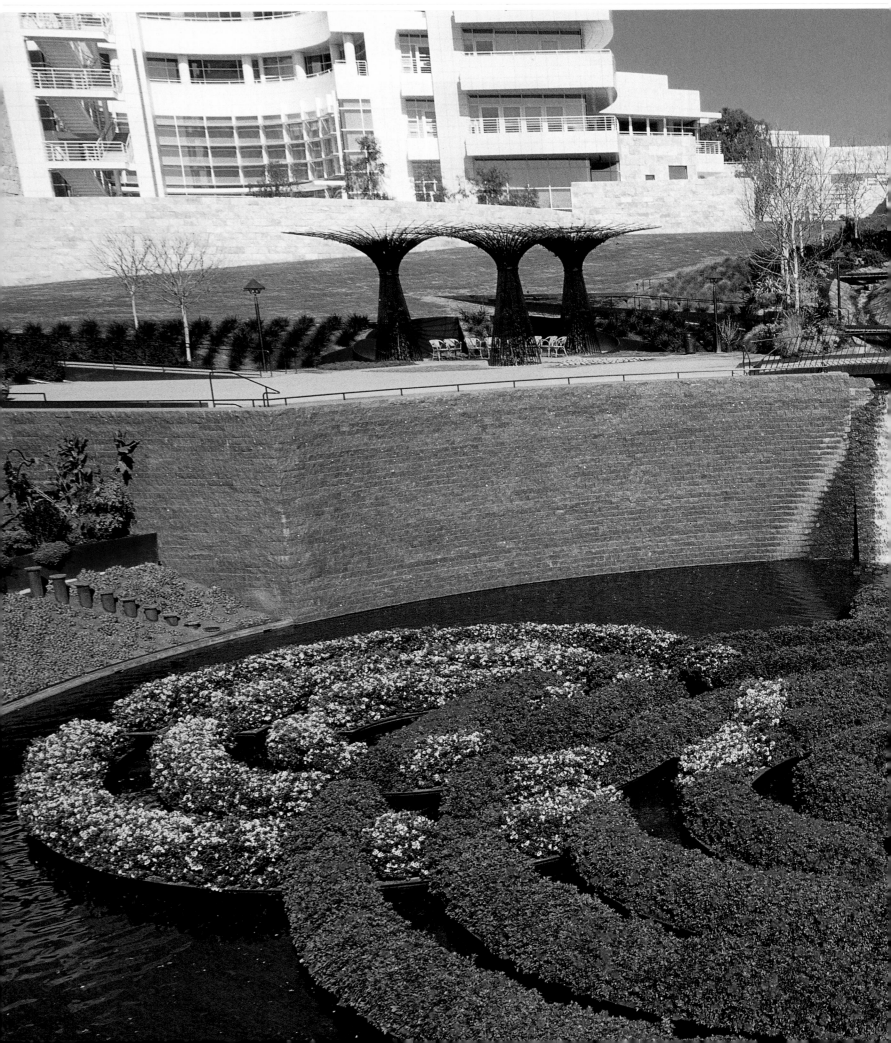

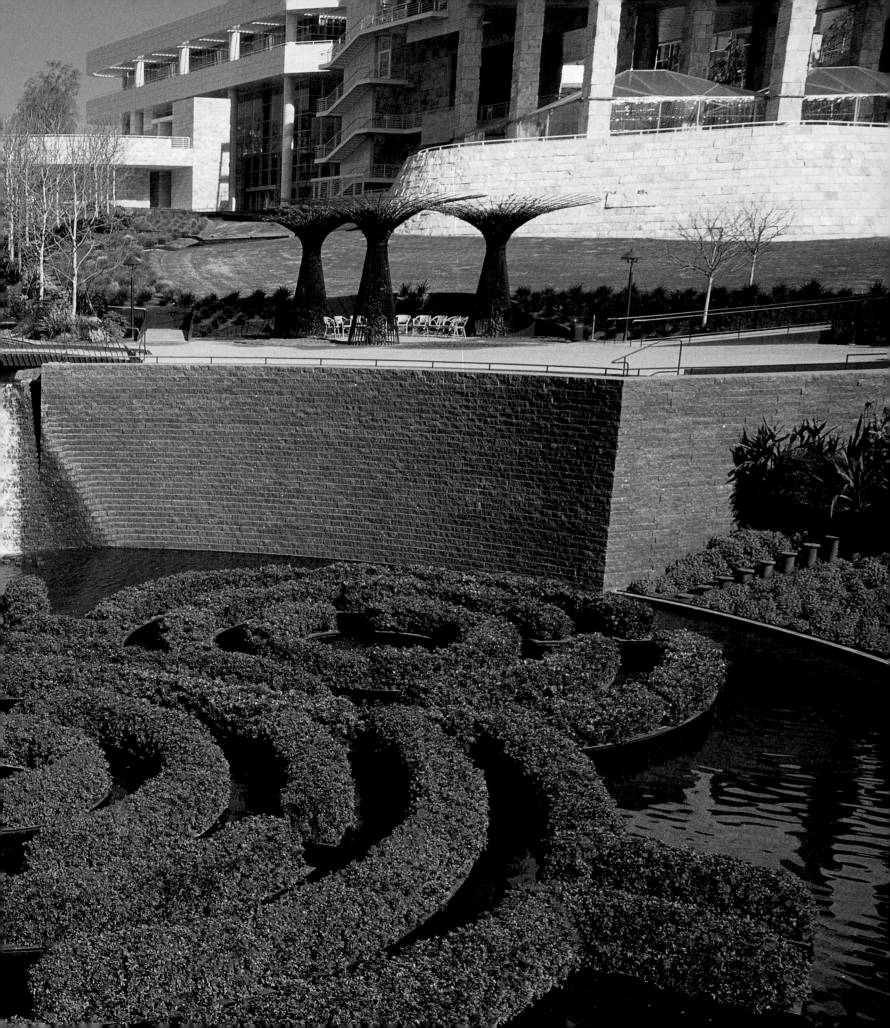

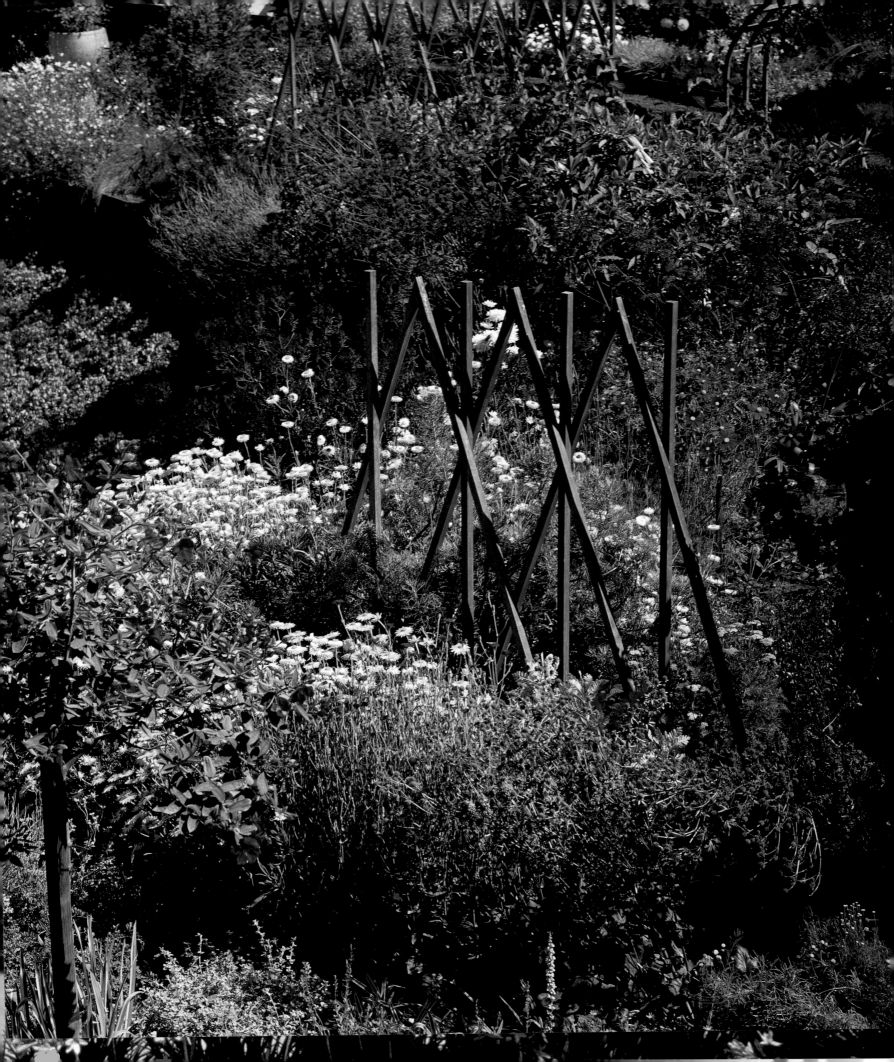

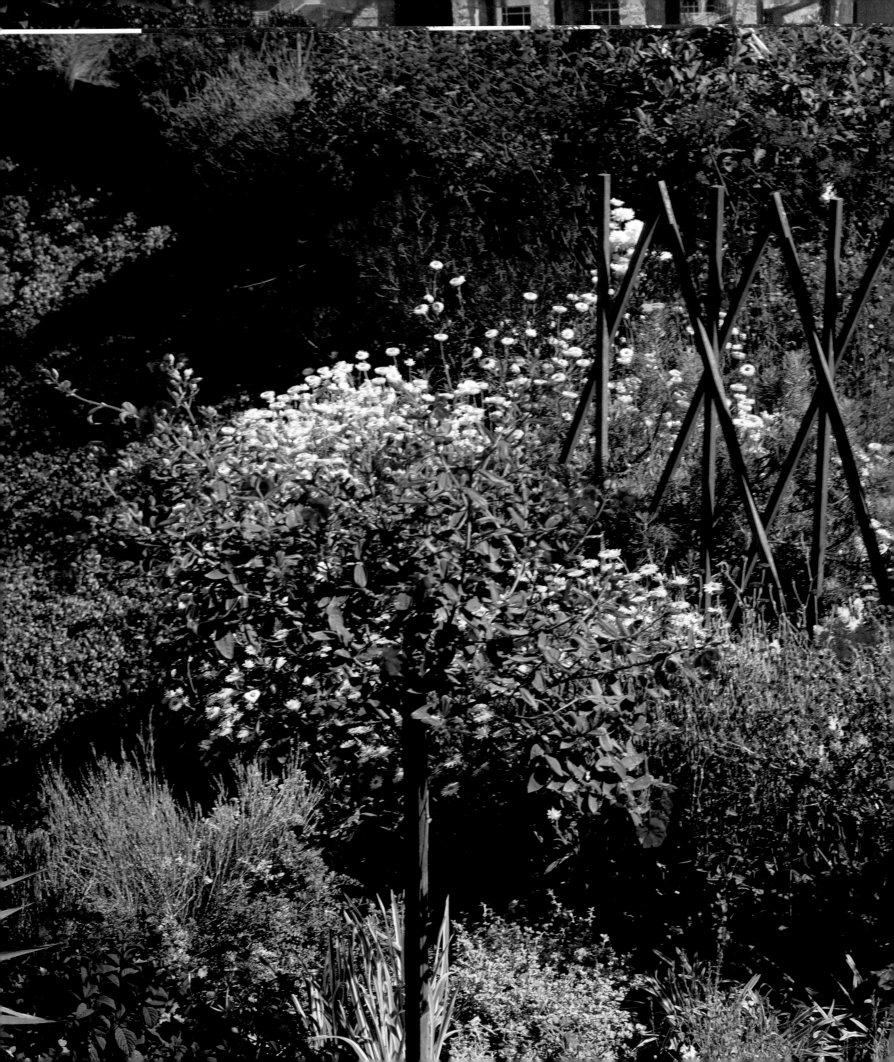

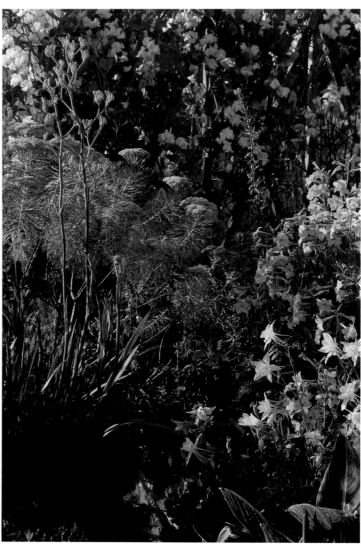

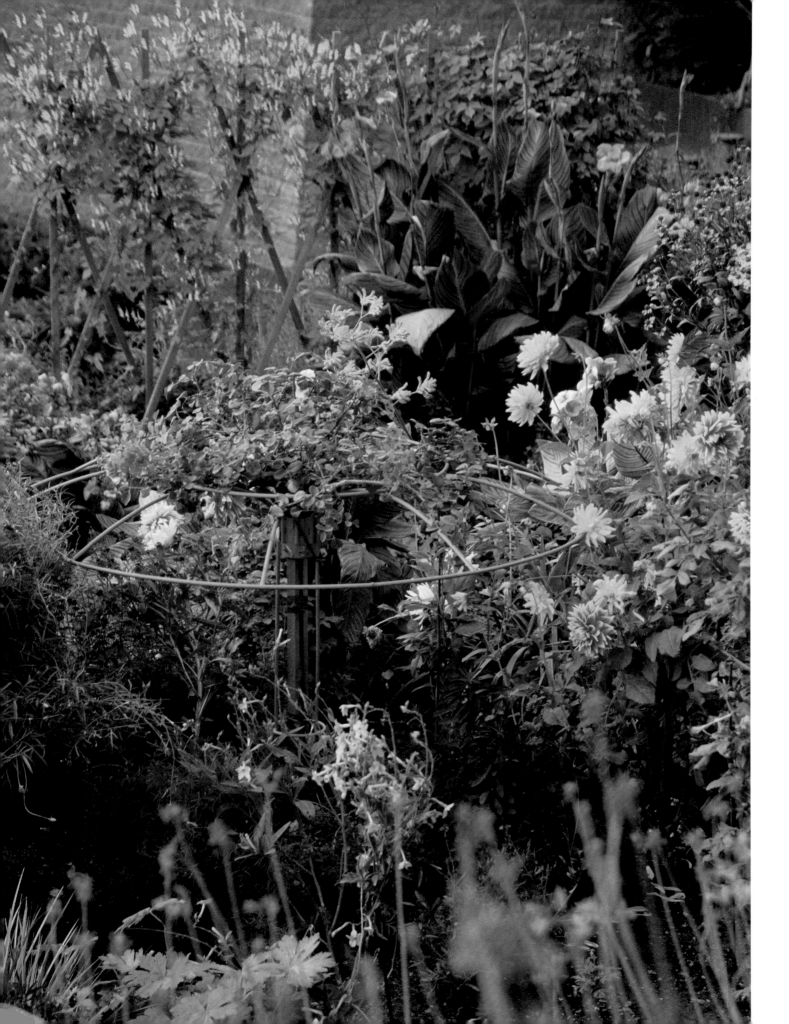

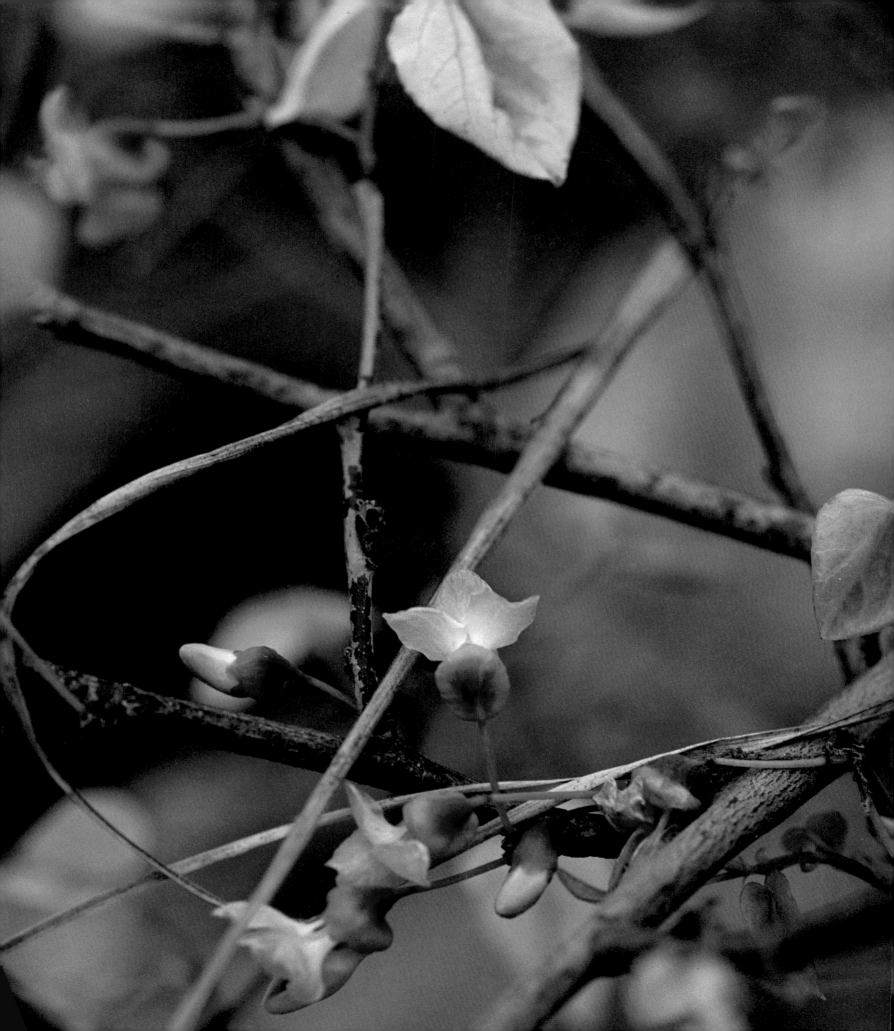

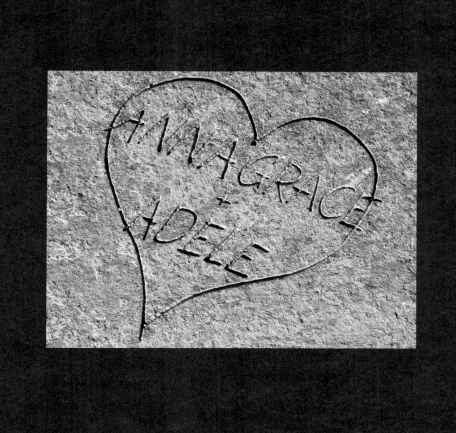

# LIST OF ILLUSTRATIONS

Unless otherwise noted or credited elsewhere, all photographs are by Becky Cohen.

## PHOTOGRAPHER'S NOTE

*Previous to photographing Robert Irwin's Getty garden I had devoted five years to photographing the three-hundred-year-old French royal gardens designed by André Le Nôtre, which are flat Cartesian planes where trees, statues, and fountains are commanded, via straight lines and squares, into arrays of outdoor "rooms," or bosquets. Every detail predicts the order of the whole and one's place in it.*

*A detail does no such thing in Irwin's garden at the Getty, where each element is a world unto itself and refers, not to some mental map of the entire garden, but to one's own powers of perception. In a walk through the garden, these details combine to ravishing and unexpected effect. The tiny succulent garden at the head of the zigzag path is itself a fragment of tapestry but doesn't give away the surprise of the richly planted and unusual annuals weaving around the grand azalea bowl.*

*I shot the photographs in this book to convey the beauty and structure of Irwin's design and his extraordinary powers as a colorist. His masses of unlikely plants merge into color effects so complex that they are overwhelming, leaving the viewer in awe and quite without a map. I can't imagine spatial philosophies more opposite than Le Nôtre's and Irwin's. The study of one sharpened my view of the other.*

*I hope these images summon the reader to experience Robert Irwin's garden at the Getty in person. It is unique in the history of gardens and as a work of art. Putting the garden on film has been a profound privilege, and I thank Robert Irwin and the J. Paul Getty Museum for the honor.*

BECKY COHEN

# INDEX

Page numbers for illustrations are in **boldface**.